THE IDEAL BOOK

THE IDEAL BOOK 🍂 ESSAYS AND LEC-
TURES ON THE ARTS OF THE BOOK
BY WILLIAM MORRIS 🍂 EDITED BY
WILLIAM S. PETERSON

UNIVERSITY OF CALIFORNIA PRESS
🍂 1982

University of California Press
Berkeley and Los Angeles, California

University of California Press, Ltd.
London, England

ISBN 0-520-04563-7
Library of Congress Catalog Card Number: 81-51339

Printed in the United States of America

1 2 3 4 5 6 7 8 9

CONTENTS

ILLUSTRATIONS

ACKNOWLEDGMENTS

IN compiling and editing this book, I have had my work made easier by the generosity of a number of individuals and institutions. The following persons have contributed substantially in the form of advice or assistance: Mr. John Dreyfus, Dr. Joseph Dunlap, Dr. David Greenwood, Dr. Edward Guiliano, Dr. Julia Markus, Mr. James Mosley, Dr. Paul Needham, Ms. Carol Parsons, my wife Eileen Peterson, and Dr. Peter Stansky. I am especially grateful to Mr. Walter E. Richardson, Supervisor of Type Design for Itek Corporation, who designed a font to our specifications for use in this book.

The Cambridge University Press supplied reproduction proofs of titles set in Morris's Golden type.

The British Library, the Library of Congress, the Pierpont Morgan Library, the National Portrait Gallery in London, and the St. Bride Printing Library provided illustrations. For permission to quote unpublished material, I am indebted to the Bodleian Library, the British Library, the Humanities Research Center (University of Texas), the Henry E. Huntington Library, and the Pierpont Morgan Library; Morris's unpublished letters are quoted by authorization also of the copyright owner, the Society of Antiquaries.

I received much courteous assistance from the staff of the Rare Book Division of the Library of Congress, particularly Mr. Peter Van Wingen, and the English Department of the University of Maryland provided a typist and proofreader. (The latter was Ms. Edith Beauchamp.) Part of the research for this book was done under a grant from the American Philosophical Society.

W.S.P.

INTRODUCTION ✦ BY THE EDITOR

HEN Dante Gabriel Rossetti, Edward Burne-Jones, William Morris, and some fellow-artists painted on the damp walls of the Oxford Union debating hall in 1857, their ignorance of fresco technique led them to produce haunting images of the Middle Ages which, in ghostly fashion, began to fade almost immediately; but the more permanent legacy of this episode was a body of richly revealing anecdotes about the Pre-Raphaelites themselves. Burne-Jones, for example, recalled that Morris was so fanatically precise about the details of medieval costume that he arranged for "a stout little smith" in Oxford to produce a suit of armor which the painters could use as a model. When the basinet arrived, Morris at once tried it on, and Burne-Jones, working high above, looked down and was startled to see his friend "embedded in iron, dancing with rage and roaring inside" because the visor would not lift.[1]

Figure 1

This picture of Morris imprisoned and blinded by a piece of medieval armor is an intriguing one: certainly it hints at an interpretation of his career that is not very flattering. But we ought to set alongside it another anecdote, from the last decade of Morris's life, the symbolism of which seems equally potent. Early in November 1892, young Sydney Cockerell, recently hired by Morris to catalogue his incunabula and medieval manuscripts, spent the entire day immersed in that remote age while studying materials in Morris's library. As evening approached, he emerged again into the nineteenth century (or so he thought) and climbed the staircase of Kelmscott House: "When I went up into the drawing room to say goodnight Morris and his wife were playing at draughts, with large ivory pieces, red and white. Mrs. M. was dressed in a glorious blue gown and as she sat on the sofa, she looked like an animated Rossetti picture or page from some old MS of a king and queen."[2] Even though his wife seemed to have stepped out of an illumination, Morris was not, in the end, crippled by a dreamy infatuation with the Middle Ages; the medievalism which suffuses his art and personal life was not merely a means of escaping ugly Victorian realities. The unifying theme of Morris's extraordinarily varied career was a desire to reunite art and craftsmanship, and this in turn led to that preoccupation with functional structure and honest use of

materials which has prompted Pevsner to call him one of the pioneers of modern design.[3] If Morris seems at times to be struggling in vain to lift the visor of his basinet, we must also remember that – by a sublime paradox which he himself would have relished – his aesthetic theories point unmistakably in the direction of Gropius, Frank Lloyd Wright, and the twentieth century.

The central dilemma of Morris's artistic career is that though he warmly condemned the servile imitation of historical styles, he nevertheless turned incessantly to medieval art for (in Burne-Jones's words) "inspiration and hope."[4] Walking such an aesthetic tightrope inevitably required some very fancy footwork. Writing in 1893, Morris offered this piece of advice (which he admitted was "a little dangerous") to C. M. Gere, who was struggling, unsuccessfully as it turned out, to provide illustrations for the Kelmscott Press edition of *The Well at the World's End*: ". . . you should now try to steep yourself, so to say, in mediæval design; look [at] illuminations in 13th & 14th century books[,] at wood cuts and so on, and make sketches from them. . . . But (there is always a but, you know) all this will be of no use to you unless you feel yourself drawn in that direction and are really enthusiastic about the old work. When I was a young-bear, I think I really succeeded in ignoring modern life altogether. And it was of great service to me." Significantly, in his next letter to Gere, Morris described his own counsel as "doubtful."[5] Victorian England, after all, was littered with cautionary examples of the danger of an indiscriminate revival of medieval styles. Ruskin himself had come to hate the mock-medievalism of suburban villas, railway stations, and banks which sprang up, to his horror, in apparent malignant response to his praise of Venetian Gothic. Morris (whom Ruskin, incidentally, described as "beaten gold" and "the ablest man of his time"[6]) always had to take special care not to be similarly misunderstood.

The founding of the Kelmscott Press by Morris in 1891 can be usefully seen, in fact, as the final phase of the Victorian Gothic revival. The ideas that lay behind the Press (such as distrust of the machine and the association of the Gothic style with a certain set of moral values) were drawn directly from Ruskin's chapter entitled "The Nature of Gothic" in *The Stones of Venice*: not surprisingly, that essay became the fourth book published by the Press, and Morris, in an Introduction, praised it as "one of the very few necessary and inevitable utterances of the century." But Morris, like Ruskin, was struggling against more than a poisonous industrialism. He had also to combat a spurious re-

vival of medievalism in bookmaking which was only slightly less alarming than the Gothicky contagion that was rapidly disfiguring Victorian cities and suburbs.

Of course the Chiswick Press had been intelligently reviving the use of Caslon's type since the middle of the century, but in the history of medievalizing typography the key event was the Caxton Exhibition – a celebration of the four hundredth anniversary of English printing – held in London during the summer of 1877. The Exhibition, with its extensive array of early printed books and an operating wooden press, aroused such enthusiasm that, according to one trade journal, "the columns even of the *Times* have been thrown open to correspondence on moot points of typographical history."[7] Stanley Morison believed that the event "had a decisive effect upon bibliographical and typographical studies."[8] At a more popular level, the rediscovery of Caxton as a patriotic hero encouraged the revival of earlier styles of typography, generally in debased form: hence by the 1880s "old-style" printing, as practiced by important firms like Unwin Brothers, the Leadenhall Press (which sometimes called itself Ye Leadenhalle Press), and Messrs. George Falkner & Sons, was rivaling "artistic" printing as one of the most fashionable typographical modes of the day.[9] An advertisement in the *Antiquary* magazine in 1881 offered readers "Old English Type" letters and monograms ("in Turkey Red, and orders can also be executed in Black") "for sewing on household linen, socks, and underclothing."

The term *medieval* was thrown about with wonderful abandon, as when a type specimen book by Unwin Brothers announced: "Type of the *Old Style* of face is now frequently used, more especially for the finer class of *Book* and *Ornamental work*. The series in use at the Gresham Steam Press are from the *Original Matrices*, which were cut at the beginning of the last century, and thus possess all the peculiarities of the *Mediæval Letters*."[10] Another word much bandied about by old-style printers was "quaint": it appeared obsessively in advertisements and printing trade journals, and there was even a magazine called *Ye Quaynt*. Falkner & Sons issued a "quaint and curious" series of Christmas cards. Andrew Tuer, of the Leadenhall Press, the most energetic of all the old-style printers, compiled a volume entitled *1,000 Quaint Cuts from Books of Other Days* (1886).

Old-style printing often consisted of a bewildering mixture of Old Style (*i.e.*, a derivative of Caslon) text type, pseudo-Caxton display types, and borders and ornaments borrowed from four centuries, with

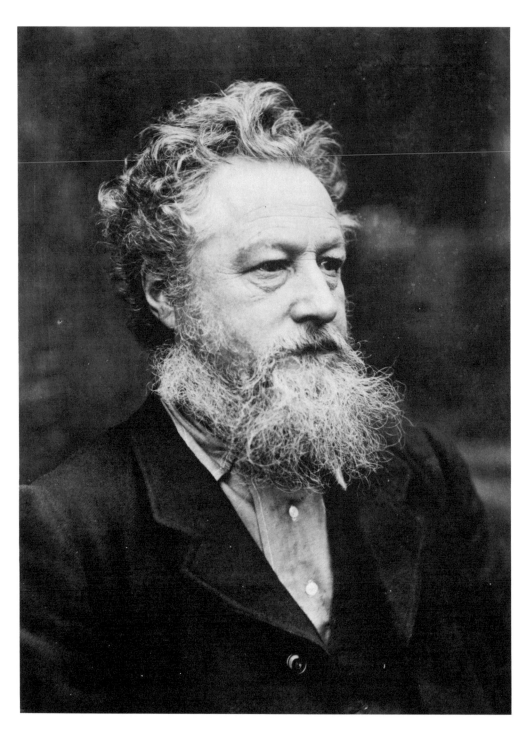

1 William Morris, as photographed on January 19, 1889. *Courtesy of the National Portrait Gallery (London).*

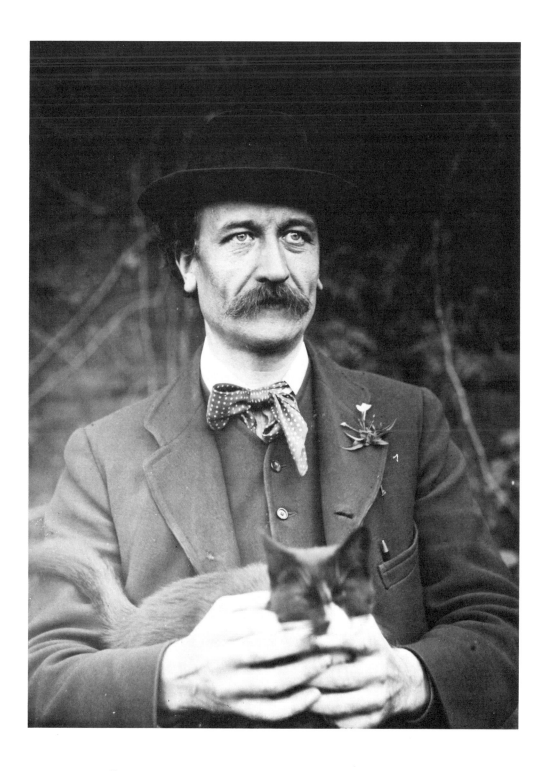

2 Emery Walker. *Courtesy of the National Portrait Gallery (London).*

the sort of archaic spelling that one would today associate with pretentious Ye Olde Antique Shoppes. A representative colophon by Falkner & Sons reads: "Concernynge thys Boke, and ye Impryntynge thereof, it hath ben done wythe cunnynge Crafte by Maister George Falkner & hys Sons, of ye antiente Citie of Manchester, in ye Royal Duchie of Lancaster, after ye style of daies longe gone bye insomuch as MAISTER WILLIAM CAXTON hymself maye have ben ye imprynter."[11] This sort of bogus medievalism in typography is clearly equivalent to the sham Gothic of eighteenth-century dilettantes like William Beckford and Horace Walpole – or, worse yet, the horrors perpetrated by Victorian jerry-builders in the name of Gothic – and it remained for Morris (just as Pugin and Ruskin had done in architecture) to step into this messy scene of Victorian commercial printing and to make clear, once and for all, the difference between seeking "quaint" typographical effects and rediscovering the fundamental structural principles of the medieval book. When Burne-Jones told Charles Eliot Norton in 1894 that he and Morris were attempting to make their edition of Chaucer "a pocket cathedral,"[12] his analogy was exactly right: each Kelmscott Press book was intended to be not a Victorian railway hotel "done in the Gothic style," but a miniature cathedral, or at least a parish church, constructed of sound materials and inspired by the Ruskinian vision of craftsmanship as an act of worship.

✿

The craft of bookmaking, like many other crafts, had long fascinated Morris. As Oxford undergraduates, he and Burne-Jones spent long hours in the Bodleian Library studying illuminated manuscripts and medieval woodcuts. In the late 1860s the two of them conceived the

Figure 29

ambitious scheme of a handsomely printed edition of Morris's *Earthly Paradise* with scores of wood-engraved illustrations to be designed by Burne-Jones.[13] The undertaking was never completed, partly because of its magnitude and partly because Morris was unable to find a typeface with sufficient weight and color to blend well with the wood-engravings. This disappointing venture proved, then, to be Morris's first practical lesson in the importance of integrating text and illustrations. Undaunted, in 1871, Morris, again with the help of Burne-Jones,

Figure 28

designed and engraved on wood several borders and decorated initials for use in his poem *Love Is Enough*, but once more the feebleness of Victorian types frustrated his intentions, and in the end only the cover

of the book bore any decoration. Thereafter, until the late 1880s, Morris's books were decently printed but undistinguished in typography and design, and he contented himself with writing and illuminating beautiful manuscripts, done in a late medieval or Renaissance manner, some of which he offered as gifts to friends.

But in 1888 the embers of Morris's dormant interest in the arts of the book were suddenly fanned into new life by a lecture delivered at the first Arts and Crafts Exhibition in London on November 15 by his friend and neighbor (and fellow-socialist) Emery Walker. Walker (1851–1933), a modest, soft-spoken man, was quietly becoming England's most distinguished typographer, though throughout his life he was overshadowed by some of the more flamboyant personalities – such as Morris, Thomas J. Cobden-Sanderson, Count Harry Kessler, and Bruce Rogers – with whom he was associated.[14] By profession he was a process-engraver, but his real passion was early printed books, which he collected and studied minutely with a printer's eye. Disdaining mere antiquarianism, Walker found in fifteenth- and sixteenth-century printing an answer to the question (which had been vexing Morris also for decades) of what was wrong with modern books; the failure lay, he decided, in the wrong proportions of margins, in excessive space between lines and words, in faulty type-design, and in the use of cheap ink and paper.

Figure 2

Walker said all of these things and more in his lecture at the New Gallery that evening. As Oscar Wilde reported in the *Pall Mall Gazette* the following day, "He pointed out the intimate connection between printing and handwriting – as long as the latter was good the printers had a living model to go by, but when it decayed printing decayed also." The essential thing with regard to illustration, he said, "is to have harmony between the type and the decoration." Walker's lecture, it should be noted, was accompanied by a series of lantern-slides which he used to demonstrate his contention that printing had declined steadily since the fifteenth and sixteenth centuries. The slides showed, in all their remarkable beauty (and on a much larger scale than anyone had ever seen them before), manuscripts and books of the late Middle Ages and early Renaissance: when a page of Vicentino's writing book appeared on the screen, the audience, according to Wilde, burst into spontaneous applause.[15]

What happened after the lecture, as Morris and Walker went back to Hammersmith together, is well known. Morris, still enraptured by the vision of those huge letters – which, contrary to expectation, had

not grown less attractive when greatly enlarged by the magic-lantern – announced that he wished to design a new typeface and asked for Walker's assistance. Walker's account of the unofficial partnership which began then is characteristically laconic and generous: "Mr. Morris finding I had some knowledge of the practical side of printing and was thus able to explain certain details of the methods of the early printers, a subject which was beginning to occupy his mind, he invited me to visit him, which, as we had other interests in common, I was glad to do. From this time until his death in 1896 I was a frequent visitor and learned much more in bulk from him of the artistic side of printing than I could teach him of the simple elements."[16] On the other hand, Morris always acknowledged his considerable indebtedness to Walker; and Sydney Cockerell, who became the second Secretary of the Kelmscott Press and later its historian, offered in 1909 this sweeping estimate of Walker's rôle: "So far as England is concerned, . . . he is simply the father of the whole movement [the revival of fine printing] and as such will unquestionably live in history. His lecture at the Arts and Crafts Exhibition of 1888 was the first public exposition of the principles underlying that movement, though Walker had before that proclaimed them in private and had begun his crusade in favour of Caslon's old faced and Miller and Richard's old style type, which, thanks chiefly to him, have made the reputation of the Chiswick Press and have spread thence to the other important Presses of the country. It is not too much to say that but for Walker there would have been no Kelmscott Press."[17]

This is striking testimony, coming as it does from a self-confessed disciple of Morris. But what precisely was the extent of Morris's intellectual debt to Walker? That is unfortunately a difficult question to answer because Walker seldom published his views on typography[18] (one reason he and Morris found each other's company congenial is that both had more faith in the craftsman's eye and hand than in abstract theories) and because probably in many instances Morris had instinctively reached similar conclusions before hearing Walker's lecture. For instance, the chief article of Walker's typographical creed, based as usual on his study of early books, was the necessity of close and even word-spacing: his advice to modern compositors was that the compartment in their type cases normally used for thick spaces should be filled instead with thin spaces. Yet a membership card which Morris designed for the Socialist Democratic Federation in 1883 shows that as early as that date Morris fully understood – in lettering if not in

printing – the importance of reducing the space between words to a
minimum.

Another means of assessing their relative contributions to the typographical theories represented in the present volume is to compare the essay entitled "Printing" (see below, pp. 59–66), which appeared under the names of both men in a volume entitled *Arts and Crafts Essays* (1893), with the earlier, much briefer version – more or less an abstract of Walker's lecture – which was published under Walker's name alone in the 1888 *Catalogue of the First Exhibition* of the Arts and Crafts Society (pp. 77–81). In general outline the essays are nearly identical, but in the 1893 version, which presumably reflects mainly Morris's additions, the illustrative examples, especially from the fifteenth century, are greatly expanded, and there are new discussions of design in typography, word-spacing, margins, and paper. Perhaps the most conspicuous difference between the two essays is that whereas in 1888 the tone is modest, restrained, and reasonable (the voice of Emery Walker, in fact), the 1893 essay, as revised by Morris, is vigorous and brilliantly polemical in its condemnation of the abuses of Victorian printing. If it is not always clear which idea came from which man, it is abundantly evident which of them was the master propagandist.

Or, moving from theory to practice, we can look at the Kelmscott books in relation to other books – especially those published by the Doves Press – which Walker had some hand in designing. But this will tell us less than we might expect. An analysis of the Doves books reveals that Walker preferred a somewhat lighter typeface than Morris, and that he was willing to leave a page completely undecorated (something Morris rarely did); that, in short, he tended to model his books after those of the Renaissance rather than of the fifteenth century. Yet the Doves books are fundamentally like the Kelmscott books except for the lack of ornament, and, for that matter, by 1900 (the year the Doves Press was established) it is no longer possible to separate the strands of influence, since both Walker and his partner Cobden-Sanderson venerated the example of Morris. Indeed, from 1891 onward, all private press books show, in varying degrees, the impact of Morris's typographical dicta.

Thus it may never be possible to do full justice to Walker's contribution. Morris, however, knew on that evening in 1888 that he had found exactly the right person to help him revive yet another craft. He asked him to become a partner in the Kelmscott Press, but Walker re-

fused: because "he had no capital to risk," according to one account, or because he was too busy, or because (in Walker's own words) he had "some sense of proportion."[19] Still, thereafter Walker became an almost daily visitor at Kelmscott House, often lingering late into the night as the two men pulled books off the shelves and talked fervently about beauty and fitness in printing. Neither was a disciple of the other; they met as equals. What Morris learned when he first heard Walker lecture was not new doctrine to him. Rather, he suddenly and rapturously discovered what had been germinating in a hidden part of his own mind for years, and with a joyous cry of recognition Morris greeted the set of ideas and ideals that were to transform the appearance of the modern book.

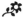

It is not especially difficult to demonstrate that most Victorian books were ill-designed (if designed at all) and made use of inferior typefaces and shoddy materials. What is more remarkable is the widespread complacency among book-printers of the day about their work. Their usual assumption was that because there had been enormous advances in printing technology during the nineteenth century, the final typographical product must itself be greatly superior to what it had been in the past. The following, for example, is a typical hymn of self-praise which appeared in a printers' trade journal in 1882: "An art which is so eminently dependent upon mechanical perfection must inevitably progress toward excellence by the successive labours of succeeding generations; and the best letterpress of the nineteenth century is not only vastly superior to the greatest efforts of Aldus and Plantin, but far superior even to the most loudly-vaunted triumphs of Baskerville and Bodoni at a much later period; and a typefounder's specimen book of the present day can safely challenge comparison with any work performed by any of the great masters of early printing."[20] One of the recurring terms in such effusions was *delicate*: the extremely fine strokes and serifs of modern typefaces were invariably described as delicate, a word which then suggested to the writer related adjectives like *fine*, *sensitive*, *graceful*, and *exquisite*, while old-face types were labeled *heavy*, *coarse*, and *clumsy*. The hidden premise was that fineness of detail in type is a hallmark of refinement – that is, a more advanced state of civilization – whereas Morris, when he turned his attention to type-design, saw thin strokes as a symptom of

modern decadence and overreacted by thickening his own Golden type tremendously. Victorian printers argued that their *delicate* faces and ornaments satisfied "an intellectual, highly cultured, and preeminently artistic taste."[21] Morris, like Browning's Childe Roland, dauntless the slug-horn to his lips set, and blew: with a mighty noise he attacked the weakness of the modern-face type and proclaimed the superiority of the simpler virtues of strength, blackness, and boldness on the printed page.

Yet it must not be supposed that Morris carried on this battle alone or that the typographical theories advanced in his essays and lectures had evolved in a cultural vacuum. The conventional view that Morris rescued printing from the depths of Victorian bad taste is fundamentally right, but how this came about is a good deal more complicated than some historians have assumed. We have already seen that Emery Walker had independently arrived at the same diagnosis of the sickness of modern book-printing. There were others as well; Morris was not a lone voice crying in the wilderness. His achievement was to bring together the complaints and proposed remedies being expressed by a number of his contemporaries, to give them a unified intellectual framework, to communicate them with extraordinary eloquence, and finally to carry his precepts out in action by producing a series of stunningly beautiful books at the Kelmscott Press.

One of the most comprehensive assaults upon Victorian bookmaking came in a paper delivered to the Library Association at Cambridge in October 1882 by Henry Stevens, an American bookseller long resident in London who had personal and professional ties with the Chiswick Press.[22] In words that directly anticipate Morris, he declared, "The manufacture of a beautiful and durable book costs little if anything more, it is believed, than it does to manufacture a clumsy and unsightly one. Good taste, skill and severe training are as requisite and necessary in the proper production of books as in any other of the fine arts. The well-recognized 'lines of beauty' are, in our judgment, as essential and well-defined in the one case as the other." Stevens went on to give detailed, and mostly very sound, advice on the improvement of ink, paper, margins, and title-pages. Like Morris, he regarded the binder's knife as a threat to civilization. The models which Stevens commended were, not unexpectedly, the Chiswick Press books and the printing of the fifteenth century.

Several of the artistic and learned societies to which Morris belonged were also expressing concern, both before and after the crea-

tion of the Kelmscott Press, about the lamentable state of contemporary printing. In 1890 the Society of Arts heard a paper by Talbot Baines Reed, one of the chief typographical scholars of the day, on "Old and New Fashions in Typography."[23] Reed's views were recognizably similar to Morris's: he revealed a personal preference for old-face types, and he praised the typography of Jenson especially in language that calls Morris to mind. But though he covered somewhat the same ground as Morris and Walker in their essay on "Printing," Reed's paper is more narrowly technical and infinitely less persuasive.

Walker's lecture at the first Arts and Crafts Society Exhibition in 1888 bore fruit the following year when Morris's *House of the Wolfings*, printed at the Chiswick Press in the Basel Roman type and designed by Morris with the assistance of Walker and C. T. Jacobi, was prominently on display. The catalogue of the exhibition in 1889 also printed an essay by Reginald T. Blomfield, an architect, entitled "Of Book Illustration and Book Decoration." Blomfield advanced the opinion – endorsed by Morris and Walker and quickly hardened into dogma among private press enthusiasts – that the only proper forms of graphic reproduction in a book were wood-engraving and (as a distant second choice) direct lithography. The Arts and Crafts Exhibition Society was in part an offshoot of the Art-Workers' Guild, which also displayed a lively interest in the art of the book. The topics discussed or demonstrated at the Guild's meetings included "Process Reproduction as Applied to Book Illustration" (May 7, 1886), "Printed Book Illustration" (June 4, 1886), "Bookbinding" (October 17, 1887), "Reformation of Printing Type" (December 2, 1887), "Book Ornamentation before Printing" (January 6, 1888), "Gothic Illustrations to Printed Books" (November 28, 1890), "Calligraphy, Typography, and the Book Beautiful" (June 3, 1892), "The Manufacture of Paper" (December 2, 1892), "Colour Printing" (May 18, 1894), and "Book Illustration" (January 3 and 17, 1896).[24] Morris (who was Master of the Guild in 1892), Walker, Cockerell, and others associated with the Kelmscott Press were active in the organization; it was undoubtedly Morris, for instance, who persuaded Joseph Batchelor, the supplier of paper to the Press, to demonstrate to the Guild the manufacture of paper with the help of a washtub.[25]

In the *Transactions of the Bibliographical Society* for 1893 one finds a further striking indication of the contemporary context of Morris's views on printing. Juxtaposed immediately next to his paper on "The Ideal Book" (see below, pp. 67–74) is another paper delivered to the

Society on the same day: "The Printing of Modern Books" (pp. 187–200) by Charles T. Jacobi, the manager of the Chiswick Press. Jacobi's paper is as sane and unexciting as his own personality ("the greatest bore in Christendom and very ignorant," Stanley Morison later complained[26]), and it contains, in rather diluted form, much of what Morris was also saying. But to flip the pages of the *Transactions* back from Jacobi to Morris again is to move from quiet good sense to the impassioned rhetoric of a man who finds in ugly books further evidence of a civilization gone wrong.

One cannot understand the moral intensity of Morris's typographical writings without realizing that he does not merely wish to improve the printing of books: in fact (as was true throughout his career) he wants to alter the course of Western history. The complaint that Francis Meynell leveled against Eric Gill's *Essay on Typography* (1936) might with equal justice be made about Morris: "Gill sets out to write about printing, but in fact it is the printer of whom he writes. He is thinking all the while of the workman, not the work...."[27] Deeply though he desires to create books that are works of art, Morris is even more preoccupied with the loss of humane values generally in the modern world. Again in this respect he resembles Ruskin, whose aim was to resurrect the artistic, social, and economic values that lay behind the Gothic cathedral rather than the cathedral itself. Hence Morris's extended meditations upon medieval books and manuscripts in the first part of this volume: they are an inspiring reminder to him of what the artisan can achieve when he is not enslaved by the tyrannical system of industrial capitalism.

It is not absolutely necessary, of course, to accept, or even to be attentive to, all of these political resonances in his writings. It is possible instead to concentrate entirely upon Morris's sensitive analysis of the medieval illustrated book and his wonderfully perceptive advice about typographical design. But we will hear only half of what he is telling us if we ever forget that lending order to the printed page is, for Morris, ultimately one way of lending meaning to human existence.

Morris's theories about book-design are rooted directly in the practice of fifteenth-century printers. This is not to say that he attempted at the Kelmscott Press a direct imitation of the medieval book, which would have violated his principles, but rather that he restored earlier

conditions of craftsmanship and then carried on the development of the arts of the book as if the intervening centuries had never existed. The Renaissance, with its emphasis on classical models, and modern technology, with its destruction of the crafts, had between them – according to Morris – disrupted the natural growth of Western art, and he believed the only solution was to return to the fountainhead: the medieval arts and crafts. By going back to their true source, the arts could once again begin to develop normally and organically.

Though Morris had exhibited an intelligent interest in them since childhood, he did not start collecting medieval books – both manuscript and printed – with real seriousness until he began to think of establishing a press in the late 1880s, and then he collected not from acquisitive motives but in order to supply himself with inspiring and instructive examples. Within the few years before his death, Morris succeeded in assembling a splendid library. As Paul Needham has commented recently, "If we exclude men such as William Beckford and Robert Curzon, who are known primarily as collectors rather than authors, it may be claimed that William Morris possessed a library of higher quality than any other major English literary figure."[28]

Figures 7, 8, 9 Aside from approximately one hundred medieval manuscripts, the library's great strength lay in its fifteenth-century German and French illustrated books, which Morris drew upon repeatedly for examples of that unity of text and illustration which was central to his definition of the ideal book. He recognized that in the following century there were individual illustrators of genius (notably Dürer), but the subtle harmony of type and picture had been lost.

It was on precisely this point that Morris's early experiments in bookmaking had foundered. Caslon, a handsome old-face type, simply was not strong enough to match the heavy lines of wood-engravings, and Caslon was then the only type of distinction available. For *The House of the Wolfings* (1889) and *The Roots of the Mountains* (1890), both printed at the Chiswick Press after his interest in typography had been aroused but before he could create a face of his own, Morris used Basel Roman (which he had once thought of adopting for *The Earthly Paradise*), a Victorian design based on a sixteenth-century face. Basel was a loose-fitting type and not wholly successful in other respects, but it at least pointed in the direction Morris wanted to go: it was more strongly colored than Caslon, and its blunt serifs prefigured those of the Golden type.

Though Morris's deepest sympathies lay with the Gothic North, he

concluded that a new Roman face would have to be based on the types of the earliest Venetian printers, preferably before they began to exhibit the debilitating influence of the Renaissance. "I am really thinking of turning printer myself in a small way," Morris wrote his friend F. S. Ellis on November 21, 1889; "the first step to that would be getting a new fount cut. Walker and I both think Jenson's the best model, taking all things into consideration. What do you think again? Did you ever have his Pliny? I have a vivid recollection of the vellum copy at the Bodleian."[29] In turning to the type of Nicholas Jenson as a model, Morris set a pattern for a generation or more of type revivals based on Jenson ("the most beautiful and legible type in the world," commented Bruce Rogers, whose own Centaur was a graceful adaptation of it[30]), but, characteristically, he also studied carefully a heavier version of the Jenson face used in Jacobus Rubeus's edition of Aretino's *Historia Florentina* (Venice, 1476). Walker photographed and enlarged pages from several incunabula, and Morris traced over the Rubeus letters (modifying the serifs in particular as he did so), after which Walker photographically reduced the tracing. Morris did this a number of times until he felt that he had mastered the letterforms, and he then made the drawings which Edward P. Prince used in engraving the Golden type.

Figure 3

Figure 4

Morris did not find designing a Roman face an entirely congenial task, and even those who in general admire the Kelmscott books have some misgivings about the Golden type. Morris deliberately thickened the strokes (already rather thick in Rubeus's version) and disfigured the capitals with heavy, slab-like serifs; when Walter Crane complained that the Golden type was almost Gothic in character, Morris accepted the accusation as a compliment.[31] In following exclusively fifteenth-century models, he also deprived himself of certain characters which most modern printers would consider essential: italics, boldface, small capitals, accents, brackets, Æ and Œ ligatures, and an en dash [–] and em dash [—] (though he did have the luxury of two different hyphens). The Golden type was produced in one size only, "English" (14 point), despite Morris's vague intentions, never realized of cutting it also in "Great Primer" size (18 point). Whatever its shortcomings, the Golden type matched the weight of the wood-engraved illustrations and decorations used in the Kelmscott books, and this was clearly the first requirement that Morris had in mind.

Figure 5

Morris's Gothic type, which he eventually had cut by Prince in two sizes (the Troy, 18 point, and the Chaucer, 12 point), was based less

Figure 5

tro faceuano grande infift

che erano gente dipregio.

oldo. Tucti quefti faccend

er lalunga moffeno efiorer

aggiote fforzo italmaniei

techati &foffi inpiu luogl

otessi ne ufcire ne étrare.I

alle man fra lemura della

fifaceuano apiftoia : Papa

decto nelpontificato p ilc

3 Leonardus Brunus Aretinus, *Historia Florentina* (Venice: Jacobus Rubeus, 1476), fol. H6ʳ; a photographic enlargement of a portion of the page, made by Emery Walker for Morris. This was Morris's chief model for the Golden type. *Courtesy of the St. Bride Printing Library.*

ella historia fiorentina.

ISCRIVERE EFON⁄
ublica fiorẽtina:gia libe
in ſ10 a: b trio.Et narre⁄
i:Et come elgouerno fu
& poi glifu tolto : Et co⁄
o nuouo ordine : & altre
acciato chefu eltyranno
a:niente dimeno ella ha

tro faceuano grande inſiſt
che erano gente dipregio.
ldo. Tueti queſti faccend
r lalunga moſſeno eſiore
aggiote ſforzo italmanier
cchati &foſſi inpiu luog
teſſi ne uſcire ne étrare.I
lle man fra lemura della
ſifaceuano apiſtoia: Pap
decto nelpontificato p̃ il

Photograph reduced from drawing by w.m.

Process block reduced from drawing by w.m. modified from
a 5 times scale photograph from part of a page of L. Actino's
Hiſt. Fiorentina 1476
(Jacobus Rubeus)

First h (rejected)

note the different shape of
white in corrected letter
kind of
buttress or
lean-to look
of the round
member. a tendency to make everything a little
too rigid & square is noticeable: can this
be remedied

seriffs perhaps
a little too fato.

this flattend
curve to be
noted and
followed

Corrected h

4 From a scrapbook compiled by Sydney Cockerell (British Library, shelf-mark C.102.h.18). The two panels above show Morris's early attempts to design the Golden type, based on the Jenson–Rubeus model. The instructions by Morris for the modification of the *h* are addressed to Edward P. Prince, who engraved all of the Kelmscott Press types. *Courtesy of the British Library.*

directly on specific models, since he had a strong intuitive feeling for northern medieval art, and it was on the whole more satisfactory than the Golden type, though Morris was unsuccessful in his attempt to revive the general use of Gothic as a text type. He was also attracted to a transitional face – midway between Gothic and Roman – first used by the German printers Sweynheym and Pannartz at Subiaco in 1465. Having purchased their *De civitate Dei* (1467) at Sotheby's, Morris designed a lower-case alphabet in November 1892,[32] but punches were never cut. Some years later Walker and Cockerell helped St. John Hornby design his "Subiaco" type for the Ashendene Press, based on the same face by Sweynheym and Pannartz.

Though Morris had learned the necessity of designing new typefaces, he did not at first plan to do his own presswork, which he thought could be done more conveniently in Walker's office at No. 16 Clifford's Inn. The contract with Bernard Quaritch (who was to act as publisher) for *The Golden Legend*, intended to be the first title produced by the Kelmscott Press, specified merely that "Mr. Morris [is] to have absolute and sole control over choice of paper, choice of type, size of the reprint and selection of the printer."[33] It should also be recalled that Morris had never attemped to print his own wallpapers, as the presswork was done so satisfactorily by Messrs. Jeffrey & Company of Islington.[34] Nevertheless, Morris took the plunge, hired compositors and pressmen, and installed a press in a rented cottage near Kelmscott House in Hammersmith.

Figure 31

Morris's decision to use a hand-press has often been misinterpreted as a doctrinaire rejection of machinery. In fact, it was an economically *Figure 30* sensible choice: the hand-press was the perfect instrument for producing small editions of the sort that Morris proposed, since his average pressrun was about 300 copies. It also possessed two further advantages that Walker and Jacobi had doubtless explained to him. With hand-rollers it was possible to apply different amounts of ink to woodblocks (which required more) and type, and the very slowness of operation of the hand-press ensured greater control of quality. And, it must be admitted, Morris *did* hate machines, especially large, smelly, noisy ones operated by steam power. In a whimsical letter written shortly after the Kelmscott Press began operation, he lamented: "Pleased as I am with my printing, when I saw two men at work on the press yesterday with their sticky printers' ink, I couldn't help lamenting the simplicity of the scribe and his desk, and his black ink and blue and red ink, and I almost felt ashamed of my press after all."[35]

TYPES USED AT THE KELMSCOTT PRESS.

The Troy Type.

A B C D E F G H I J K L M N O P Q R S T U V W X Y Z

1 2 3 4 5 6 7 8 9 0

a b c d e f g h i j k l m n o p q r s t u v w x y z

æ œ & ff fi ffi fl ffl ! ? (' . , : ; - ,

The Chaucer Type.

A B C D E F G H I J K L M N O P Q R S T U V W X Y Z

1 2 3 4 5 6 7 8 9 0

a b c d e f g h i j k l m n o p q r s t u v w x y z

æ œ & ff fi ffi fl ffl ! ? (' . , : ; - ,

The Golden Type.

A B C D E F G H I J K L M N O P Q R S T U V W X Y Z Æ Œ

1 2 3 4 5 6 7 8 9 0

a b c d e f g h i j k l m n o p q r s t u v w x y z

æ œ & ff fi ffi fl ffl ! ? (' . , : ; ,

5 Specimen sheet of Kelmscott Press types. *Courtesy of the Pierpont Morgan Library.*

Morris's prolonged exposure to medieval books had taught him that good materials were fundamental to bookmaking, and he searched energetically for suitable paper and ink. Walker introduced him to Messrs. Joseph Batchelor & Son in Kent, who allowed Morris to take off his coat and make two sheets of paper; then, having grasped the process and persuaded himself that Batchelor knew how to produce a handmade paper similar to that used by the earliest printers, Morris bought it exclusively thereafter.[36] Likewise, all of his ink came from one manufacturer in Germany, though he often spoke of trying to make it himself. Vellum was a more troublesome problem. At first he ordered it from Italy but there found himself in competition with the Vatican for the limited supplies. Eventually (after threatening to appeal to the Pope) he found a more or less satisfactory source in England. Morris used vellum for a few copies of each book printed at the Kelmscott Press (thus avoiding the perils of "large-paper" editions) and for covers. The limp vellum binding became, in fact, one of the hallmarks of the Kelmscott book.

Oddly, Morris displayed little interest in the subject of bindings. In 1885 he horrified Cobden-Sanderson (who had taken up bookbinding at Mrs. Morris's suggestion) by saying that bindings should be as "rough" and cheap as possible and suggesting "that some machinery should be invented to bind books." (Yet when Cobden-Sanderson founded the Doves Bindery in 1893, he noted complacently in his journal that the talents of Douglas Cockerell, Sydney's brother, were "suited to the rougher, franker work which we propose to develop in association with the Kelmscott Press."[37]) The simple but attractive trade bindings – generally either limp vellum with ties or quarter holland with bluish-gray paper on boards – were supplied by the firm of J. & J. Leighton of London. Morris evidently assumed that each customer, following the more old-fashioned custom, would have the book rebound to his own specifications, as the following note, signed by Morris and inserted in copies of *The Golden Legend*, indicates: "If this book be bound the edges of the leaves should only be TRIMMED, not cut." However, at the time of his death Morris was designing a pigskin binding for the *Chaucer* that was later executed on forty-eight copies by the Doves Bindery. Had he lived longer, Morris would probably have turned his attention to the one book art that he had hitherto neglected.

Another distinguishing characteristic of the Kelmscott Press books was their extensive decoration with wood-engraved initials, title-

pages, borders, and frames designed by Morris; some also had illustra-
tions by Burne-Jones and others. Indeed, the visual richness of the
books has proved a stumbling-block to many in our own century, for
it has been argued that Morris's pages are as cluttered as a Victorian
parlor and that the undecorated Doves Press style supplies a safer
model, or at any rate that it is closer to modern taste in book-design.
Morris's writings on the subject make it clear that he did not by any
means consider decoration and illustration essential: "I lay it down,"
he declared, ". . . that a book quite un-ornamented can look actually
and positively beautiful, and not merely un-ugly, if it be, so to say, ar-
chitecturally good." But Morris lavished his considerable decorative
skills upon the Kelmscott books because of medieval precedent and
because he found pleasure in doing so. The worst that can be said of
Morris's ornaments is not that they fail in themselves but that they set
a dangerous example for his many less-talented imitators.

By the "architecture" of a book, which he says is more fundamen-
tal than its decoration, Morris means primarily type-design, leading
(or lack thereof), word-spacing, and margins. One of Morris's main
complaints about the page of a typical Victorian book was that the
text area looked feeble and gray. He believed, on the contrary, that
the printed rectangle should be as black as possible and that this could
be achieved by designing darker typefaces and by eliminating leads
between lines and excessive space between words. Here Morris was
flying in the face of advice given by most nineteenth-century typo-
graphical authorities, who argued that more generous spacing be-
tween lines and words enhanced legibility. The two surviving versions
of the first trial page set at the Kelmscott Press (on January 31, 1891)
suggest that Morris had some difficulty in persuading his own com-
positors to abandon their usual practice: in the first the word-spacing
is conspicuously looser than Morris was ever to tolerate again, and in
the second, though tighter, there are still em quads – especially wide *Figure 33*
spaces – after periods.[38] (In both versions, incidentally, the decorated
initials fail to align properly.) In forcing his compositors to go back to
the procedures of earlier printers, Morris was fulfilling a vow made to
F. S. Ellis in late 1888 when *The House of the Wolfings* had just been pub-
lished: "I am very glad that you like the new book. I quite agree with
you about the type [Basel Roman]; they have managed to knock the
guts out of it somehow. Also I am beginning to learn something about
the art of type-setting; and I now see what a lot of difference there is
between the work of the conceited numskulls of to-day and that of the

15th and 16th century printers merely in the arrangement of the words, I mean the spacing out: it makes all the difference in the beauty of a page of print. If ever I print another book I shall enter into the conflict on this side also."[39]

Morris's advice about margins,[40] again based on the precedent of incunabula, was that the basic unit of book-design is the double-page opening rather than the single page: hence it followed that the inner margin should be half the width of the outer margin, because the two adjoining inner margins were always linked together by the eye. His argument for an especially large margin at the bottom grew out of the practical need to hold the page with one's thumbs, and this appeal to common sense is very characteristic of Morris. Though he seemed always to hark back to medieval examples, he was in fact testing them by the rules of utility and fitness. Invoking the same standard, he deliberately discarded other features of the fifteenth-century book, such as the catchword at the bottom of each page and the tied letters and contractions.

The latter, however, he abandoned with some reluctance, for he was aware that contractions and variant spellings allowed early printers flexibility in justifying short lines, and he revived the use of the ampersand and a second kind of hyphen for precisely that reason. On at least one occasion Morris even allowed himself the liberty of altering spelling in order to achieve closer and more regular word-spacing, for, according to Sparling, "When we came to the *Godefrey of Boloyne*, Morris decided that the original spelling need not be rigorously adhered to, as Caxton was an erratic speller, following no discernible rule, and that we were consequently free to retrench or add a letter where the justification of a line could be improved or a 'river' avoided thereby."[41] In another instance Morris changed the subtitle of *The House of the Wolfings* and added a freshly-written poem to the title-page because both alterations seemed pleasing to the eye.[42] If, as Stanley Morison has argued,[43] the chief function of the typographer is to interpret a text visually rather than to make attractive patterns on the page, then Morris – who appears at times to be seduced by pattern-making – remained always a designer instead of a typographer. Nevertheless, he laid down the principles which remain the foundation of modern book typography.

Note by Emery Walker
See Cockerell Smith's statement
Sydney Cockerell 23 Mar 1947

One row printed from wood; the other from electrotypes (done to convince W.M. that Electro's cd. be used without artistic loss

6 Emery Walker's note reads: "One row printed from wood, the other from electrotypes. (Done to convince w.m. that electros cd. be used without artistic loss. [)]" *Courtesy of the Pierpont Morgan Library.*

Morris's influence upon the twentieth-century book is enormous but difficult to assess, partly because his views were so frequently misunderstood. His type, ornaments, and general style were imitated by other printers at once, especially in America, where it was said in 1896 that "Kelmscott-Jenson type, more or less accurately reproduced, has spread from Portland [Maine] to San Francisco, and seems especially dear to the heart of advertisers of bicycles and malt extracts."[44] The most bizarre follower of Morris in the United States was Elbert Hubbard (known to his followers as "Fra Elbertus"), who established a "craft" community in upstate New York and, with an alarming admixture of snake-oil salesmanship ("all things work for righteousness and profit at Hubbard's happy home"), preached the somewhat sullied gospel of Morris through a series of "Roycrofter" books printed at his press.

In England, after Morris's death, C. R. Ashbee bought all of the equipment of the Kelmscott Press (with the exception of the type and ornaments) and hired some of Morris's printers for his own Essex House Press. Unfortunately Ashbee knew little about printing, and his claim to be the successor to the Kelmscott Press nearly provoked Cockerell, as one of Morris's executors, to bring a lawsuit against him.[45] The genuine idealism of arts and crafts figures like Ashbee was not always coupled with Morris's technical curiosity or his superb sense of design. (Ashbee's Endeavour typeface, for example, was less attractive than most commercially available faces.) Furthermore, some of Morris's professed disciples, in their unrelenting hostility toward the machine, failed to take into account how heavily Morris had depended upon nineteenth-century technology, especially photography, in his work at the Kelmscott Press. It was, after all, a series of enlarged photographic images on a screen that had provided the initial impetus for the Press. Throughout the designing of the Golden type Morris relied upon the enlargements and reductions supplied by Emery Walker (who, let it be recalled, earned his living as a process-engraver). Though Burne-Jones's designs for the *Chaucer* were carved by hand on wood, the drawings were transferred to the blocks by means of photography, using a technique similar to that which Morris & Company had employed for many years in photographically enlarging Burne-Jones's designs for tapestries and stained-glass windows.[46] In 1894 Morris was giving serious thought to publishing a photographic reproduction of a thirteenth-century manuscript in the Bodleian Library.[47] Altogether Morris showed more tolerance of me-

Figure 4

chanical aids than his followers did, at least whenever he could be convinced (usually by Walker, one suspects) that, in modest ways, machines could sometimes usefully extend the power of the human eye or hand.

A series of distinguished private presses – established in Britain, America, and elsewhere as a direct result of Morris's example – inevitably helped to raise typographical standards in commercial printing. But it was the exclusive identification of Morris with the private press movement and with the anti-technology fervor of arts and crafts enthusiasts that damaged his reputation among many printers in the early part of the twentieth century. All the while, however, his precepts and example were making themselves felt at a subterranean level, and when the revolution came in commercial printing in the 1920s, one finds Morris's ideas suddenly re-emerging into daylight, but now being applied to the mass-produced book. Stanley Morison, who more than any other person in our century was responsible for that revolution, offered this tribute to Morris in a lecture delivered in 1944: "His teaching continues to exert a beneficial influence upon the [printing] trade. Although the fullest expression of Morris's ideas is to be found in the books of the Kelmscott Press, his influence was not confined to luxurious uncommercial printing. Nor could it be said that he was altogether without sympathy for machine-made books. His paper, *The Ideal Book* . . . , makes plain his principle that machine-made paper was satisfactory when it did not pretend to be hand-made, and that a machine-made book could be a work of art if the type was rightly designed and due attention given to its arrangement on the page. . . . It cannot be denied that, without the spectacular appearance of books like the Kelmscott *Chaucer* and the Ashendene *Dante*, both of which were designed without regard to commercial considerations, the notable improvement observable in English, German, and American books during the last twenty-five years would hardly have taken place."[48]

By one of those curious ironies with which history abounds, William Morris's search for the ideal book in the Middle Ages helped to make possible the well-designed, machine-made book of the twentieth century. He did not succeed in transforming a civilization, as he had hoped to do, but he did teach us how to bring new grace and beauty to one of the chief artifacts of civilization.

A NOTE ON THE TEXT AND ILLUS-TRATIONS

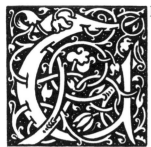 HIS volume consists of all of William Morris's extant lectures and essays on the arts of the book – with a few minor exceptions to be cited below. At the beginning of the notes for each of these I have provided bibliographical information. The first essay, "Some Thoughts on the Ornamented Manuscripts of the Middle Ages," was privately printed in 1934 but is here freshly transcribed from the manuscript in the Huntington Library. The text of "A Note by William Morris on His Aims in Founding the Kelmscott Press" is that of the Kelmscott edition published in 1898, even though it had appeared in an American periodical a year and a half earlier. In all other instances the essays are reprinted from their first appearances in print, and the lectures from the fullest and most trustworthy published reports available.

Two of Morris's lectures – "Printing" and "The Ideal Book" – were delivered on several occasions with slight variations: *The Times* of November 6, 1893 (p. 4), for instance, supplies a brief account of a lecture by Morris entitled "On the Printing of Books" which he gave at the New Gallery on the previous Thursday; a slightly fuller report also appears in the supplement to the *Printers' Register* on December 6, 1893 (pp. vii–viii). It did not seem worthwhile to reprint these and other such reports of lectures that were virtually identical to known lectures. On the other hand, I have included the lecture entitled "The Early Illustration of Printed Books," because Morris scholars appear to have been unaware of its existence in print, and because it does not seriously overlap with Morris's other utterances on the subject. I have not reprinted the sometimes fulsome introductions to the lectures by various chairmen, but I did feel it was essential to include (albeit in smaller type) the records of discussions following two of them, as Morris participated in these.

Because this volume is intended for nonspecialist readers, I have taken the liberty of copyediting Morris's text very slightly. The modifications fall under the following categories: (*a*) I have not altered Morris's renderings of fifteenth-century titles (which he frequently translates) except to normalize capitalization; however, in the index I listed the titles as given in the *Catalogue of Books Printed in the XVth*

Century Now in the British Museum, with cross-references when necessary. (*b*) Since Morris spells the names of fifteenth-century printers and artists inconsistently, I have adopted for surnames the spellings used by Frederick Goff in his *Incunabula in American Libraries*, 3rd ed. (New York, 1964); I have not tampered with Morris's frequent anglicization of given names, though in the index I have adopted Goff's spellings of both names. (*c*) I have made consistent the spelling of place-names. (*d*) I have spelled out abbreviations like *8vo* and *&c.* and expanded ampersands. (For Morris, the ampersand was merely a convenience to the compositor in justifying awkward lines.) (*e*) I have deleted a few hyphens (*e.g.*, woodcuts) and inserted a few (*e.g.*, self-respect). (f) I have supplied a small number of commas when the syntax required it. (*g*) I have italicized all titles of books. (*h*) I have spelled out ordinal numbers. (*i*) In general, I have tried to make Morris's very erratic spelling and capitalization conform to his own usual pattern.

I have no doubt that Morris himself (or, more likely, the meticulous Sydney Cockerell) would have done this minor tidying-up of the text had he collected these documents for publication in a book during his lifetime. (One might also cite the precedent of Morris's free handling of Caxton's spelling in *Godefrey of Boloyne*.)

I thought it important to use all of the illustrations which originally accompanied the essays, especially since most of them were handsomely printed from process blocks prepared by Emery Walker. However, the illustrations which appeared in "Some Notes on the Illuminated Books of the Middle Ages" were halftones – evidently of Morris's own medieval manuscripts – which would not reproduce well. This essay, therefore, is now illustrated by photographs of some leaves from manuscripts once owned by Morris and presently in the Pierpont Morgan Library. One of these (Fig. 8) is identical to the original illustration; the other leaves are similar in style and period to those mentioned by Morris. Throughout the book I have also added a number of new illustrations.

Appendix A contains a reprint of Cockerell's pithy and justly celebrated history of the Kelmscott Press, and Appendix B supplies four journalistic interviews with Morris about his work as a printer. The latter, though naïve and effusive in tone, provide an amusing glimpse of the "Master Printer" in his more relaxed moments. Clearly Morris was the equal of any modern politician in his shrewd handling of obtuse and sometimes tedious interviewers.

Finally, I wish to say a word about the design of this book. The titles are set in Morris's Golden type from the original fonts owned by the Cambridge University Press; the decorated initials are reprinted (slightly reduced) from the Kelmscott *Chaucer*; and the text is set in Bembo, a twentieth-century design based on the first Roman type used by Aldus Manutius in 1495. In designing this volume I have followed closely Morris's own practices, but experienced eyes will detect that in some matters (such as his abhorrence of leading) I have silently registered dissent.

W. S. P.

THE IDEAL BOOK

SOME THOUGHTS ON THE ORNA- MENTED MANUSCRIPTS OF THE MID- DLE AGES A FRAGMENTARY ESSAY NEVER PUBLISHED BY MORRIS

F I were asked to say what is at once the most important production of Art and the thing most to be longed for, I should answer, A beautiful House; and if I were further asked to name the production next in importance and the thing next to be longed for, I should an- swer, A beautiful Book. To enjoy good houses and good books in self-respect and decent comfort, seems to me to be the pleasurable end towards which all soci- eties of human beings ought now to struggle.

Leaving the House alone for the present, let us say concerning the Book, that to cosset and hug it up as a material piece of goods, is surely natural to a man who cares about the ideas that lie betwixt its boards. Only the present age of superabundance of books makes some enthu- siastic lovers of the spiritual part of books show their love for them by treating them as some men do their closest cronies and friends, speak- ing with familiar roughness to them, checking them affectionately though rudely in all their little vanities and the like, because they feel that they understand each other too well, that the bond between them is too close to be broken by such outside maltreatment. Just so I have seen a man take hold of his dearly beloved book-friend, the mislaying of which would destroy his night's rest, and bend back the boards till the back cracked again; I have seen him thump its familiar pages with his fist, dogs-ear its leaves, turn it face downwards on a dirty table, blot it with ink and smear the blot off with his thumb; in short so maul it that he deserved to have his books read aloud to him henceforward, instead of being allowed to read them to himself. Such behaviour may be forgiven, but only on the grounds that the utilitarian production of makeshifts, which is the especial curse of modern times, has swept away the book-producer in its current, and that few books nowadays can at the best claim anything more than negative qualities as to their appearance; if they are revoltingly ugly and vulgar in aspect that [is] about as much as we can expect of them.

In the Middle Ages it was very different; the book-lover, the stu- dent had before him, as he took in the thoughts of his author, a piece

of beauty obvious to the eyesight. The Clerk of Oxenford if he took up one of his "Twentie bookes clad in black and red";[1] the fellow of the college, when with careful ceremony he took the volume from the chest of books which held the common stock of literature; the Scholar of the early Renaissance when he sold his best coat to buy the beworshipped classic new-printed by Vindelin or Jenson, each of these was dealing with a palpable work of art, a comely body fit for the habitation of the dead man who was speaking to them: the craftsman, scribe, limner, printer, who had produced it had worked on it directly as an artist, not turned it out as the machine of a tradesman; and moreover amidst the traditions that swayed him he could no more help doing so than the present book-maker can help working as a machine. Let us consider for a little the position of the mediæval craftsman with relation to the arts. And first it may be necessary to warn our readers against the theory that this art was the outcome of religion, or rather ecclesiasticism. For this theory, started in the Horace Walpole,[2] or sham-Gothic period, and, as to our subject, compendiously expressed by the misnomer of "missal-painting" applied to the painted ornament of mediæval books, should now be more completely exploded than I fear it is. Let us look at the other side of the question. The real state of the case is more like this: the mediæval craftsman had two sides to his artistic mind, the love of ornament, and the love of story. Working as a free-workman, or artist, amidst just the amount of traditional skill and mechanical appliances best fitted for making an ordinarily intelligent man an artist; organized (as far as he was organized) not by a portion of a vast commercial system, but by his craft guild and politically and socially rather than commercially, his relation to art was personal and not mechanical. So that he was free to develop both his love for ornament and his love for story to the full. As to the first quality, he was not hampered by having to produce a cheap makeshift for a market of which he knew nothing: the price of wares was kept down not by using a machine instead of thoughtful handiwork, but by simplicity, or roughness of work suitable to the use of the thing made, whose inferiority was obvious, but which, since the inferiority was necessary, need by no means lack art: subordination of the work to its end, is one of the essentials of the productions of the mediæval craftsman, as it is of all works of art. The ornament produced by him under these conditions is now generally admitted to be consummate in skill, abundant of invention, and as beautiful as such work can be. But as to the product of the other side of his mind, the love of story, the

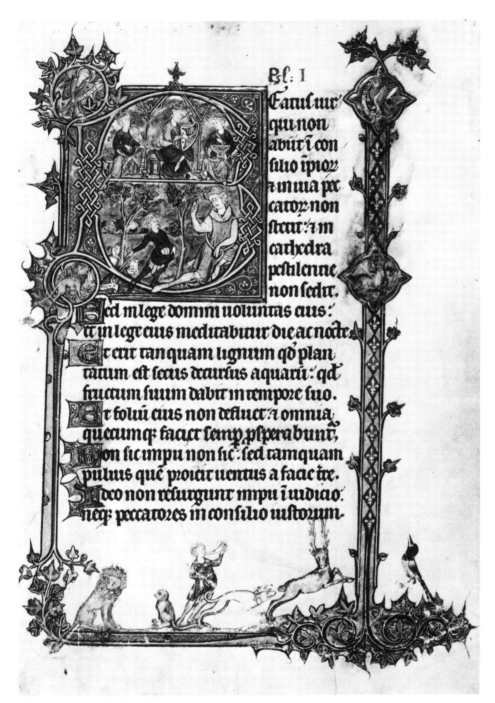

7 Morgan Library M. 98, fol. 1ʳ. A Latin Psalter from North France, in the vicinity of Beauvais, in the thirteenth century. "It appears that Morris bought this Psalter privately, probably before 1894, from Charles Butler, who in any case owned the manuscript in 1888" (WMAB, p. 101). The following note by Morris appears in the manuscript: "This book has a complete and satisfactory scheme of ornament which is nowhere departed from, and the colour of which is thoroughly harmonious. Many of the dragon-scrolls end in daintily painted little heads, drawn with much expression & sense of fun; and the hair of them is beautifully designed, and drawn very firmly. The figure-work in the eight historiated letters is everywhere quite up to the average of its date; but on the first page, in the Beatus and the symbols of the Evangelists, goes a good deal beyond that. Altogether an admirable specimen of the work of the later 13th century." *Courtesy of the Pierpont Morgan Library.*

rhetorical conventional art of the Renaissance, and the plausible conventional art of modern Europe, has for most people obscured its worth.

The mediæval workman not only lived amidst beautiful works of handicraft, and a nature unspoiled by the sordidness of commercialism; but also he was deeply imbued with a sense of the epic of the World, as it was understood in his day. It is true that the solution of the mystery of existence, the science of the time, was given by an arbitrary theology, as set forth by the fellowship of the Catholic Church: but while on the one side this theology is not really conterminous with religion as understood both by Catholics and Protestants at the present time, so on the other to the mediæval mind it was no mere formula but a statement of fact, a tale of the events of the past, the present and the future, and was really believed in by all people. It has always seemed to me that the courage and dignity with which even bad men in the Middle Ages met a violent death is a strong confirmation of this reality of belief in the continuity of life.

Now, apart from mere ornament, which flowed from the workman's hand with little consciousness of his producing art, it was the business of the workmen artists of the Middle Ages to represent this story of the life of the World in pictures; and if the doing this conscientiously, and as the artist *saw* the event, was an act of religious [belief?], then undoubtedly the mediæval artists were of all men the most religious. Yet their ways of dealing with the scenes of the Bible or the lives of the Saints and so forth, are usually mere outrages on the religious feeling of today; thoroughly sincere though they be. Let me draw an illustration from the kindred art of dramatic literature, in the Mystery Plays of the fifteenth century. The Plays acted on solemn occasions at York and Wakefield were done by the very men who produced the art of the period, the workmen of the crafts of those places, for the behoof of the people at large: they have been, and perhaps still are, held up to our execration, as showing the coarseness and profanity of the Middle Ages in dealing with sacred subjects. This is a sad mistake; for they are not *coarse* though they are *rude*; but I admit that they would make the average religious person of today shudder at their plainness of speech. Yet there is no levity in them: every personage represented up to God himself is thoroughly believed in, and is made to speak and act as the playwright *knew* he would act under the given conditions. They are in a word full of *life*. But this is not religion, but art, acting on assured belief; and granted the mental qualities of the

4

artists, would have treated similarly whatever they had happened to believe in.

As a proof that the book-ornamenters' work was not necessarily ecclesiastical, I here give first an illustration from a Bestiary[3] of the twelfth century: second one from a Euclid of the early fourteenth; and third one from a medical book of the middle of the fifteenth.[4]

Also as a picture-illustration of the fact that even when dealing with ecclesiastic furniture, the minds of the artists were not ecclesiastical, I give first a page from the Psalter at the Brit.[ish] Mus.[eum], known as the Tenison Psalter (date about 1268), which is one of the loveliest works of the English School: and second a page from the book called at the Museum Queen Mary's Psalter,[5] in which the "coarseness" of the artist (*i.e.* his appreciation of the facts of ordinary life) is set forth in some of the most delicately beautiful drawings ever given to the world. I must ask the reader, then, to accept my position that the mediæval workman was a free workman or artist; that he made his work beautiful almost unconsciously; that consciously and of intent he represented in the most direct and sincere manner scenes of life in which he believed, and that even if he were an ecclesiastic himself (as doubtless he often was, especially in the early Middle Ages), he was first of all a man, and thought it no impiety to draw a jest, his quaint and simple expression of how he personally felt the strangeness of life, even on the page of a service book. What I have further to say will be strictly confined to his work in the painting or decoration of books. These ornamented books form of themselves a school of art; and are of special importance in these rougher and damper climates, because they have kept for us a record of the kind of design which once covered the walls of all our Churches in [*sic*] public buildings through the whole period of the fully developed Middle Ages; though of course that design was modified to suit the scale and materials of the smaller and more delicate ground for painting.

I do not attempt to give examples of all the main schools of this marvellous body of art; but a few words concerning them may stand in writing, for the information of those of my readers who have not turned their attention at all to this form of art.

The first style practiced in these islands was that of the Irish calligraphists who flourished from the eighth century onwards. Their writing is past all praise for its regularity, beauty, and legibility, and may be called the best of all writing: it was founded on the calligraphy of the Latin Byzantine books, but did not slavishly follow its forms. The

5

ornament which accompanied it, however, was native and quite pe-
culiar. It produced marvels of intricacy and firm drawing of lines, but
has no admixture of epical capacity, belonging to that family of prim-
itive ornament that made no serious attempt to master the difficulties
of the art of representing human or animal form: dragon heads and
endless interlaced scrolls drawn with absolutely unerring accuracy are
all that it has to offer us, except where a symbol of human form is a ne-
cessity which is then drawn with the baldest incapacity: if so much as a
leaf form occurs spontaneously in one of these books it may be taken
for granted that it is no longer purely Irish, but is passing into the next
substyle, the Anglo-Saxon, in which the direct influence of Byzantine
art is felt, though its artists at first adapted the Irish calligraphy and
ornament.

In France and Germany the ornament clove much closer to the
Byzantine forms; while in England towards the time of Athelstan illu-
mination began to fall into line with the general European art which
was rapidly advancing towards the complete Middle Ages [. . .]

6

SOME NOTES ON THE ILLUMINATED BOOKS OF THE MIDDLE AGES 🌿 AN ESSAY PUBLISHED IN 1894

HE Middle Ages may be called the epoch of writing *par excellence*. Stone, bronze, wooden rune-staves, waxed tablets, papyrus, could be written upon with one instrument or another; but all these – even the last, tender and brittle as it was – were but makeshift materials for writing on; and it was not until parchment and vellum, and at last rag-paper, became common, that the true material for writing *on*, and the quill pen, the true instrument for writing *with*, were used. From that time till the period of the general use of printing must be considered the age of written books. As in other handicrafts, so also in this, the great period of genuine creation (once called the Dark Ages by those who had forgotten the past, and whose ideal of the future was a comfortable prison) did all that was worth doing as an art, leaving makeshifts to the period of the New Birth and the intelligence of modern civilisation.

Byzantium was doubtless the mother of mediæval calligraphy, but the art spread speedily through the North of Europe and flourished there at an early period, and it is almost startling to find it as we do in full bloom in Ireland in the seventh century. No mere writing has been done before or since with such perfection as that of the early Irish ecclesiastical books; and this calligraphy is interesting also, as showing the development of what is now called by printers "lower-case" letter, from the ancient majuscular characters. The writing is, I must repeat, positively beautiful in itself, thoroughly *ornamental*; but these books are mostly well equipped with actual ornament, as carefully executed as the writing – in fact, marvels of patient and ingenious interlacements. This ornament, however, has no relation in any genuine *Irish* book to the traditional style of Byzantium, but is rather a branch of a great and widespread school of primal decoration, which has little interest in the representation of humanity and its doings, or, indeed, in any organic life, but is contented with the convolutions of abstract lines, over which it attains to great mastery. The most obvious example of this kind of art may be found in the carvings of the Maoris of New Zealand; but it is common to many races at a certain stage of development. The colour of these Irish orna-

ments is not very delightful, and no gold appears in them.[1]

This Irish calligraphy and illumination was taken up by the North of England monks; and from them, though in less completeness, by the Carlovingian makers of books both in France and even in Germany; but they were not content with the quite elementary representation of the human form current in the Irish illuminations, and filled up the gap by imitating the Byzantine picture-books with considerable success,[2] and in time developed a very beautiful style of illumination combining ornament with figure-drawing, and one seat of which in the early eleventh century was Winchester.[3] Gold was used with some copiousness in these latter books, but is not seen in the carefully-raised and highly-burnished condition which is so characteristic of mediæval illumination at its zenith.

It should be noticed that amongst the Byzantine books of the earlier period are some which on one side surpass in mere sumptuousness all books ever made; these are written in gold and silver on vellum, stained purple throughout. Later on again, in the semi-Byzantine-Anglo-Saxon or Carlovingian period, are left us some specimens of books written in gold and silver on white vellum. This splendour was at times resorted to (chiefly in Italy) in the latter half of the fifteenth century.

The just-mentioned late Anglo-Saxon style was the immediate forerunner of what may be called the first complete mediæval school, that of the middle of the twelfth century. Here the change for the better is prodigious. Apart from the actual pictures done for explanation of the text and the edification of the "faithful," these books are decorated with borders, ornamental letters, etc., in which foliage and forms human, animal, and monstrous are blended with the greatest daring and most complete mastery. The drawing is firm and precise, and it may be said also that an unerring system of beautiful colour now makes its appearance. This colour (as all schools of decorative colour not more or less effete) is founded on the juxtaposition of pure red and blue modified by delicate but clear and bright lines and "pearlings" of white, and by the use of a little green and spaces of pale pink and flesh-colour, and here and there some negative greys and ivory yellows. In most cases where the book is at all splendid, gold is very freely used, mostly in large spaces – backgrounds and the like – which, having been gilded over a solid ground with thick gold-leaf, are burnished till they look like solid plates of actual metal. The effect of this is both splendid and refined, the care with which the gold is laid

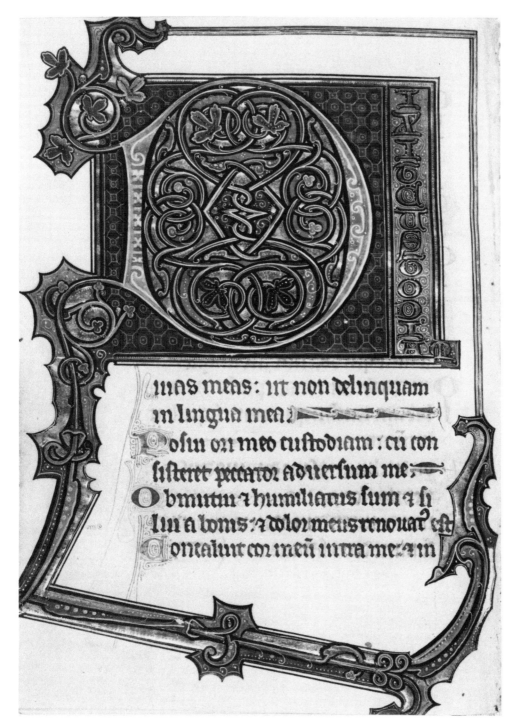

8 Morgan Library M. 100, fol. 50ᵛ. A Latin Psalter written and illuminated in London at the end of the thirteenth century; known as the "Clare Psalter." Morris purchased the manuscript from Quaritch in about 1892 or 1893. The following note by Morris appears in the manuscript: "Though this book is without figure-work, the extraordinary beauty and invention of the ornament make it most interesting; and the said ornament is thoroughly characteristic of English work: the bold folded-over leaf in the great *B* on the 1st p.[age] of the text [see Fig. 9] is an undeniable token of an English hand. The great thickness of the black boundary lines is worth noting, and no doubt is the main element in producing the effect of the colour, which is unusual. The beauty of the simple blue & gold calendar will scarcely be missed by anyone taking up the book. The writing is fine throughout." *Courtesy of the Pierpont Morgan Library.*

on, and its high finish, preventing any impression of gaudiness. The writing of this period becoming somewhat more definitely "Gothic," does not fall short of (it could not surpass) that of the previous half-century.

From this time a very gradual change – during which we have to note somewhat more of delicacy in drawing and refinement of colour – brings us to the first quarter of the thirteenth century; and here a sundering of the styles of the different peoples begins to be obvious. Throughout the twelfth century, though there is a difference, it is easier to distinguish an English or French book from a German or Italian by the writing than by the illumination: but after 1225 the first glance on opening the book will most often cry out at you, German, Italian, or French–English. For the rest, the illuminations still gain in beauty and delicacy, the gold is even more universally brilliant, the colour still more delicious. The sub-art of the rubricator, as distinguished from the limner and the scribe, now becomes more important and remains so down to the end of the fifteenth century. Work of great fineness and elegance, drawn mostly with the pen, and always quite freely, in red and blue counterchanged, is lavished on the smaller initials and other subsidiaries of the pages, producing, with the firm black writing and the ivory tone of the vellum, a very beautiful effect, even when the more solid and elaborate illumination is lacking.

Figures 7–9

During this period, apart from theological and philosophical treatises, herbals, "bestiaries," etc., the book most often met with, especially when splendidly ornamented, is the Psalter, as sung in churches, to which is generally added a calendar, and always a litany of the saints. This calendar, by the way, both in this and succeeding centuries, is often exceedingly interesting, from the representations given in it of domestic occupations. The great initial B (*Beatus vir qui non*) of these books affords an opportunity to the illuminator, seldom missed, of putting forth to the full his powers of design and colour.

Figure 9

The last quarter of the thirteenth century brings us to the climax of illumination considered apart from book-pictures. Nothing can exceed the grace, elegance, and beauty of the drawing and the loveliness of the colour found at this period in the best-executed books; and it must be added that, though some work is rougher than other, at this time there would appear, judging from existing examples, to have been no bad work done. The tradition of the epoch is all-embracing and all-powerful, and yet no single volume is without a genuine individuality and life of its own. In short, if all the other art of the early

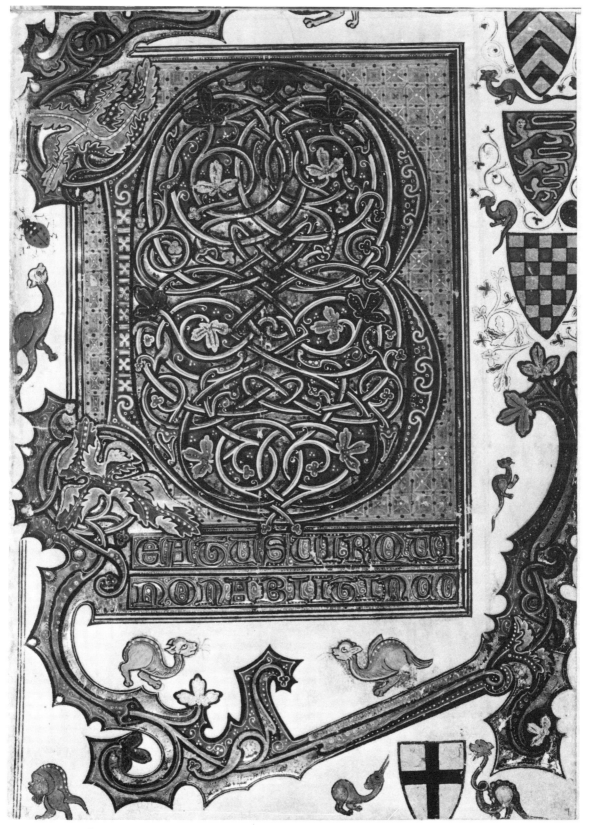

9 Morgan Library, M. 100, fol. 7ʳ. Another leaf of the Clare Psalter. The arms of William, first Baron de Vescy (d. 1297), appear in the lower border. *Courtesy of the Pierpont Morgan Library.*

Middle Ages had disappeared, they might still claim to be considered a great period of art on the strength of their ornamented books.

In the latter part of the thirteenth century we note a complete differentiation between the work of the countries of Europe. There are now three great schools: the French–Flemish–English, the Italian, and the German. Of these the first is of the most, the last of the least, importance. As to the relations between England and France, it must be said that, though there is a difference between them, it is somewhat subtle, and may be put thus: of some books you may say, This is French; of others, This is English; but of the greater part you can say nothing more than, This belongs to the French–English school. Of those that can be differentiated with something like certainty, it may be said that French excel specially in a dainty and orderly elegance, the English specially in love of life and nature, and there is more of rude humour in them than in their French contemporaries; but he must be at once a fastidious and an absolute man who could say the French is better than the English or the English than the French.

The Norwich Psalter, in the Bodleian Library; the Arundel,[4] Queen Mary's, and Tennison Psalters, in the British Museum, are among the finest of these English books: nothing can surpass their fertility of invention, splendour or execution, and beauty of colour.

This end of the thirteenth century went on producing splendid psalters at a great rate; but between 1260 and 1300 or 1320 the greatest industry of the scribe was exercised in the writing of Bibles, especially pocket volumes. These last, it is clear, were produced in enormous quantities, for in spite of the ravages of time many thousands of them still exist. They are one and all beautifully written in hands necessarily very minute, and mostly very prettily illuminated with tiny figure-subjects in the initials of each book.

For a short period at the end of this and the beginning of the next century many copies of the Apocalypse were produced, illustrated copiously with pictures, which give us examples of serious Gothic design at its best, and seem to show us what wall-pictures of the period might have been in the North of Europe.

The fourteenth century, the great mother of change, was as busy in making ornamental books as in other artistic work. When we are once fairly in the century a great change is apparent again in the style. It is not quite true to say that it is more redundant than its predecessor, but it has more mechanical redundancy. The backgrounds to the pictures are more elaborated; sometimes diapered blue and red, sometimes

gold most beautifully chased with dots and lines. The borders cover
the page more; buds turn into open leaves; often abundance of birds
and animals appear in the borders, naturalistically treated (and very
well drawn); there is more freedom, and yet less individuality in this
work; in short the style, though it has lost nothing (in its best works) of
elegance and daintiness – qualities so desirable in an ornamented book
– *has* lost somewhat of manliness and precision; and this goes on in-
creasing till, towards the end of the century, we feel that we have be-
fore us work that is in peril of an essential change for the worse.[5]

The differentiation, too, betwixt the countries increases; before
the century is quite over, England falls back in the race,[6] and French–
Flanders and Burgundy come forward, while Italy has her face turned
toward the Renaissance, and Germany too often shows a tendency to-
ward coarseness and incompleteness, which had to be redeemed in the
long last by the honesty of invention and fitness of purpose of her
woodcut ornaments to books. Many most beautiful books, however,
were turned out, not only throughout the fourteenth, but even in the
first half of the fifteenth century.[7]

The first harbinger of the great change that was to come over
the making of books I take to be the production in Italy of most beau-
tifully-written copies of the Latin classics. These are often very highly
ornamented; and at first not only do they imitate (very naturally) the
severe hands of the eleventh and twelfth centuries, but even (though
a long way off) the interlacing ornament of that period. In these books
the writing, it must be said, is in its kind far more beautiful than the or-
nament. There were so many written and pictured books produced in
the fifteenth century that space quite fails me to write of them as their
great merits deserve. In the middle of the century an invention, in
itself trifling, was forced upon Europe by the growing demand for
more and cheaper books. Gutenberg somehow got hold of punches,
matrices, the adjustable mould, and so of cast movable type; Schoef-
fer, Mentelin, and the rest of them caught up the art with the energy
and skill so characteristic of the mediæval craftsman. The new Ger-
man art spread like wildfire into every country of Europe; and in a
few years written books had become mere toys for the immensely
rich.

Yet the scribe, the rubricator, and the illuminator died hard. Dec-
orated written books were produced in great numbers after printing
had become common; by far the greater number of these were Books
of Hours, very highly ornamented and much pictured. Their style is as

definite as any of the former ones, but it has now gone off the road of logical consistency; for divorce has taken place between the picture-work and the ornament. Often the pictures are exquisitely-finished miniatures belonging to the best schools of painting of the day; but often also they are clearly the work of men employed to fill up a space, and having no interest in their work save livelihood. The ornament never fell quite so low as that, though *as* ornament it is not very "distinguished," and often, especially in the latest books, scarcely adds to the effect on the page of the miniature to which it is subsidiary.

But besides these late-written books, in the first years of printing, the rubricator was generally, and the illuminator not seldom, employed on printed books themselves. In the early days of printing the big initials were almost always left for the rubricator to paint in in red and blue, and were often decorated with pretty scroll-work by him; and sometimes one or more pages of the book were surrounded with ornament in gold and colours, and the initials elaborately finished in the same way.

The most complete examples of this latter work subsidiary to the printed page are found in early books printed in Italy, especially in the splendid editions of the classics which came from the presses of the Roman and Venetian printers.

By about 1530 all book illumination of any value was over, and thus disappeared an art which may be called peculiar to the Middle Ages, and which commonly shows mediæval craftsmanship at its best, partly because of the excellence of the work itself, and partly because that work can only suffer from destruction and defacement, and cannot, like mediæval buildings, be subjected to the crueller ravages of "restoration."

THE EARLY ILLUSTRATION OF PRINT-ED BOOKS A LECTURE DELIVERED IN 1895

R. WILLIAM MORRIS commenced by re-marking that the title of his lecture in full would be "The Early Illustration of Printed Books," which, he said, limited it rather more than the title of his subject as advertised, and he should not try, as far as the actual slides were concerned, to go beyond these strict lim-its. However, before the lantern came into play, Mr. Morris gave, as we have said, a most delightful though nec-essarily brief survey of the growth of art, its development, and so far as Gothic art was concerned, its attainment of perfection, and decay.

Properly speaking, all arts, he pointed out, belonged to the defi-nitely Gothic school. With a touch of humour he here remarked that probably some of those present had a vague idea of what that meant, some thinking it referred to churches and Gregorian chants. Certainly they were a part of Gothic art, but not the whole; therefore he would give a few words of history to explain what one meant by Gothic art. For the present they would consider the beginning of things – the be-ginning of the art amongst the great civilised nations.

First of all this art – perhaps on the whole the only kind of art that could be really considered a fine art – was what he should call "Or-ganic Art"; the principle of growth in it being not merely accidental or individual, but connected by a long line of tradition, of practice and craftsmanship. It appeared to him they had – first of all in the days of the old classical civilisation before the time of Pericles – this organic art in a very vigorous and complete condition, limited, of course, like all other arts must be, by various conditions. It went on progressing along these lines of organic growth in the early days of Greek art, and approached something near perfection about the time of Pericles. Then came the question, What was to be done next? Well, for rea-sons too long to go into, and perhaps rather obscure for a matter of that, the society of that period was not equal – when it had got this ori-ginal organic art into something like perfection – to turning about and finding some new field in which to run the old material. The conse-quence of this was that after going on in this brilliant way for some time this art crystallised and entered into the second condition of the

15

ancient classical art epidemic period, during which, although there
appeared to be a certain amount of vitality, there was no growth, no
advance. Although the arts went on cultivating, nevertheless they did
not progress, nor did they die. He said there must be some explanation
for this. Probably all kinds of things outside the higher art were made:
a few examples were left in the pots and pans and things like that, in
which was the difference between their epidemic condition and ours.
Although the art did not grow, the people of these times went on in an
ordinary way, making things – not ugly; they did not understand what
an ugly thing was, said the lecturer, and never tried to make anything
unless it was particularly artistic.

Another change came in Europe losing her civilisation almost en-
tirely, and in the integration of Europe a new art sprang up. Men can
scarcely do without some form of picture, of beauty or incident. Any-
how, in the early days of the new civilisation it was clear men did not
intend to sit down with their hands before them and never turn out
anything beautiful or interesting because the old civilisation and views
of art had left them. And so they tried to realise a new art, and in that
art there lay – at any rate from the very first – the seeds of what he
called Gothic art. This name meant to us nowadays, he said, a mis-
nomer, and he pointed out its first application as a term of derision,
meaning, to the people who first used the word and knew anything
about the Goths, a savage and perhaps rather ferocious art. This ought
not to be, with its first beginning of what one would call the classical
art, an art partly made up of the old classical art and ideas from the sur-
rounding countries, and considerably under the influence of the east-
ern nations – the Persians notably – and their peculiar ideas of beauty.
From the position of its first home in Constantinople it was able to
carry the ideas which were current East and West and all over Europe
– Constantinople in the early Middle Ages being not only a great city,
but The Great City of Europe. This new art, after having taken ideas
from the East, was presently to take ideas also from much ruder peo-
ple – the people of the North and West, who somehow or other had
got a kind of art amongst them, perhaps the barest form, as that pre-
sented to us in the early works of art of the Irish. Their art appeared to
be actually the growth of the soil, without any outside influence, and
had an extraordinary incapacity for giving any tolerable representa-
tion of the human form.

After this union of the East with the old classical world and then
with the North and Celtic, the next stage was what they might call the

11. One of two full-page cuts in Sprenger's Die erneuerte Rosenkranz-Bruderschaft, printed at Augsburg by John Baemler, without date but c. 1476.

10 *Some German Woodcuts of the Fifteenth Century* (Kelmscott Press, 1897), p. 8.

art of quite an early mediæval period, which they dated to the end of the Norman Conquest. The epoch-making time, he here stated, was always rather the beginning of centuries than the end. The architects called this style "Early Norman." He was obliged sometimes to use architectural phrases, he said, and he asked them to take it for granted once for all that they could not take one art by itself; all arts were intertwined one with another – there was in fact only one art, with various manifestations. To their minds this art had a certain amount of gloom – the windows and buildings were small to a great extent, but he believed there was a kind of practical utility in this. Again, it was very directly and distinctly under the influence of the art of Rome and Constantinople, and on the other hand showed very strongly the influence of that other form of art, the non-classical, the Celtic and barbarian element – he did not use the latter phrase in a bad sense, because, on the whole, he thought it far better than civilisation.

Out of this gloom came a most amazing and unaccountable new style, as different as light and darkness. Everything suddenly turned from gloomy stolidity to a lightness and elegance which words could hardly express. For instances he called attention to Salisbury Cathedral and the nave of Ely Cathedral. This change took place after a very brief transition, and pointed arches were almost universally used, instead of round ones. In spite of this extraordinary change there was nothing in the habits of the time or the thoughts of the people to give any reason why this sudden change took place. Just consider the extraordinary rapidity of the march of events from the eleventh to the fifteenth century. Everything changes and excitement, both distinctly mental and what was sometimes called spiritual, was in everybody's mind and in everybody's heart, and with reference to art it seemed to him the growth was almost too quick. The first tendency seemed to get to the top of the hill, and then begin to go down the other side. The twelfth century might be described as the century when the seed was

Figures 7, 8, 9 sown, the thirteenth when the tree blossomed, and the early fourteenth the autumn time of art, when the blossom gave place to the ripe fruit. By the middle of the fourteenth century the decay was not merely a thing to be sought out; it becomes obvious something had gone wrong. Art became more and more elaborate, but not more and more beautiful, and the first years of the fifteenth century and towards the middle the change was startling enough to everybody. Decay had set in, and the Middle Ages were coming to an end. One thing generally quoted as a token of this was the invention of the art of printing, in

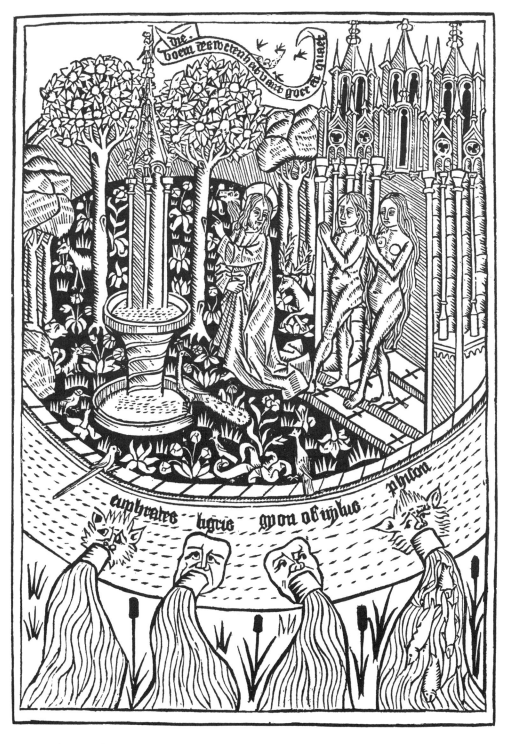

11 Ludophus de Saxonia, *Vita Christi* (Antwerp: Gerard Leeu, 1487), II, fol.
BI^v. Size of original: 178 × 167 mm. Morris's copy is in the Morgan Library.

itself not much of an invention – rather a poor one of writing made
easy. The difference between the printed book and the written one
was very little indeed. It was such a very feeble instrument itself that
with the diffusion of knowledge it was not able to get over other
changes which had taken place. The educated people who knew how
to read all read one language – Latin, and under the old plan a book
went to the various writing places and was published in about a week,
whereas now they had to be written in English, and had to go to Ger-
many to find someone to translate it. Then as soon as it was translated
everybody began pulling it to pieces, saying they did not understand
this and criticising that, and it was about six years before that book got
before the public, and then all interest in it had died out. Perhaps this
was partly accounted for by the isolation that existed in the Middle
Ages, when Europe was international; now it was national. The results
of printing, although considerable, were nothing like so considerable
as people tried to make out.

And now he had got to the point at which his lecture properly be-
gan. Instead of books written by hand and ornamented by hand also,
books were now produced by simple machinery and ornamented by
woodcuts. These woodcuts were not produced in the same way as ours
were at the present day. The latter were cut with a burin on section
pieces of boxwood, while the former were cut with a knife drawn to-
wards the operator on a plain kind of wood, such as holly or pear-tree.
When a workman was skilful in this craft there was no limit to his skill.
As to the principles of this Gothic art, in all the work which could
properly be called organic, which sprang from a definite root, was ac-
tually living, that also had at the back of it a vast body of experience
and tradition of the workman – and he held art could not be living un-
less also traditional – there were two great principles always influenc-
ing the art. In the first place, there was the epic side, the telling of a
story with the interest of incident; in the second place, there was the
ornamental part, the sense of expression of the beautiful and fitness
from the beautiful – a proportional point of view of the picture and
the work in which it is set. He might say in passing that this had been
the effect of all the art of the organic period, although there were var-
ious productions where only the epic element was produced. There
was very little epic, it being all ornamental afterwards. The epic was
always simple and true; relating facts and not roundabout effects. This
epical art had a very short life of it, only lasting fifty years, and it then
fell dead. There was a sort of sensual feeling for ornament and story-

20

amentes effecti miferabiliter in terirent
De fancto Siluestro

Iluefter dicit̃ a file q̃o é lux et terra q̃fi
lux tére io eft ecclefie q̃ inftar bone terre
h̃i piguediné bonne opacóis nigredine̱
huiliacóis et dulcediné deuocóis p ifta
ei tria agnofcit bona téra vt ait palladi̱
vl'filuefté dicit̃ a filuas ꝗ theos q̃a hóies
filueftres ꝗ ícultos et duros ad fidé tra
xit Vel ficut dicit̃ i glafacó filuefté dicit̃
viridis agreftis vmbrof̱ nemorof̱ Viridis celeftia contéplá
do Agreftis feip̃m excolédo. Vmbrof̱ ab omí cócupifcentia
refrigeraṯ nemorof̱ íter arbores celi plátaṯ· Ei̱ legendá co
pilauiteufebi̱ eefariéfis q̃ b́ṯ blafi̱ i cófilio feptuginta epi
ftcoporúakatholicis legédá cómemorat ficut in decreto habet̃

Iluefter a
matre te 6̃2
nomíe iufta
geitus a cirino prefpi
tero eru diṯhofpitali/
taté fumme exercebat
thimothe̱ aút quida̱
criftianiffim̱ ab eo in
hofpiciú fufcipit̃ q̃ t̃n
ob pfecucóné ab alijs
vitabatur h̃·poft annú
corona̱ affecuṯ mar/
tirij dum predicaret ꝯ/
ftantiffime fidem crifti
Putans autem tarqui
nius prefectus thymo·

15. One of 140 cuts, making 162 by repetition, in a Legenda aurea, printed at Augsburg by Gunther Zainer, without date, but c. 1475.

12 *Some German Woodcuts of the Fifteenth Century* (Kelmscott Press, 1897), p. 11. (The German title of Günther Zainer's book was *Das goldene Spiel*.)

telling which went together, and the epic and ornamental art were displaced finally by what he would call oratorical art, which put flourishes round about the story; it did not tell you the story or anything particularly to do with it, but introduced all sorts of ordinary incidents into the work which had nothing to do with the story. Anything like truth was not thought necessary to that side of the art. The ornamental side was desperately clever, but there was no instinct for beauty. With regard to St. Paul's Cathedral, the architects, he said, did not think about beauty, but to see how near they could get to Julius Caesar's time. What he wanted to point out was, that these two qualities in the arts they would find in all work that really had any claim to be considered as part of the history of the world's art. This art of ornamenting books by woodcuts was practically of German origin – it had its rise there, and the best part was carried out in that country. But the Germans had not any great success in the art of ornamenting, the Italians, Flemings, and French, and the English doing better, and he felt a certain amount of pleasure to find the English should have done so well as they did then – a people universally esteemed the most inartistic in the world, and he could not help saying that nowadays there are more reasonable grounds for that opinion than there were at the time of Caesar.

Mr. MORRIS then exhibited a number of lantern slides representing the woodcut block work of the fifteenth and early sixteenth centuries, beginning with Germany and thence proceeding to Holland, France, Italy, and Spain. Only one English book, printed in Oxford, was displayed, but as the printer was a German and the type came from Cologne, it did not reflect much credit on England.

In conclusion, he warned those of his audience who were engaged in art work in any way to guard against the folly of imitating this early art. It was a hard thing to say in one respect, because it was very beautiful. But that time had clean passed away, and however real the continuity of history, they must recognise the enormous gulf between that period and the present. They were living under changed ways of life, and how on earth could they expect people to do the same sort of work now as was done then? A horrible crime of these latter days, of which he had seen so much until he was absolutely sick of it, was the crime of "restoration" as it was called; the foolish idea that one could restore an old building to what it was 500 or 600 years ago. Why, they could not find a mason in the whole of the United Kingdom who could turn out of a piece of masonry a piece of work like the people

22

did all those ages ago. To change their habits in a few days or years and make them work like the people did in those ancient times was absolutely absurd. Recognising the continuity of history and recognising the continuous change that was always taking place, if they did anything at all let them do their own work for themselves, and realise for themselves what kind of epic it was the illustration of a book wanted to tell, and at the same time what kind of listening to beauty it was they wanted to express, and by the time they could do this and make things as well as the Middle Ages they would begin to know what the capabilities of art were, and by that time – it could not come before – they would thus create in a great part of the population in civilised life a general interest in the fine arts. As things went at present there was very little interest indeed on that side of intelligence. The intelligence of the present day tended towards the cultivation of the sciences and not art. A day would doubtless come when people would get tired of letting their intelligence rest on the scientific side of things, and almost invariably would turn their attention to art. Curiously the present day differed from the past ages in this respect: the whole population of the present time could not do without art on any terms, whereas formerly a great part of the population did not care a snap of the finger for it. The real test as to whether they really liked it, was for them to give up some ordinary sort of pleasure for the sake of art. He thought they would eventually get through the ages of science and get a sort of transition age between science and art, and then the latter would have a tolerably good time of it. Of course people had a right to exercise their intelligence in a way that gave them pleasure. At the present day art should be in some degree represented in a great municipality like this London, the greatest in the world, and the County Council was doing a good work in calling attention to, and giving instruction in, the production of things of art, which was now unduly neglected. (*Applause.*)

Mr. Cobden-Sanderson, in moving a hearty vote of thanks to Mr. Morris, said there were two points he would like to mention in expressing their thanks to Mr. Morris. First, what he might call his thoroughness; for no one had so qualified himself to speak of the great mediæval works of art as Mr. Morris. He had produced a craftsmanship in many directions, and the result would be, he ventured to think, as a light on the horizon for many generations yet to come. He had made it his business in each craft to familiarise himself with the most

23

beautiful expressions that art could attain to. In this last essay it had been his business, although printed books were not a new field to him, to surround himself with all that was best worth knowing in the works of his great predecessors, whether as writers, illuminators, printers, or decorators, and they had seen that night some of the beautiful results of his latest research. Although they were not to imitate the things he had just shown them, there would be no indiscretion, he thought, if he and they were to imitate Mr. Morris in his thoroughness, wideness of view, and research. The other point was his disinterestedness. His work was for the pure love of the beauty in the work. This was a very significant point, he ventured to think, in that particular place and under those circumstances. The beginning of technical education, he believed, was associated with the industrial supremacy of England in the great competitive markets of the world. He would not venture to depreciate that aim – sometimes he thought there was in all this work a greater aim still. Mr. Morris, following Ruskin, his predecessor, believed there must be something in the world to hallow the work that is going on in the world, and Mr. Morris thought that artistic expression was that that should and will hallow the work which is so necessary a part of the lives of all of us. He (Mr. Sanderson) hoped they might also imitate Mr. Morris in that particular point.

Mr. WILLIAM LETHABY seconded the vote of thanks, which was carried by acclamation, and the meeting dispersed.

THE WOODCUTS OF GOTHIC BOOKS
A LECTURE DELIVERED IN 1892

I SHALL presently have the pleasure of showing you in some kind of sequence a number of illustrations taken from books of the fifteenth and first years of the sixteenth centuries. But before I do so I wish to read to you a few remarks on the genesis and the quality of the kind of art represented by these examples, and the lessons which they teach us.

Since the earliest of those I have to show is probably not earlier in date than about 1420, and almost all are more than fifty years later than that, it is clear that they belong to the latest period of mediæval art, and one or two must formally be referred to the earliest days of the Renaissance, though in spirit they are still Gothic. In fact, it is curious to note the suddenness of the supplanting of the Gothic by the neo-classical style in some instances, especially in Germany: *e.g.*, the later books published by the great Nuremberg printer, Koberger, in the fourteen-nineties, books like the *Nuremberg Chronicle*, and the *Schatz-behalter*, show no sign of the coming change, but ten years worn, and hey, presto, not a particle of Gothic ornament can be found in any German printed book, though, as I think, the figure-works of one great man, Albert Dürer, were Gothic in essence.

The most part of these books, in fact all of them in the earlier days (the exceptions being mainly certain splendidly ornamented French books, including the sumptuous books of "Hours"), were meant for popular books: the great theological folios, the law books, the decretals, and such like of the earlier German printers, though miracles of typographical beauty, if ornamented at all, were ornamented by the illuminator, with the single exception of Gutenberg's splendid *Psalter*, which gives us at once the first and the best piece of ornamental colour-printing yet achieved. Again, the dainty and perfect volumes of the classics produced by the earlier Roman and Venetian printers disdained the help of wood-blocks, though they were often beautifully illuminated, and it was not till after the days of Jenson, the Frenchman who brought the Roman letter to perfection, it was not till Italian typography began to decline, that illustration by reproducible methods became usual; and we know that these illustrated books were looked upon as inferior wares, and were sold far cheaper than the un-

adorned pages of the great printers. It must be noted in confirmation of the view that the woodcut books were cheap books, that in most cases they were vernacular editions of books already printed in Latin.

The work, then, which I am about to show you has first the disadvantage of the rudeness likely to disfigure cheap forms of art in a time that lacked the resource of slippery plausibility which helps out cheap art at the present day. And secondly, the disadvantage of belonging to the old age rather than the youth or vigorous manhood of the Middle Ages. On the other hand, it is art, and not a mere trade "article"; and though it was produced by the dying Middle Ages, they were not yet dead when it was current, so that it yet retains much of the qualities of the more hopeful period; and in addition, the necessity of adapting the current design to a new material and method gave it a special life, which is full of interest and instruction for artists of all times who are able to keep their eyes open.

All organic art, all art that is genuinely growing, opposed to rhetorical, retrospective, or academical art, art which has no real growth in it, has two qualities in common: the epical and the ornamental; its two functions are the telling of a story and the adornment of a space or tangible object. The labour and ingenuity necessary for the production of anything that claims our attention as a work of art are wasted, if they are employed on anything else than these two aims. Mediæval art, the result of a long unbroken series of tradition, is preeminent for its grasp of these two functions, which, indeed, interpenetrate then more than in any other period. Not only is all its special art obviously and simply beautiful as ornament, but its ornament also is vivified with forcible meaning, so that neither in one nor the other does the life ever flag, or the sensuous pleasure of the eye ever lack. You have not got to say, Now you have your story, how are you going to embellish it? Nor, Now you have made your beauty, what are you going to do with it? For here are the two together, inseparably a part of each other. No doubt the force of tradition, which culminated in the Middle Ages, had much to do with this unity of epical design and ornament. It supplied deficiencies of individual by collective imagination (compare the constantly recurring phrases and lines in genuine epical or ballad poetry); it ensured the inheritance of deft craftsmanship and instinct for beauty in the succession of the generations of workmen; and it cultivated the appreciation of good work by the general public. Nowadays artists work essentially for artists, and look on the ignorant layman with a contempt, which even the necessity of earning a livelihood

cannot force them wholly to disguise. In the times of art, they had no one but artists to work for, since everyone was a potential artist.

Now, in such a period, when written literature was still divine, and almost miraculous to men, it was impossible that books should fail to have a due share in the epical–ornamental art of the time. Accordingly, the opportunities offered by the pages which contained the wisdom and knowledge of past and present times were cultivated to the utmost. The early Middle Ages, beginning with the wonderful calligraphy of the Irish manuscripts, were, above all times, the epoch of *writing*. The pages of almost all books, from the eighth to the fifteenth century, are beautiful, even without the addition of ornament. In those that are ornamented without pictures illustrative of the text, the eye is so pleasured, and the fancy so tickled by the beauty and exhaustless cheerful invention of the illuminator, that one scarcely ventures to ask that the tale embodied in the written characters should be further illustrated. But when this is done, and the book is full of pictures, which tell the written tale again with the most conscientious directness of design, and as to execution with great purity of outline and extreme delicacy of colour, we can say little more than that the only work of art which surpasses a complete mediæval book is a complete mediæval building. This must be said, with the least qualification, of the books from about 1160 to 1300. After this date, the work loses, in purity and simplicity, more than it gains in pictorial qualities, and, at last, after the middle of the fifteenth century, illuminated books lose much of their individuality on the ornamental side; and, though they are still beautiful, are mostly only redeemed from commonplace when the miniatures in them are excellent.

But here comes in the new element, given by the invention of printing, and the gradual shoving out of the scribe by the punch-cutter, the typefounder, and the printer. The first printed characters were as exact reproductions of the written ones as the new craftsmen could compass, even to the extent of the copying of the infernal abbreviations which had gradually crept into manuscript; but, as I have already mentioned, the producers of serious books did not at first supply the work of the illuminator by that of the wood-cutter, either in picture work or ornament. In fact the art of printing pictures from woodblocks is earlier than that of printing books, and is undoubtedly the parent of book illustration. The first woodcuts were separate pictures of religious subjects, circulated for the edification of the faithful, in existing examples generally coloured by hand, and certainly always

27

intended to be coloured. The earliest of these may be as old as 1380, and there are many which have been dated in the first half of the fifteenth century; though the dates are mostly rather a matter of speculation. But the development of book illustration proper by no means put an end to their production. Many were done between 1450 and 1490, and some in the first years of the sixteenth century; but the earlier ones only have any special character in them. Of these, some are cut rudely and some timidly also, but some are fairly well cut, and few so ill that the expression of the design is not retained. The design of most of these early works is mostly admirable, and as far removed from the commonplace as possible; many, nay most of these cuts, are fine expressions of that passionate pietism of the Middle Ages which has been somewhat veiled from us by the strangeness, and even grotesqueness, which has mingled with it, but the reality of which is not doubtful to those who have studied the period without prejudice. Amongst these may be cited a design of Christ being pressed in the wine press, probably as early as the end of the fourteenth century, which may stand without disadvantage beside a fine work of the thirteenth century.[1]

The next step towards book illustration brings us to the block-books, in which the picture-cuts are accompanied by a text, also cut on wood; the folios being printed by rubbing off on one side only. The subject of the origin of the most noteworthy of these books, the *Ars moriendi*, the *Lord's Prayer*, the *Song of Solomon*, the *Biblia pauperum*, the *Apocalypse*, and the *Speculum humanæ salvationis*, has been debated, along with the question of the first printer by means of movable types, with more acrimony than it would seem to need. I, not being a learned person, will not add one word to the controversy; it is enough to say that these works were done somewhere between the years 1430 and 1460, and that their style was almost entirely dominant throughout the Gothic period in Flanders and Holland, while it had little influence on the German wood-cutters. For the rest, all these books have great merit as works of art; it would be difficult to find more direct or more poetical rendering of the events given than those of the *Speculum humanæ salvationis*; or more elegant and touching designs than those in the *Song of Solomon*. The cuts of the *Biblia pauperum* are rougher, but full of vigour and power of expression. The *Ars moriendi* is very well drawn and executed, but the subject is not so interesting. The *Apocalypse* and the *Lord's Prayer* are both of them excellent, the former being scarcely inferior in design to the best of the Apocalypse picture manuscripts of the end of the thirteenth century.

Figure 22

Figure 22

We have now come to the woodcuts which ornament the regular books of the Gothic period, which began somewhat timidly. The two examples in Germany and Italy, not far removed from each other in date, being the *Historie von Joseph, Daniel, Judith, und Esther*, printed by Albrecht Pfister, at Bamberg, in 1462; and the *Meditations of Turrecremata* (or *Torquemada*), printed at Rome by Ulric Han, in the year 1467, which latter, though taken by the command of the Pope from the frescoes of a Roman Church (Sta. Maria Sopra Minerva) are as German as need be, and very rude in drawing and execution, though not without spirit.

But, after this date, the school of woodcarving developed rapidly; and, on the whole, Germany, which had been very backward in the art of illumination, now led the new art.

The main schools were those of Ulm and Augsburg, of Mainz, of Strassburg, of Basel, and of Nuremberg, the latter being the later. The examples which I shall presently have the pleasure of showing you are wholly of the first and the last, as being the most representative, Ulm and Augsburg of the earlier style, Nuremberg of the later. But I might mention, in passing, that some of the earlier Basel books, notably Bernard Richel's *Speculum humanæ salvationis*, are very noteworthy; and that, in the fourteen-eighties, there was a school at Mainz that produced, amongst other books, a very beautiful *Herbal*, and Breydenbach's *Peregrinatio*, which, amongst other merits, such as actual representations of the cities on the road to the Holy Land, must be said to contain the best executed woodcuts of the Middle Ages. Of course, there were many other towns in Germany which produced illustrated books, but they may be referred in character to one or other of these schools.

In Holland and Flanders there was a noble school of wood-cutting, delicately decorative in character, and very direct and expressive, being, as I said, the direct descendant of the block-books. The name of the printer who produced most books of this school was Gerard Leeu (or Lion), who printed first at Gouda, and afterwards at Antwerp. But Colard Mansion, of Bruges, who printed few books, and was the master of Caxton in the art of printing, turned out a few very fine specimens of illustrated books. One of the most remarkable illustrated works published in the Low Countries – which I mention for its peculiarity – is the *Chevalier délibéré* (an allegorical poem on the death of Charles the Rash), and I regret not being able to show you a slide of it, as it could not be done satisfactorily. This book, published at Schiedam

Figure 11

in 1500, decidedly leans towards the French in style, rather than the native manner deduced from the earlier block-books.

France began both printing and book illustration somewhat late, most of its important illustrated works belonging to a period between the years 1485 and 1520; but she grasped the art of book decoration with a firmness and completeness very characteristic of French genius; and, also, she carried on the Gothic manner later than any other nation. For decorative qualities, nothing can excel the French books, and many of the picture-cuts, besides their decorative merits, have an additional interest in the romantic quality which they introduce: they all look as if they might be illustrations to the *Morte D'Arthur* or *Tristram*.

In Italy, from about 1480 onward, book illustrations became common, going hand-in-hand with the degradation of printing, as I said before. The two great schools in Italy are those of Florence and Venice. I think it must be said that, on the whole, the former city bore away the bell from Venice, in spite of the famous Aldine *Polyphilus*, the cuts in which, by the way, are very unequal. There are a good many book illustrations published in Italy, I should mention, like those to Ulric Han's *Meditations of Turrecremata*, which are purely German in style; which is only to be expected from the fact of the early printers in Italy being mostly Germans.

I am sorry to have to say it, but England cannot be said to have a school of Gothic book illustration; the cuts in our early printed books are, at the best, French or Flemish blocks pretty well copied; at the worst, they are very badly copied. This lamentable fact is curious, considered along with what is also a fact: that in the thirteenth and fourteenth centuries the English were, on the whole, the best book decorators.

I have a few more words to say yet on the practical lessons to be derived from the study of these works of art; but before I say them, I will show you, by your leave, the slides taken from examples of these woodcuts. Only I must tell you first, what doubtless many of you know, that these old blocks were not produced by the graver on the end section of a piece of fine-grained wood (box now invariably), but by the knife on the plank section of pear-tree or similar wood – a much more difficult feat when the cuts were fine, as, *e.g.*, in Lützelburger's marvellous cuts of the *Dance of Death*.

[*Mr. Morris then showed a series of lantern slides, which he described as follows: –*]

30

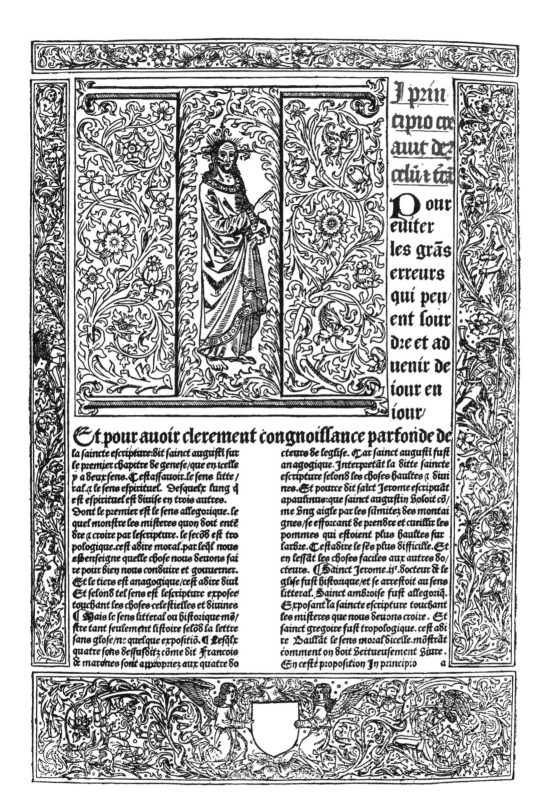

13 *La Mer des Histoires* (Paris: Pierre Le Rouge for Vincent Commin, 1488–89),
1, fol. A1ʳ. Size of original: 371 × 254 mm. Morris owned a copy of this book.

Figure 19

1. This is taken from the *Ars moriendi*, date about 1420. You may call it Flemish or Dutch, subject to raising the controversy I mentioned just now. ¶ 2. The *Song of Solomon*, about the same date. ¶ 3. From the first illustrated book of the Ulm school. *The Renowned and Noble Ladies of Boccaccio*. It begins with Adam and Eve. The initial letter is very characteristic of the Ulm school of ornament. The tail of the serpent forms the *S*, and in the knots of the tail are little figures representing the seven deadly sins. ¶ 4. Another page from the same book. *Ceres and the Art of Agriculture*. One of the great drawbacks to wood-block printing in those times was the weakness of the presses. Their only resource was to print with the paper very wet, and with very soft packing, so that the block went well into the paper; but many books, and this amongst others, have suffered much from this cause. ¶ 5. Another page of the same book. The date is 1473.

6. This is from an Augsburg book, *Speculum vitæ humanæ*, written by a Spanish bishop, which was a great favourite in the Middle Ages. It gives the advantages and disadvantages of all conditions of life. This block contains a genealogical tree of the Hapsburg family, and is an exceedingly beautiful piece of ornamental design very well cut. ¶ 7. From the same book; representing not the "Five Alls," with which you are familiar, but the "Four Alls"; the gentleman, the merchant, the nobleman, and the poor man, who is the support of the whole lot, with his toes coming through his shoes. This is a fine specimen of the printing of Günther Zainer. The initial letters are very handsome in all these Augsburg books. ¶ 8. There is a picture of the Unjust Lawyer, from the same book, taking money from both sides. The date of this book is about 1475. ¶ 9. From *Æsop's Fables*, a reproduction of the "Ulm *Æsop*," by Anthony Sorg, of Augsburg (but the pictures are printed from the same blocks), the "Fly on the Wheel," and the "Jackdaw and Peacock." These designs for the Æsop pictures went all through the Middle Ages, with very little alteration.[2] ¶ 10. "King

Figure 21

Stork and King Log," from the same book. ¶ 11. This is from the *Fable-book of Bidpay*, by Conrad Dinckmut, who carried on the early glories of the Ulm school in a later generation; about 1486. ¶ 12. "The Parrot in a Cage," with the ladies making a sham storm to cause the poor bird to be put to death. Dinckmut did some very remarkable work: one of the best of which was a German translation of the *Eunuchus* of Terence; another the *Chronicle of the Swabians*. ¶ 13. The *Schatzbehalter*, published by Koberger, of Nuremberg; 1491. Although so late, there is no trace of any classical influence in the design. The architecture, for

14 Rodericus Zamorensis, *Spiegel des menschlichen Lebens* (Augsburg: Günther Zainer, 1475–78), fol. 8ᵛ.
Size of original: 62 × 40 mm. Morris's copy (in the Morgan Library) contains the following note in his
hand: ". . . I should call this the best of the Augsburg picture-books, the greater number of the cuts being
admirably designed by Günther Zainer's second artist. . . . A genealogy of the House of Hapsburg pre-
cedes the text, and is illustrated by a cut of a genealogical tree of figures and leafage; it is an unsurpassable
ornamental work of its kind, both as to figures and scroll work, and is very well cut, as indeed are the pic-
tures to the book generally, though some are spoiled in the cutting. . . ."

instance, is pure late German architecture. ¶ 14. From the same book,
"Joshua Meeting the Angel," and "Moses at the Burning Bush." ¶ 15.
A page, or part of a page, from the celebrated *Nuremberg Chronicle*,
printed by Koberger in 1493. This is in a way an exception to the rule
of illustrated books being in the vernacular, as it is in Latin; but there
is also a German edition. ¶ 16. Another specimen of the same book. ¶
17. From a curious devotional book, *Der Seusse*, printed by Anthony
Sorg, at Augsburg; about 1485. ¶ 18. Another page, which shows the
decorative skill with which they managed their diagram pictures.

19. An example of the Flemish school, and characteristic of the de-
sign of white on black, which is so often used both by the Florentine
and the Flemish wood-cutters. It is from a life of Christ, published by

Figure 11 Gerard Leeu in 1487. ¶ 20. Another page from the same book. There
are certainly two artists in this book, and the one on the left appears to
be the more pictorial of the two; though his designs are graceful, he is
hardly as good as the rougher book illustrator. Gerard Leeu had a very
handsome set of initial letters, a kind of ornament which did not be-
come common until after 1480. ¶ 21. Another one from the same book.
¶ 22. From another Flemish book, showing how the style runs through
them all. St. George and the Dragon; from *A Golden Legend*, 1503.

23. One of French series, from a very celebrated book called *La Mer*

Figure 13 *des histoires*. It begins the history of France a little before the deluge. It
is a most beautiful book, and very large. One would think these bor-
ders were meant to be painted, as so many "Books of Hours" were,
but I have never seen a copy which has had the borders painted,
though, as a rule, when the borders are meant to be painted, it is not
common to find one plain. ¶ 24. Another page from the same book;
but the slide does not do justice to it. I will here mention that one fail-
ing of the French publishers was to make one picture serve for several
purposes. The fact is, they were more careful of decoration than il-
lustration. ¶ 25. Another French book by a French printer, the *Aubre
des batailles*, which illustrates that curious quality of romance which
you find in the French pictures. It is true that many of these cuts were
not made for this book; in fact, they were done for another edition of
the *Chevalier délibéré*, the Flemish edition of which I have mentioned
before, for some have that name on them. ¶ 26. Another from the
same book. ¶ 27. Another good example of the French decorative
style. It is from Petrarch's *Remedy of Either Fortune*. This is the author
presenting his book to the king, and is often used in these French
books. ¶ 28. From another French book of about the same date (the

34

15 Federico Frezzi, *Quatriregio in terza rima volgare* (Florence: for Piero Pacino,
1508); the descent of Minerva. Size of original: 20.5 × 25.5 mm.

beginning of the sixteenth century), *The Shepherd's Calendar*, of which
there were a great number of English editions, even as late as 1656, the
cuts being imitated from these blocks. ¶ 29. A page from one of the
beautiful "Books of Hours," which were mostly printed on vellum,
every page of which is decorated more or less with this sort of picture.
Here is the calendar, with the signs of the Zodiac, the work of the
months, the saints that occur in it, and games and sports; on the other
side is the Sangraal. This book is throughout in the same style – wholly
Gothic. It was printed in 1498, and about twenty years after these
service-books became very much damaged by having Renaissance
features introduced from German artists of the time. ¶ 30. Another
page from the same book. The Resurrection, and the raising of Lazarus
are the principal subjects.

31. Nominally an Italian woodcut; the book was printed at Milan,
but this cut is probably of German design, if not execution. ¶ 32. From
a very beautiful book in the Florentine style. One of the peculiarities
is the copious use of white out of black. ¶ 33. Another from the same –
The Quatre reggio, 1508. ¶ 34. Another, very characteristic of the Flor- *Figure 15*

35

entine style, with its beautiful landscape background. ¶ 35. This is one
in which the ornament has really got into the Renaissance style. It is a
sort of "Lucky Book," with all sorts of ways of finding your fortune,
discovering where your money has gone, who is your enemy, and so
on. One of the Pescia books, actually printed at Milan, but of the Ve-
netian school. ¶ 36. From a book of the Venetian style, about the same
date. I show it as an example of the carefulness and beauty with which
the artists of the time combined the border work with the pictures.
There is something very satisfactory in the proportion of black and
white in the whole page.

Now you have seen my examples, I want once more to impress
upon you the fact that these designs, one and all, while they perform
their especial function – the office of telling a tale – never forget their
other function of decorating the book of which they form a part; this
is the essential difference between them and modern book illustra-
tions, which I suppose make no pretence at decorating the pages of the
book, but must be looked upon as black and white pictures which it is
convenient to print and bind up along with the printed matter. The
question, in fact, which I want to put to you is this, Whether we are to
have books which are beautiful as books; books in which type, paper,
woodcuts, and the due arrangement of all these are to be considered,
and which are so treated as to produce a harmonious whole, some-
thing which will give a person with a sense of beauty real pleasure
whenever and wherever the book is opened, even before he begins to
look closely into the illustrations; or whether the beautiful and inven-
tive illustrations are to be looked on as separate pictures embedded in
a piece of utilitarianism, which they cannot decorate because it cannot
help them to do so. Take as an example of the latter, Mr. Fred Walk-
er's illustrations to *Philip* in the *Cornhill Magazine*, of the days when
some of us were young, since I am inclined to think that they are about
the best of such illustrations.[3] Now they are part of Thackeray's story,
and I don't want them to be in any way less a part of it, but they are in
no respect a part of the tangible printed book, and I do want them to
be that. As it is, the mass of utilitarian matter in which they are embed-
ded is absolutely helpless and dead. Why, it is not even ugly, at least
not vitally ugly.

Now the reverse is the case with the books from which I have taken
the examples which you have been seeing. As things to be looked at
they are beautiful taken as a whole; they are alive all over, and not
merely in a corner here and there. The illustrator has to share the suc-

cess and the failure, not only of the wood-cutter, who has translated his drawing, but also of the printer and the mere ornamentalist, and the result is that you have a book which is a visible work of art.

You may say that you don't care for this result, that you wish to read literature and to look at pictures; and that so long as the modern book gives you these pleasures you ask no more of it; well, I can understand that, but you must pardon me if I say that your interest in books in that case is literary only, and not artistic, and that implies, I think, a partial crippling of the faculties; a misfortune which no one should be proud of.

However, it seems certain that there is growing up a taste for books which are visible works of art, and that especially in this country, where the printers, at their best, do now use letters much superior in form to those in use elsewhere, and where a great deal of work intending to ornament books reasonably is turned out; most of which, however, is deficient in some respect; which, in fact, is seldom satisfactory unless the whole page, picture, ornament, and type is reproduced literally from the handiwork of the artist, as in some of the beautiful works of Mr. Walter Crane.[4]

But this is a thing that can rarely be done, and what we want, it seems to me, is not that books should sometimes be beautiful, but that they should generally be beautiful; indeed, if they are not, it increases the difficulties of those who would make them sometimes beautiful immensely. At any rate, I claim that illustrated books should always be beautiful, unless, perhaps, where the illustrations are present rather for the purpose of giving information than for that of giving pleasure to the intellect through the eye; but surely, even in this latter case, they should be reasonably and decently good-looking.

Well, how is this beauty to be obtained? It must be by the harmonious cooperation of the craftsmen and artists who produce the book. First, the paper should be good, which is a more important point than might be thought, and one in which there is a most complete contrast between the old and the modern books; for no bad paper was made till about the middle of the sixteenth century, and the worst that was made even then was far better than what is now considered good. Next, the type must be good, a matter in which there is more room for excellence than those may think who have not studied the forms of letters closely. There are other matters, however, besides the mere form of the type which are of much importance in the producing of a beautiful book, which, however, I cannot go into tonight, as it is a lit-

tle beside my present subject. Then, the mere ornament must be good, and even very good. I do not know anything more dispiriting than the mere platitudes of printers' ornaments – trade ornaments. It is not uncommon nowadays to see handsome books quite spoiled by them – books in which plain, unadorned letters would have been far more ornamental.

Then we come to the picture woodcuts. And here I feel I shall find many of you differing from me strongly; for I am sure that such illustrations as those excellent black and white pictures of Fred Walker could never make book ornaments. The artist, to produce these satisfactorily, must exercise severe self-restraint, and must never lose sight of the page of the book he is ornamenting. That ought to be obvious to you, but I am afraid it will not be. I do not think any artist will ever make a good book illustrator, unless he is keenly alive to the value of a well-drawn line, crisp and clean, suggesting a simple and beautiful *silhouette*. Anything which obscures this, and just to the extent to which it does obscure it, takes away from the fitness of a design as a book ornament. In this art vagueness is quite inadmissible. It is better to be wrong than vague in making designs which are meant to be book ornaments.

Again, as the artists' designs must necessarily be reproduced for this purpose, he should never lose sight of the material he is designing for. Lack of precision is fatal (to take up again what I have just advanced) in an art produced by the point of the graver on a material which offers just the amount of resistance which helps precision. And here I come to a very important part of my subject, to wit, the relation between the designer and the wood-engraver; and it is clear that if these two artists do not understand one another, the result must be failure; and this understanding can never exist if the wood-engraver has but to cut servilely what the artist draws carelessly. If any real school of wood-engraving is to exist again, the wood-cutter must be an artist translating the designer's drawing. It is quite pitiable to see the patience and ingenuity of such clever workmen, as some modern wood-cutters are, thrown away on the literal reproduction of mere meaningless scrawl.[5] The want of logic in artists who will insist on such work is really appalling. It is the actual touches of the hand that give the speciality, the final finish to a work of art, which carries out in one material what is designed in another; and for the designer to ignore the instrument and material by which the touches are to be done, shows complete want of understanding of the scope of reproducible design.

I cannot help thinking that it would be a good thing for artists who consider designing part of their province (I admit there are very few such artists) to learn the art of wood-engraving, which, up to a certain point, is a far from difficult art; at any rate for those who have the kind of eyes suitable for the work. I do not mean that they should necessarily always cut their own designs, but that they should be able to cut them. They would thus learn what the real capacities of the art are, and would, I should hope, give the executant artists genuine designs to execute, rather than problems to solve. I do not know if it is necessary to remind you that the difficulties in cutting a simple design on wood (and I repeat that all designs for book illustrations should be simple) are very much decreased since the fifteenth century, whereas instead of using the knife on the plank section of the wood, we now use the graver on the end section. Perhaps, indeed, some of you may think this simple wood-cutting contemptible, because of its ease; but delicacy and refinement of execution are always necessary in producing a line, and this is not easy, nay it is not possible to those who have not got the due instinct for it; mere mechanical deftness is no substitute for this instinct.

Again, as it is necessary for the designer to have a feeling for the quality of the final execution, to sympathise with the engraver's difficulties, and know why one block looks artistic and another mechanical; so it is necessary for the engraver to have some capacity for design, so that he may know what the designer wants of him, and that he may be able to translate the designer, and give him a genuine and obvious *cut* line in place of his *pencilled* or *penned* line without injuring in any way the due expression of the original design.

Lastly, what I want the artist – the great man who designs for the humble executant – to think of is, not his drawn design, which he should look upon as a thing to be thrown away when it has served its purpose, but the finished and duly printed ornament which is offered to the public. I find that executants of my humble designs always speak of them as "sketches," however painstaking they may be in execution. This is the recognised trade term, and I quite approve of it as keeping the "great man" in his place, and showing him what his duty is, to wit, to take infinite trouble in getting the finished work turned out of hand. I lay it down as a general principle in all the arts, where one artist's design is carried out by another in a different material, that doing the work twice over is by all means to be avoided as the source of dead mechanical work. The "sketch" should be as slight as possi-

ble, *i.e.*, as much as possible should be left to the executant.

A word or two of recapitulation as to the practical side of my subject, and I have done. An illustrated book, where the illustrations are more than mere illustrations of the printed text, should be a harmonious work of art. The type, the spacing of the type, the position of the pages of print on the paper, should be considered from the artistic point of view. The illustrations should not have a mere accidental connection with the other ornament and the type, but an essential and artistic connection. They should be designed as a part of the whole, so that they would seem obviously imperfect without their surroundings. The designs must be suitable to the material and method of reproduction, and not offer to the executant artist a mere thicket of unnatural difficulties, producing no result when finished, save the exhibition of a *tour de force*. The executant, on his side, whether he be the original designer or someone else, must understand that his business is sympathetic translation, and not mechanical reproduction of the original drawing. This means, in other words, the designer of the picture-blocks, the designer of the ornamental blocks, the wood-engraver, and the printer, all of them thoughtful, painstaking artists, and all working in harmonious cooperation for the production of a work of art. This is the only possible way in which you can get beautiful books.

Mr. Lewis Day expressed his thorough agreement with Mr. Morris, and the pleasure it had afforded him to hear the paper. There were plenty of competent lecturers who could talk very well on any subject under the sun, but it was a very different thing to hear a man speak straight out from his heart on a subject which he had made thoroughly his own. A comparison had been drawn between the old printing and the new. He did not pretend to be learned with regard to old printing, and could not, therefore, attempt to criticise anything which had been said about it; he was content to enjoy the old work. But really the two things were hardly to be compared; the old books were few, produced by the few, and for the few; whilst the new were for the many, done by the many, and there were a great many too many of them. He sympathised entirely with Mr. Morris when he spoke of book illustration as it should be, but doubted very much if that ever would be. He believed in many impossibilities, but not in that one, and he should really like to know how far Mr. Morris himself believed in it. Mr. Morris had lately been printing books himself, having designed type for the purpose, and very beautiful work he had turned out. But that formed only, as it were, a little oasis in the wilderness of general printing, and did not go far towards fertilising the dead level of dreary monotonous

tradework all around. One obvious reason why the new work was so different
from the old had been referred to by Mr. Morris when he spoke of sketches
and designs. Nowadays, if a man had to make designs for book illustration, he
was, first of all, asked to send in rough suggestions; then he had to make what
are called "finished" drawings of such as were approved, to be again submitted
to the publisher and his head man, and all sorts of people who did not know
anything about it. Even when they did not take what good there was in a thing
out of it, and produce it vilely, they were pretty sure to insist upon all sorts of
preliminary business, by which the heart was taken out of the artist. He should
like to know if Mr. Morris really had any hope of general improvement in
book illustration; it was only faith that worked miracles, and this would cer-
tainly be a miracle. The man who believed in it might accomplish it; and if any-
body could do it Mr. Morris could.

Mr. F. S. ELLIS said he also entirely agreed with all that Mr. Morris had said,
and he had the greatest hopes of a good result from the efforts Mr. Morris had
lately made. Having been only a publisher – though he was one no longer, and
not in any sense an artist – he could only look at the matter from his own point
of view. He thought publishers would stand very much in their own light if
they interfered with an artist, when they had found one capable of illustrating
their books in a proper manner. If books were sensibly and properly illus-
trated, he felt sure the public would be only too thankful to get them, and the
whole system would soon undergo a very material improvement.

Mr. MATTHEW WEBB suggested that there was a practical difficulty in pro-
ducing woodcuts, which should combine the two qualities of illustrating the
story and at the same time ornamenting the book. For ornamental purposes
there should be very little light and shade, but their absence would materially
interfere with the story-telling power.

Mr. HUGH STANNUS said his knowledge of this subject began just where
the paper left off. Once or twice in his life he had been able to purchase some
of the fine old Italian woodcut books, dating from the beginning to the middle
of the sixteenth century, which was just after the period Mr. Morris had dealt
with. He could only hope that he would carry on the subject, which was a most
interesting and important one, and give them the result at some future meeting.

Mr. J. SACHS thought wood-engravers should be encouraged to develop
their birthright, which was the production of texture. There was hardly any art
in black and white which could produce texture like wood-engraving; it could
be seen in any common catalogue. He must take exception to the remark that
wood-engraving could be learned easily. He had been an apprentice himself,
and had had many apprentices, and he was prepared to say that no one could
produce even a sound line without three or four months steady application. It
had often been said that Albert Dürer and Holbein engraved their own blocks,
which was absurd. They evidently employed block-cutters to cut the drawings
which they had made.

The Chairman [SIR GEORGE BIRDWOOD], in moving a vote of thanks to
Mr. Morris, said he could not offer any critical observations on the subject of

the paper, but there were one or two points connected with it which specially interested him. When Mr. Morris was considering the date of some of the blocks it struck him that the plants and trees represented would, in some cases, furnish a clue. There was one block, said to be Italian, which Mr. Morris thought must have been cut by a German. He should say most probably, for the plant represented seemed to him to be the mountain ash. In the Florentine engraving of 1508, which followed, the tree was, apparently, a Lombardy poplar, and if so, it was interesting, because the tree was introduced from America, and the block showed that it had already become common in Italy at that date. Turning to woodcuts in modern books, he could not help referring to Walter Crane's *Grimm's Tales*, one of the best illustrated books he had seen for a long time. He always purchased ten or twelve copies of all Mr. Crane's cheaper books, and he had distributed that one very widely. He might perhaps be allowed to say, quite incidentally, that he did not share Mr. Morris's prejudice against the unjust judge who took money from both parties to any suit he was trying. In the East he was considered the perfect judge who took a bribe from each litigant and returned it to the unsuccessful one, who then felt satisfied that the judge had done everything possible for him, but was unable to decide in his favour. In conclusion, he wished the proprietors of illustrated papers would do more for the cause of the good decoration of books. They certainly might lead the way in this branch of the revival of national taste. He had for years been carrying on a correspondence with the managers of some of these papers, in the hope of inducing them to give up advertising on the backs of their best illustrations, and so completely spoiling them. The manager of the *Graphic* wrote to him a year or two ago, to say that his criticisms had been taken seriously to heart, and that when the existing contracts ran out they would try to avoid the pernicious practice; but they had not fulfilled their promise. Probably the receipts from the advertisers were too great a temptation for the proprietors. The practice was more general and obtrusive than ever, and he had in consequence given up binding the weekly illustrated papers, for in book form they were now offensive to the eye. He was on the free list of the *Graphic*, and it might seem ungracious to look a gift horse in the mouth; but it was in the interest of the illustrated papers themselves that he raised this protest, for such sordid "double-dealing" has always proved the damnation of art.

The vote of thanks having been carried unanimously, Mr. MORRIS, in reply, said it was a pity that the contrary view to his own had not been put forward by some one, as there was a good deal to be said *pro* and *con*. What Mr. Sachs had said about texture was very true, but it applied after all to a particular kind of wood-cutting, not to that which he was thinking of as being suitable to the ornamentation of a page. He remembered a lecturer showing a very beautiful slide of Bewick's starling, which looked exceedingly handsome, but it had no relationship whatever to the type of the page on which it appeared, or rather the type had no relationship to it, and the result was that the starling did not make an ornament to the page, and one would prefer to have a separate proof of the starling. That was a strong case, because he yielded to no one in his admi-

ration for Bewick's work, especially when it was employed on fur and feathers. But this view of texture may be carried so far as to apply it to the mere presentation of outline; since it made all the difference in the world whether those lines were cut nice and round, and sweet, or whether they were reduced to a straight needle point on the one hand, or, on the other hand, were chopped out and were made edgy and sour. He did not propose to go into any battle of the styles, but the page of the book, the type, and the woodcut ought to go together. If it were necessary to have such woodcuts as Mr. Fred Walker's illustrations to *Philip*, the type ought to go with them, to be of the same style. But though this might be possible, it was unnatural, because the essential character of a book was that it was stamped; printers called the types stamps, and the woodcuts were stamps. There ought to be that same kind of clearness and distinctness – that absence of vagueness which you got in the stamping of a coin. Mr. Webb said there might be a difficulty in reconciling the story-telling function of a woodcut with its ornamental function, and no doubt that was true; but it seemed to him that it was just that kind of difficulty or limitation which made an art worth following. If there were no difficulty in carrying out a work of art in any special material, instead of learning to be an artist in pottery, or glass, or wood-cutting, why not follow the most simple and direct form of art, which gave the advantages of all others, not perhaps in the easiest, but in the fullest, way – that of oil painting. But that was not what was wanted. Oil painting might be the most important of all the arts, though he was not quite sure about that; but nevertheless you wanted other arts as well. The wood-cutter or the artist had no more right to grumble at the conditions under which he worked than the poet had at having to write in rhyme instead of prose. If he wanted to write prose he could do so. As a matter of fact, if books were largely ornamented in this way, some *modus vivendi* would be found between the ornamental and the story-telling capacity of the art; a school would grow up which would have its own due and proper conventions, under which it would work with perfect ease. The question raised by Mr. Day as to what hope there was for an improvement in book illustration and ornamentation, was really whether it could be hoped for as an ordinary and general thing. He did see certain difficulties, which mostly reduced themselves in the long-run into commercial ones, with which he was not bound to deal on the present occasion. If people chose, they could have such books in very large measure, but no doubt the commercial difficulty would put a stopper on many attempts to decorate books properly. He thoroughly sympathised with what Mr. Day said about the publisher and his man interfering with the artist. The publisher ought to select the artist, tell him what the book was, and the subject required, and let him do his best. But there was one thing in favour of the possibility of having beautiful books; they were self-contained. If he were asked whether it were possible to have buildings generally good in the present day, he should say, no; but, in the case of books, which were self-contained things, he would say yes. There were not the same difficulties with a book as with many other articles of commerce. The first thing necessary was to have a certain number of artists who had an in-

tense desire to produce work suitable for book ornament; and those artists would, in some way, force the public to give them an opportunity for producing those books. He threw the whole burden really on the group of which he was a humble member, the artists themselves; the public could only take such books as were offered them. The publishers' part was to open their purse as widely as possible, not be afraid to spend a good deal of money on a good book, though they only sold a few copies. Finally, even if books were not beautiful, they might be made tolerably good-looking. Perhaps some little advance had been made. The principal difficulty in getting a cheap book to look well was the paper, but if people would only turn their attention to this matter, they could easily get paper much better for its purpose than what was now considered good paper – paper which would show on the surface of it that it was common paper, but would not be disagreeable to handle or read, and would not be of that horrible shiny character, and look as if you could rub it all to pieces, which, in fact, you could. Some books you could not even carry comfortably from one end of a room to the other, on account of the extra weight of the adulterants necessary for that kind of paper. He had had in his hand a moderate sized book, a royal octavo, which weighed as heavy as the biggest folio of the fifteenth century. All that extra weight was not real finish, it was only trade finish, and was done in order that the books might sell. There was as much hope of doing something in the way of producing good-looking and even beautiful books, as of getting any betterment in any kind of decoration whatever; and after all it need not cost more to print books from beautiful stamps rather than ugly ones. He had the highest possible hopes, if artists would only be true to themselves.

ON THE ARTISTIC QUALITIES OF THE WOODCUT BOOKS OF ULM AND AUGS, BURG IN THE FIFTEENTH CENTURY AN ESSAY PUBLISHED IN 1895

HE invention of printing books, and the use of wood-blocks for book ornament in place of hand-painting, though it belongs to the period of the degradation of mediæval art, gave an opportunity to the Germans to regain the place which they had lost in the art of book decoration during the thirteenth and four-teenth centuries. This opportunity they took with vigour and success, and by means of it put forth works which showed the best and most essential qualities of their race. Unhappily, even at the time of their first woodcut book, the beginning of the end was on them; about thirty years afterwards they received the Renais-sance with singular eagerness and rapidity, and became, from the ar-tistic point of view, a nation of rhetorical pedants. An exception must be made, however, as to Albert Dürer; for, though his method was in-fected by the Renaissance, his matchless imagination and intellect made him thoroughly Gothic in spirit.

Amongst the printing localities of Germany the two neighbouring cities of Ulm and Augsburg developed a school of woodcut book or-nament second to none as to character, and, I think, more numerously represented than any other. I am obliged to link the two cities, because the early school at least is common to both; but the ornamented works produced by Ulm are but few compared with the prolific birth of Augsburg.

It is a matter of course that the names of the artists who designed these woodblocks should not have been recorded, any more than those of the numberless illuminators of the lovely written books of the thirteenth and fourteenth centuries; the names under which the Ulm and Augsburg picture-books are known are all those of their printers. Of these by far the most distinguished are the kinsmen (their degree of kinship is not known), Günther Zainer of Augsburg and John Zainer of Ulm. Nearly parallel with these in date are Ludwig Hohenwang and John Bämler of Augsburg, together with Pflanzmann of Augs-burg, the printer of the first illustrated German Bible. Anthony Sorg, a little later than these, was a printer somewhat inferior, rather a *re-*

printer in fact, but by dint of reusing the old blocks, or getting them re-cut and in some cases redesigned, not always to their disadvantage, produced some very beautiful books. Schönsperger, who printed right into the sixteenth century, used blocks which were ruder than the earlier ones, through carelessness, and I suppose probably because of the aim at cheapness; his books tend towards the chap-book kind.

Figure 23

The earliest of these picture-books with a date is Günther Zainer's *Golden Legend*,[1] the first part of which was printed in 1471; but, as the most important from the artistic point of view, I should name: first,

Figure 22

Günther Zainer's *Speculum humanæ salvationis* (undated but probably

Figure 19

of 1471); second, John Zainer's Boccaccio *De claris mulieribus* (dated in a

Figure 21

cut, as well as in the colophon, 1473); third, the *Æsop*, printed by both the Zainers, but I do not know by which first, as it is undated; fourth,

Figure 18

Günther Zainer's *Spiegel des menschlichen Lebens* (undated but about 1475), with which must be taken his German *Belial*, the cuts of which are undoubtedly designed by the same artist, and cut by the same hand, that cut the best in the *Spiegel* above mentioned; fifth, a beautiful little book, the story of Sigismonda and Guiscard, by Günther

Figure 20

Zainer, undated;[2] sixth, *Tuberinus, die geschicht von Symon*, which is the story of a late German Hugh of Lincoln, printed by G. Zainer about 1475; seventh, John Bämler's *Das Buch der Natur* (1475), with many full-page cuts of much interest; eighth, by the same printer, *Das Buch von den 7 Todsünden und den 7 Tugenden* (1474); ninth, Bämler's Sprenger's

Figure 10

Rosencranz-Bruderschaft, with only two cuts, but those most remarkable.

To these may be added as transitional (in date at least), between the earlier and the later school next to be mentioned, two really characteristic books printed by Sorg: (*a*) *Der Seusse*, a book of mystical devotion, and (*b*) the *Council of Constance*, printed in 1483; the latter being, as far as its cuts are concerned, mainly heraldic.

At Ulm, however, a later school arose after a transitional book, Leonard Holle's splendid *Ptolemy* of 1482; of this school one printer's name, Conrad Dinckmut, includes all the most remarkable books: to wit, *Der Seelen-wurzgarten* (1483), *Das Buch der Weisheit* (1485), the Swa-

Figure 24

bian *Chronicle* (1486), Terence's *Eunuchus* (in German) (1486). Lastly, John Reger's *Descriptio Obsidionis Rhodiæ* (1496) worthily closes the series of the Ulm books.

It should here be said that, apart from their pictures, the Ulm and Augsburg books are noteworthy for their border and letter decoration. The Ulm printer, John Zainer, in especial shone in the produc-

46

INCIPIT · EPISTOLA · FRANCI/
SCI · PETRARCHE · DE · INSIGNI ·
OBEDIENTIA · ET · FIDE · VXO/
RIA · GRISELDIS · IN · WALTHE
RVM ·

Ibrum· tuum quem noſtro materno elo
quio ·vt opinor olim iuuenis edidiſti·neſcio quidē
vnde vel qualiter ad me delatū vidi·nam ſi dicā legi·
mētiar · Siquidem ipſe magnus valde · vt ad maior·
& tempus anguſtum erat · Idqᵣ ipſum vt noſtri vulgus·
& ſoluta ſcriptus oratione · & occupatio mea bellicis
vndiqᵣ motibus inquietū · A quibus etſi animo pro /
cul abſim : nequeo tamen fluctuante re publica non
moueri · Quid ergo· excucurri eū · & feſtini viatoris in/
morem · binc atqᵣ binc circumſpiciens · nec ſubſiſtens·
animaduerti alicubi · librum ipſum · canumdentibus la=
ceſſitum · tuo tamē baculo egregie · tuaqᵣ voce defenſū
Nec miratus ſum · nam et vires ingenii tui noui · & ſcio
expertus eſſe bominum genus & inſolēs & ignanū· qui
quicquid ipſi ·vel nolunt· vel neſciunt· vel non poſſunt
in aliis reprebendunt ad boc vnum docti & arguti Sed
elingues ad reliqua · delectatus ſum·ipſo in tranſitu · Et
ſiquid laſciuie liberioris occurreret · excuſabat etas tunc
tua · dum id ſcriberes·ſtilus · ydioma · ipſa quoqᵣ rerum
leuitas · & eorum qui lecturi talia videbantur · Refert
enim largiter quibus ſcribas · morumqᵣ varietate·ſtili va
rietas excuſatur · Inter multa ſane iocoſa & leuia· quedā
pia & grauia deprebendi·de quibus tñ diffinitiue quid
iudicē nō babeo·vt qui nuſqᵣ totus in beſerim·At quod
fere accidit · eo more currentibus curioſius aliquanto qᵣ̃

16 Francesco Petrarca, *Historia Griseldis* (Ulm: Johann Zainer, 1473), fol.
[A1ʳ]. Size of original: 207 × 155 mm.

tion of borders. His *De claris mulieribus* excels all the other books of the school in this matter; the initial *S* of both the Latin and the German editions being the most elaborate and beautiful piece of its kind; and, furthermore, the German edition has a border almost equal to the *S* in beauty, though different in character, having the shield of Scotland supported by angels in the corner. A very handsome border (or half-border rather), with a zany in the corner, is used frequently in J. Zainer's books,[3] *e.g.* in the 1473 and 1474 editions of the *Rationale* of Durandus, and, associated with an interesting historiated initial *O*, in Alvarus, *De planctu ecclesiæ*, 1474. There are two or three other fine borders, such as those in Steinhöwel's *Büchlein der Ordnung*, and Petrarch's *Griseldis* (here shown), both of 1473, and in Albertus Magnus, *Summa de eucharistiæ sacramento*, 1474.

Figure 19

A curious alphabet of initials made up of leafage, good, but not very showy, is used in the *De claris mulieribus* and other books. An alphabet of large initials, the most complete example of which is to be found in Leonard Holle's *Ptolemy*, is often used and is clearly founded on the pen-letters, drawn mostly in red and blue, in which the Dutch "rubrishers" excelled.[4] This big alphabet is very beautiful and seems to have been a good deal copied by other German printers, as it well deserved to be.[5] John Reger's *Caoursin* has fine handsome "blooming-letters," somewhat tending towards the French style.

In Augsburg Günther Zainer has some initial *I*'s of strap-work without foliation: they are finely designed, but gain considerably when, as sometimes happens, the spaces between the straps are filled in with fine pen-tracery and in yellowish brown; they were cut early in Günther's career, as one occurs in the *Speculum humanæ salvationis*, *c.* 1471, and another in the *Calendar*, printed 1471. These, as they always occur in the margin and are long, may be called border-pieces. A border occurring in *Eyb, ob einem Manne tzu nemen ein Weib* is drawn very gracefully in outline, and is attached, deftly enough, to a very good *S* of the pen-letter type, though on a separate block; it has three shields of arms in it, one of which is the bearing of Augsburg. This piece is decidedly illuminators' work as to design.

Günther's *Margarita Davidica* has a border (attached to a very large *P*) which is much like the Ulm borders in character.

Figure 14

A genealogical tree of the House of Hapsburg prefacing the *Spiegel des menschlichen Lebens*, and occupying a whole page, is comparable for beauty and elaboration to the *S* of John Zainer above mentioned; on the whole, for beauty and richness of invention and for neatness of ex-

Ewangelium.

In illo tempore
dixit Ihesus
discipulis suis·
Si quis diligit
me sermonem
meum seruabit
et pater meus
diliget eū et ad
eum veniemus·
ioßis·xiiij·caᵒ.
In der zeit/ſagt
ſprach Ihesus
zů seinen iūgern
vn d ſprach wer

mich lieb hat der behaltet mein red/vnd mein vater

17 *Epistolæ et Evangelia* (Augsburg: Günther Zainer, 1474), II, fol. xxxiiʳ. Size
of original (woodcut only): 89 × 82 mm.

18 Rodericus Zamorensis, *Spiegel des menschlichen Lebens* (Augsburg: Günther
Zainer, 1475–78), fol. xliʳ. Size of original: 81 × 115 mm. Morris's copy is in the
Morgan Library.

ecution, I am inclined to give it the first place amongst all the decorative pieces of the German printers.

Günther Zainer's German Bible of *c.* 1474 has a full set of pictured letters, one to every book, of very remarkable merit: the foliated forms which make the letters and enclose the figures being bold, inventive, and very well drawn. I note that these excellent designs have received much less attention than they deserve.

In almost all but the earliest of Günther's books a handsome set of initials are used, a good deal like the above-mentioned Ulm initials, but with the foliations blunter, and blended with less of geometrical forms: the pen origin of these is also very marked.

Ludwig Hohenwang, who printed at Augsburg in the seventies, uses a noteworthy set of initials, alluded to above, that would seem to have been drawn by the designer with a twelfth-century manuscript before him, though, as a matter of course, the fifteenth century betrays itself in certain details, chiefly in the sharp foliations at the ends of the scrolls, etc. There is a great deal of beautiful design in these letters; but the square border round them, while revealing their origin from illuminators' work, leaves over-large whites in the backgrounds, which call out for the completion that the illuminator's colour would have given them.

Bämler and the later printer Sorg do not use so much ornament as Günther Zainer; their initials are less rich both in line and design than Günther's, and Sorg's especially have a look of having run down from the earlier ones: in his *Seusse,* however, there are some beautiful figured initials designed on somewhat the same plan as those of Günther Zainer's Bible.

Now it may surprise some of our readers, though I should hope not the greatest part of them, to hear that I claim the title of works of art, both for these picture-ornamented books as books, and also for the pictures themselves. Their two main merits are first their decorative and next their story-telling quality; and it seems to me that these two qualities include what is necessary and essential in book-pictures. To be sure the principal aim of these unknown German artists was to give the essence of the story at any cost, and it may be thought that the decorative qualities of their designs were accidental, or done unconsciously at any rate. I do not altogether dispute that view; but then the accident is that of the skilful workman whose skill is largely the result of tradition; it has thereby become a habit of the hand to him to work in a decorative manner.

50

R ɡɪa greca mulier ab antiquis argiuorú
regibus generoſam ducens originé adraſti
regis filia fuit ι ꝗ ſpectabili pulcbritudine
ſuaιuri de ſe cú temporaneis letum ſpectacu

19 Giovanni Boccaccio, *De claris mulieribus* (Ulm: Johann Zainer, 1473), fols.
xxiiii^v and lxxii^r. Size of originals: 78 × 108 mm; 103 × 110 mm. Morris's copy is
in the Morgan Library.

To turn back to the books numbered above as the most important of the school, I should call John Zainer's *De claris mulieribus*, and the *Æsop*, and Günther Zainer's *Spiegel des menschlichen Lebens* the most characteristic. Of these my own choice would be the *De claris mulieribus*, partly perhaps because it is a very old friend of mine, and perhaps the first book that gave me a clear insight into the essential qualities of the mediæval design of that period. The subject-matter of the book also makes it one of the most interesting, giving it opportunity for setting forth the mediæval reverence for the classical period, without any of the loss of romance on the one hand, and epical sincerity and directness on the other, which the flood-tide of Renaissance rhetoric presently inflicted on the world. No story-telling could be simpler and more straightforward, and less dependent on secondary help, than that of these curious, and, as people phrase it, rude cuts. And in spite (if you please it) of their rudeness, they are by no means lacking in definite beauty: the composition is good everywhere, the drapery well designed, the lines rich, which shows of course that the cutting is good. Though there is no ornament save the beautiful initial *S* and the curious foliated initials above mentioned, the page is beautifully proportioned and stately, when, as in the copy before me, it has escaped the fury of the bookbinder.

The great initial *S* I claim to be one of the very best printers' ornaments ever made, one which would not disgrace a thirteenth-century manuscript. Adam and Eve are standing on a finely-designed spray of poppy-like leafage, and behind them rise up the boughs of the tree. Eve reaches down an apple to Adam with her right hand, and with her uplifted left takes another from the mouth of the crowned woman's head of the serpent, whose coils, after they have performed the duty of making the *S*, end in a foliage scroll, whose branches enclose little medallions of the seven deadly sins. All this is done with admirable invention and romantic meaning, and with very great beauty of design and a full sense of decorative necessities.

As to faults in this delightful book, it must be said that it is somewhat marred by the press-work not being so good as it should have been even when printed by the weak presses of the fifteenth century; but this, though a defect, is not, I submit, an essential one.

Figure 21

In the *Æsop*[6] the drawing of the designs is in a way superior to that of the last book: the line leaves nothing to be desired; it is thoroughly decorative, rather heavy, but so firm and strong, and so obviously in submission to the draughtsman's hand, that it is capable of even great

⸿ Nach dem aber vnd er den weg nahend haym mit
dem vnschuldigen kind komen was/ vnd sich allent

20 Johannes Matthias Tiberinus, *Geschicht und Legende von dem seligen Kind gennant Simon* (Augsburg: Günther Zainer, *c.* 1475), fol. A5ᵛ. Size of original (woodcut only): 74 × 120 mm.

21 *Æsopus Vita et Fabulæ* (Augsburg: Johann and Günther Zainer, *c.* 1480), fol. D6ᵛ. Size of original: 78 × 106 mm.

Archa teſtaṁti ꝓfiꝯauit beã vginē mariã. Exo·xx
Die arch des altten geſacz hat bedewt Mariam.

22 *Speculum humanæ salvationis* (Augsburg: ss. Ulrich and Afra, [1473]), fol.
[G6ʳ]. Size of original (woodcut only): 75 × 120 mm. Morris's copy is in the
Morgan Library.

23 Ingold, *Das goldene Spiel* (Augsburg: Günther Zainer, 1472), fol. [C2ʳ].
Size of original: 86 × 117 mm.

Trafo

Parmeno

Gnato

24 Terence, *Eunuchus* (Ulm: Conrad Dinckmut, 1486), fol. xxvi^v. Size of
original: 191 × 125 mm. Morris's copy is in the Morgan Library.

delicacy as well as richness. The figures both of man and beast are full of expression; the heads clean drawn and expressive also, and in many cases refined and delicate. The cuts, with few exceptions, are not bounded by a border, but amidst the great richness of line no lack of one is felt, and the designs fully sustain their decorative position as a part of the noble type of the Ulm and Augsburg printers; this *Æsop* is, to my mind, incomparably the best and most expressive of the many illustrated editions of the Fables printed in the fifteenth century. The designs of the other German and Flemish ones were all copied from it.

Figures 14, 18　　Günther Zainer's *Spiegel des menschlichen Lebens* is again one of the most amusing of woodcut books. One may say that the book itself, one of the most popular of the Middle Ages, runs through all the conditions and occupations of men as then existing, from the Pope and Kaiser down to the field labourer, and, with full indulgence in the mediæval love of formal antithesis, contrasts the good and the evil side of them. The profuse illustrations to all this abound in excellent pieces of naïve characterisation; the designs are very well put together, and, for the most part, the figures well drawn, and draperies good and crisp, and the general effect very satisfactory as decoration. The designer in this book, however, has not been always so lucky in his cutter as those of the last two, and some of the pictures have been considerably injured in the cutting. On the other hand the lovely genealogical tree above mentioned crowns this book with abundant honour, and the best of the cuts are so good that it is hardly possible to rank it after

Figure 22　　the first two. Günther Zainer's *Speculum humanæ salvationis* and his
Figure 12　　*Golden Legend* have cuts decidedly ruder than these three books; they are simpler also, and less decorative as ornaments to the page, nevertheless they have abundant interest, and most often their essential qualities of design shine through the rudeness, which by no means excludes even grace of silhouette: one and all they are thoroughly expressive of the story they tell. The designs in these two books by the by do not seem to have been done by the same hand; but I should think that the designer of those in the *Golden Legend* drew the subjects that "inhabit" the fine letters of Günther's German Bible. Both seem to me to have a kind of illuminator's character in them. The cuts to the story of Simon bring us back to those of the *Spiegel des menschlichen Le-*
Figure 20　　*bens*; they are delicate and pretty, and tell the story, half so repulsive, half so touching, of "little Sir Hugh," very well.

I must not pass by without a further word on *Sigismund* and *Guiscard*. I cannot help thinking that the cuts therein are by the same hand

that drew some of those in the *Æsop*; at any rate they have the same qualities of design, and are to my mind singularly beautiful and interesting.

Of the other contemporary, or nearly contemporary, printers Bämler comes first in interest. His book *von den 7 Todsünden*, etc., has cuts of much interest and invention, not unlike in character to those of Günther Zainer's *Golden Legend*. His *Buch der Natur* has full-page cuts of animals, herbs, and human figures exceedingly quaint, but very well designed for the most part. A half-figure of a bishop "in pontificalibus" is particularly bold and happy. Rupertus a sancto Remigio's History of the Crusade and the *Cronich von allen Konigen and Kaisern* are finely illustrated. His *Rosencranz-Bruderschaft* above mentioned has but two cuts, but they are both of them, the one as a fine decorative work, the other as a deeply felt illustration of devotional sentiment, of the highest merit.

Figure 21

Figure 17

The two really noteworthy works of Sorg (who, as aforesaid, was somewhat a plagiaristic publisher) are, first, the *Seusse*, which is illustrated with bold and highly decorative cuts full of meaning and dignity, and next, the *Council of Constance*, which is the first heraldic woodcut work (it has besides the coats-of-arms, several fine full-page cuts, of which the burning of Huss is one). These armorial cuts, which are full of interest as giving a vast number of curious and strange bearings, are no less so as showing what admirable decoration can be got out of heraldry when it is simply and well drawn.

To Conrad Dinckmut of Ulm, belonging to a somewhat later period than these last-named printers, belongs the glory of opposing by his fine works the coming degradation of book-ornament in Germany. The *Seelen-wurzgarten*, ornamented with seventeen full-page cuts, is injured by the too free repetition of them; they are, however, very good; the best perhaps being the Nativity, which, for simplicity and beauty, is worthy of the earlier period of the Middle Ages. The *Swabian Chronicle* has cuts of various degrees of merit, but all interesting and full of life and spirit: a fight in the lists with axes being one of the most remarkable. *Das buch der Weisheit* (Bidpay's Fables) has larger cuts which certainly show no lack of courage; they are perhaps scarcely so decorative as the average of the cuts of the school, and are somewhat coarsely cut; but their frank epical character makes them worthy of all attention. But perhaps his most remarkable work is his Terence's *Eunuchus* (in German), ornamented with twenty-eight cuts illustrating the scenes. These all have backgrounds showing (mostly)

Figure 24

57

the streets of a mediæval town, which clearly imply theatrical scenery; the figures of the actors are delicately drawn, and the character of the persons and their action is well given and carefully sustained throughout. The text of this book is printed in a large handsome black-letter, imported, as my friend Mr. Proctor informs me, from Italy. The book is altogether of singular beauty and character.

The *Caoursin* (1496), the last book of any account printed at Ulm, has good and spirited cuts of the events described, the best of them being the flight of Turks in the mountains. One is almost tempted to think that these cuts are designed by the author of those of the Mainz *Breidenbach* of 1486, though the cutting is much inferior.

All these books, it must be remembered, though they necessarily (being printed books) belong to the later Middle Ages, and though some of them are rather decidedly late in that epoch, are thoroughly "Gothic" as to their ornament; there is no taint of the Renaissance in them. In this respect the art of book-ornament was lucky. The neo-classical rhetoric which invaded literature before the end of the four-teenth century (for even Chaucer did not quite escape it) was harmless against this branch of art at least for more than another hundred years; so that even Italian book-pictures are Gothic in spirit, for the most part, right up to the beginning of the sixteenth century, long after the New Birth had destroyed the building arts for Italy: while Germany, whose Gothic architecture was necessarily firmer rooted in the soil, did not so much as feel the first shiver of the coming flood till suddenly, and without warning, it was upon her, and the art of the Middle Ages fell dead in a space of about five years, and was succeeded by a singularly stupid and brutal phase of that rhetorical and academical art, which, in all matters of ornament, has held Europe captive ever since.

RINTING, in the only sense with which we are at present concerned, differs from most if not from all the arts and crafts represented in the Exhibition in being comparatively modern. For although the Chinese took impressions from wood blocks engraved in relief for centuries before the wood-cutters of the Netherlands, by a similar process, produced the block books, which were the immediate predecessors of the true printed book, the invention of movable metal letters in the fifteenth century may justly be considered as the invention of the art of printing. And it is worth mention in passing that, as an example of fine typography, the earliest book printed with movable types, the Gutenberg, or "forty-two–line Bible" of about 1455, has never been surpassed.

Printing, then, for our purpose, may be considered as the art of making books by means of movable types. Now, as all books not primarily intended as picture-books consist principally of types composed to form letterpress, it is of the first importance that the letter used should be fine in form; especially as no more time is occupied, or cost incurred, in casting, setting, or printing beautiful letters than in the same operations with ugly ones. And it was a matter of course that in the Middle Ages, when the craftsmen took care that beautiful form should always be a part of their productions whatever they were, the forms of printed letters should be beautiful, and that their arrangement on the page should be reasonable and a help to the shapeliness of the letters themselves. The Middle Ages brought calligraphy to perfection, and it was natural therefore that the forms of printed letters should follow more or less closely those of the written character, and they followed them very closely. The first books were printed in black-letter, *i.e.* the letter which was a Gothic development of the ancient Roman character, and which developed more completely and satisfactorily on the side of the "lower-case" than the capital letters; the "lower-case" being in fact invented in the *early* Middle Ages. The earliest book printed with movable type, the aforesaid Gutenberg Bible, is printed in letters which are an exact imitation of the more formal ecclesiastical writing which obtained at that time; this has since

been called "missal type," and was in fact the kind of letter used in the many splendid missals, psalters, etc., produced by printing in the fifteenth century. But the first Bible actually dated (which also was printed at Mainz by Peter Schoeffer in the year 1462) imitates a much freer hand, simpler, rounder, and less *spiky*, and therefore far pleasanter and easier to read. On the whole the type of this book may be considered the *ne-plus-ultra* of Gothic type, especially as regards the lower-case letters; and type very similar was used during the next fifteen or twenty years not only by Schoeffer, but by printers in Strassburg, Basel, Paris, Lübeck, and other cities. But though on the whole, except in Italy, Gothic letter was most often used, a very few years saw the birth of Roman character not only in Italy, but in Germany and France. In 1465 Sweynheym and Pannartz began printing in the monastery of Subiaco near Rome, and used an exceedingly beautiful type, which is indeed to look at a transition between Gothic and Roman, but which must certainly have come from the study of the twelfth- or even the eleventh-century manuscripts. They printed very few books in this type, three only; but in their very first books in Rome, beginning with the year 1468, they discarded this for a more completely Roman and far less beautiful letter. But about the same year Mentelin at Strassburg began to print in a type which is distinctly Roman; and the next year Günther Zainer at Augsburg followed suit; while in 1470 at Paris Ulrich Gering and his associates turned out the first books printed in France, also in Roman character. The Roman type of all these printers is similar in character, and is very simple and legible, and unaffectedly designed for *use*; but it is by no means without beauty. It must be said that it is in no way like the transition type of Subiaco, and though more Roman than that, yet scarcely more like the complete Roman type of the earliest printers of Rome.

A further development of the Roman letter took place at Venice. John of Spires and his brother Vindelin, followed by Nicholas Jenson, began to print in that city, 1469, 1470; their type is on the lines of the German and French rather than of the Roman printers. Of Jenson it must be said that he carried the development of Roman type as far as it can go: his letter is admirably clear and regular, but at least as beautiful as any other Roman type. After his death in the fourteen-eighties, or at least by 1490, printing in Venice had declined very much; and though the famous family of Aldus restored its technical excellence, rejecting battered letters, and paying great attention to the "press work" or actual process of *printing*, yet their type is artistically on a much lower

level than Jenson's, and in fact they must be considered to have ended the age of fine printing in Italy.

Jenson, however, had many contemporaries who used beautiful type, some of which – as, *e.g.*, that of Jacobus Rubeus or Jacques le *Figure 3* Rouge – is scarely distinguishable from his. It was these great Venetian printers, together with their brethren of Rome, Milan, Parma, and one or two other cities, who produced the splendid editions of the Classics, which are one of the great glories of the printer's art, and are worthy representatives of the eager enthusiasm for the revived learning of that epoch. By far the greater part of these *Italian* printers, it should be mentioned, were Germans or Frenchmen, working under the influence of Italian opinion and aims.

It must be understood that through the whole of the fifteenth and the first quarter of the sixteenth centuries the Roman letter was used side by side with the Gothic. Even in Italy most of the theological and law books were printed in Gothic letter, which was generally more formally Gothic than the printing of the German workmen, many of whose types, indeed, like that of the Subiaco works, are of a transitional character. This was notably the case with the early works printed at Ulm, and in a somewhat lesser degree at Augsburg. In fact Günther Zainer's first type (afterwards used by Schüssler) is remarkably like the type of the before-mentioned Subiaco books.

In the Low Countries and Cologne, which were very fertile of printed books, Gothic was the favourite. The characteristic Dutch type, as represented by the excellent printer Gerard Leeu, is very pronounced and uncompromising Gothic. This type was introduced into England by Wynkyn de Worde, Caxton's successor, and was used there with very little variation all through the sixteenth and seventeenth centuries, and indeed into the eighteenth. Most of Caxton's own types are of an earlier character, though they also much resemble Flemish or Cologne letter. After the end of the fifteenth century the degradation of printing, especially in Germany and Italy, went on apace; and by the end of the sixteenth century there was no really beautiful printing done; the best, mostly French or Low-Country, was neat and clear, but without any *distinction*; the worst, which perhaps was the English, was a terrible falling-off from the work of the earlier presses; and things got worse and worse through the whole of the seventeenth century, so that in the eighteenth printing was very miserably performed. In England about this time, an attempt was made (notably by Caslon, who started business in London as a type-

founder in 1720) to improve the letter in form. Caslon's type is clear and neat, and fairly well designed; he seems to have taken the letter of the Elzeviers of the seventeenth century for his model: type cast from his matrices is still in everyday use.

In spite, however, of his praiseworthy efforts, printing had still one last degradation to undergo. The seventeenth-century founts were bad rather negatively than positively. But for the beauty of the earlier work they might have seemed tolerable. It was reserved for the founders of the later eighteenth century to produce letters which are *positively* ugly, and which, it may be added, are dazzling and unpleasant to the eye owing to the clumsy thickening and vulgar thinning of the lines: for the seventeenth-century letters are at least pure and simple in line. The Italian, Bodoni, and the Frenchman, Didot, were the leaders in this luckless change, though our own Baskerville, who was at work some years before them, went much on the same lines; but his letters, though uninteresting and poor, are not nearly so gross and vulgar as those of either the Italian or the Frenchman.

With this change the art of printing touched bottom, so far as fine printing is concerned, though paper did not get to its worst till about 1840. The Chiswick Press in 1844 revived Caslon's founts, printing for Messrs. Longman the *Diary of Lady Willoughby*. This experiment was so far successful that about 1850 Messrs. Miller and Richard of Edinburgh were induced to cut punches for a series of "old style" letters. These and similar founts, cast by the above firm and others, have now come into general use and are obviously a great improvement on the ordinary "modern style" in use in England, which is in fact the Bodoni type a little reduced in ugliness. The design of the letters of this modern "old style" leaves a good deal to be desired, and the whole effect is a little too grey, owing to the thinness of the letters. It must be remembered, however, that most modern printing is done by machinery on soft paper, and not by the hand press, and these somewhat wiry letters are suitable for the machine process, which would not do justice to letters of more generous design.

It is discouraging to note that the improvement of the last fifty years is almost wholly confined to Great Britain. Here and there a book is printed in France or Germany with some pretension to good taste, but the general revival of the old forms has made no way in those countries. Italy is contentedly stagnant. America has produced a good many showy books, the typography, paper, and illustrations of which are, however, all wrong, oddity rather than rational beauty and

meaning being apparently the thing sought for both in the letters and
the illustrations.

To say a few words on the principles of design in typography: it is
obvious that legibility is the first thing to be aimed at in the forms of
the letters; this is best furthered by the avoidance of irrational swell-
ings and spiky projections, and by the using of careful purity of line.
Even the Caslon type when enlarged shows great shortcomings in this
respect: the ends of many of the letters such as the *t* and *e* are hooked
up in a vulgar and meaningless way, instead of ending in the sharp and
clear stroke of Jenson's letters; there is a grossness in the upper finish-
ings of letters like the *c*, the *a*, and so on, an ugly pear-shaped swelling
defacing the form of the letter: in short, it happens to this craft, as to
others, that the utilitarian practice, though it professes to avoid orna-
ment, still clings to a foolish, because misunderstood conventionality,
deduced from what was once ornament, and is by no means *useful*;
which title can only be claimed by *artistic* practice, whether the art in it
be conscious or unconscious.

In no characters is the contrast between the ugly and vulgar illegi-
bility of the modern type and the elegance and legibility of the ancient
more striking than in the Arabic numerals. In the old print each figure
has its definite individuality, and one cannot be mistaken for the
other; in reading the modern figures the eyes must be strained before
the reader can have any reasonable assurance that he has a 5, an 8, or a 3
before him, unless the press work is of the best: this is awkward if you
have to read Bradshaw's Guide in a hurry.[1]

One of the differences between the fine type and the utilitarian
must probably be put down to a misapprehension of a commercial ne-
cessity: this is the narrowing of the modern letters. Most of Jenson's
letters are designed within a square, the modern letters are narrowed
by a third or thereabout; but while this gain of space very much ham-
pers the possibility of beauty of design, it is not a real gain, for the
modern printer throws the gain away by putting inordinately wide
spaces between his lines, which, probably, the lateral compression of
his letters renders necessary. Commercialism again compels the use of
type too small in size to be comfortable reading: the size known as
"Long primer"[2] ought to be the smallest size used in a book meant to
be read. Here, again, if the practice of "leading" were retrenched
larger type could be used without enhancing the price of a book.

One very important matter in "setting up" for fine printing is the
"spacing," that is, the lateral distance of words from one another. In *Figure 26*

good printing the spaces between the words should be as near as possible equal (it is impossible that they should be quite equal except in lines of poetry); modern printers understand this, but it is only practised in the very best establishments. But another point which they should attend to they almost always disregard; this is the tendency to the formation of ugly meandering white lines or "rivers" in the page, a blemish which can be nearly, though not wholly, avoided by care and forethought, the desirable thing being "the breaking of the line" as in bonding masonry or brickwork, thus:

The general *solidity* of a page is much to be sought for: modern printers generally overdo the "whites" in the spacing, a defect probably forced on them by the characterless quality of the letters. For where these are boldly and carefully designed, and each letter is thoroughly individual in form, the words may be set much closer together, without loss of clearness. No definite rules, however, except the avoidance of "rivers" and excess of white, can be given for the spacing, which requires the constant exercise of judgement and taste on the part of the printer.

The position of the page on the paper should be considered if the book is to have a satisfactory look. Here once more the almost invariable modern practice is in opposition to a natural sense of proportion. From the time when books first took their present shape till the end of the sixteenth century, or indeed later, the page so lay on the paper that there was more space allowed to the bottom and fore margin than to the top and back of the paper, thus:

the unit of the book being looked on as the two pages forming an opening. The modern printer, in the teeth of the evidence given by his own eyes, considers the single page as the unit, and prints the page in the middle of his paper – only nominally so, however, in many cases, since when he uses a headline he counts that in, the result as measured

by the eye being that the lower margin is less than the top one, and that the whole opening has an upside-down look vertically, and that laterally the page looks as if it were being driven off the paper.

The paper on which the printing is to be done is a necessary part of our subject: of this it may be said that though there is some good paper made now, it is never used except for very expensive books, although it would not materially increase the cost in all but the very cheapest. The paper that is used for ordinary books is exceedingly bad even in this country, but is beaten in the race for vileness by that made in America, which is the worst conceivable. There seems to be no reason why ordinary paper should not be better made, even allowing the necessity for a very low price; but any improvement must be based on showing openly that the cheap article *is* cheap, *e.g.* the cheap paper should not sacrifice toughness and durability to a smooth and white surface, which should be indications of a delicacy of material and manufacture which would of necessity increase in cost. One fruitful source of badness in paper is the habit that publishers have of eking out a thin volume by printing it on thick paper almost of the substance of cardboard, a device which deceives nobody, and makes a book very unpleasant to read. On the whole, a small book should be printed on paper which is as thin as may be without being transparent. The paper used for printing the small highly ornamented French service-books about the beginning of the sixteenth century is a model in this respect, being thin, tough, and opaque. However, the fact must not be blinked that machine-made paper cannot in the nature of things be made of so good a texture as that made by hand.

The ornamentation of printed books is too wide a subject to be dealt with fully here; but one thing must be said on it. The essential point to be remembered is that the ornament, whatever it is, whether picture or pattern-work, should form *part of the page*, should be a part of the whole scheme of the book. Simple as this proposition is, it is necessary to be stated, because the modern practice is to disregard the relation between the printing and the ornament altogether, so that if the two are helpful to one another it is a mere matter of accident. The due relation of letter to pictures and other ornament was thoroughly understood by the old printers; so that even when the woodcuts are very rude indeed, the proportions of the page still give pleasure by the sense of richness that the cuts and letter together convey. When, as is most often the case, there is actual beauty in the cuts, the books so ornamented are amongst the most delightful works of art that have ever

Printing been produced. Therefore, granted well-designed type, due spacing of the lines and words, and proper position of the page on the paper, all books might be at least comely and well-looking: and if to these good qualities were added really beautiful ornament and pictures, printed books might once again illustrate to the full the position of our Society that a work of utility might be also a work of art, if we cared to make it so.

THE IDEAL BOOK A LECTURE DE-LIVERED IN 1893

Y the Ideal Book, I suppose we are to under-stand a book not limited by commercial ex-igencies of price: we can do what we like with it, according to what its nature, as a book, de-mands of Art. But we may conclude, I think, that its matter will limit us somewhat; a work on differential calculus, a medical work, a dic-tionary, a collection of a statesman's speeches, of a treatise on manures, such books, though they might be hand-somely and well printed, would scarcely receive ornament with the same exuberance as a volume of lyrical poems, or a standard classic, or such like. A work *on* Art, I think, bears less of ornament than any other kind of book (*non bis in idem*[1] is a good motto); again, a book that *must* have *illustrations*, more or less utilitarian, should, I think, have no ac-tual *ornament* at all, because the ornament and the illustration must almost certainly fight. Still, whatever the subject-matter of the book may be, and however bare it may be of decoration, it can still be a work of art, if the type be good and attention be paid to its general ar-rangement. All here present, I should suppose, will agree in thinking an opening of Schoeffer's 1462 Bible beautiful, even when it has nei-ther been illuminated nor rubricated; the same may be said of Schüss-ler, or Jenson, or, in short, of any of the *good* old printers; their works, without any further ornament than they derived from the design and arrangement of the letters, were definite works of art. In fact a book, printed or written, has a tendency to be a beautiful object, and that we of this age should generally produce ugly books, shows, I fear, some-thing like malice prepense – a *determination* to put our eyes in our pock-ets wherever we can.

Well, I lay it down, first, that a book quite un-ornamented can look actually and positively beautiful, and not merely un-ugly, if it be, so to say, architecturally good, which, by the by, need not add much to its price, since it costs no more to pick up pretty stamps than ugly ones, and the taste and forethought that goes to the proper setting, position, and so on, will soon grow into a habit, if cultivated, and will not take up much of the master-printer's time when taken with his other nec-essary business.

Now, then, let us see what this architectural arrangement claims of

us. *First*, the pages must be clear and easy to read; which they can hardly be unless, *Secondly*, the type is well designed; and *Thirdly*, whether the margins be small or big, they must be in due proportion to the page of letters.

For clearness of reading the things necessary to be heeded are, first, that the letters should be properly put on their bodies, and, I think, especially that there should be small whites between them: it is curious, but to me certain, that the irregularity of some early type, notably the Roman letter of the early printers of Rome, which is, of all Roman type, the rudest, does *not* tend toward illegibility: what does do so is the lateral compression of the letter, which necessarily involves the over-thinning out of its shape. Of course I do not mean to say that the above-mentioned irregularity is other than a fault to be corrected. One thing should *never* be done in ideal printing, the spacing out of letters, that is, putting an extra white between them; except in such hurried and unimportant work as newspaper printing, it is inexcusable.

This leads us to the second matter on this head, the lateral spacing of words (the whites between them); to make a beautiful page great attention should be paid to this, which, I fear, is not often done. No more white should be used between the words than just clearly cuts *Figure 26* them off from one another; if the whites are bigger than this it both tends to illegibility and makes the page ugly. I remember once buying a handsome fifteenth-century Venetian book, and I could not tell at first why some of its pages were so worrying to read, and so commonplace and vulgar to look at, for there was no fault to find with the type. But presently it was accounted for by the spacing; for the said pages were spaced like a modern book, *i.e.*, the black and white nearly equal. Next, if you want a legible book, the white should be clear and the black black. When that excellent journal, the *Westminster Gazette*, first came out, there was a discussion on the advantages of its green paper, in which a good deal of nonsense was talked.[2] My friend, Mr. Jacobi, being a practical printer, set these wise men right, if they noticed his letter, as I fear they did not, by pointing out that what they had done was to lower the tone (not the moral tone) of the paper, and that, therefore, in order to make it as legible as ordinary black and white, they should make their black blacker – which of course they do not do. You may depend upon it that a grey page is very trying to the eyes.

As above said, legibility depends also much on the design of the letter: and again I take up the cudgels against compressed type, and that

especially in Roman letter: the full-sized lower-case letters *a*, *b*, *d*, and
c, should be designed on something like a square to get good results:
otherwise one may fairly say that there is no room for the design; fur-
thermore, each letter should have its due characteristic drawing; the
thickening out for a *b*, *e*, *g*, should not be of the same kind as that for a
d; a *u* should not merely be an *n* turned upside down;[3] the dot of the *i* *Figure 5*
should not be a circle drawn with compasses, but a delicately drawn
diamond, and so on. To be short, the letters should be designed by an
artist, and not an engineer. As to the forms of letters in England (I
mean Great Britain), there has been much progress within the last
forty years. The sweltering hideousness of the Bodoni letter, the most
illegible type that was ever cut,[4] with its preposterous thicks and thins,
has been mostly relegated to works that do not profess anything but
the baldest utilitarianism (though why even utilitarianism should use
illegible types, I fail to see), and Caslon's letter, and the somewhat
wiry, but in its way, elegant old-faced type cut in our own days, has
largely taken its place. It is rather unlucky, however, that a somewhat
low standard of excellence has been accepted for the design of modern
Roman type at its best, the comparatively poor and wiry letter of Plan-
tin, and the Elzeviers, having served for the model, rather than the
generous and logical designs of the fifteenth-century Venetian print-
ers, at the head of whom stands Nicholas Jenson; when it is so obvi-
ous that this is the best and clearest Roman type yet struck, it seems a
pity that we should make our starting point for a possible new depar-
ture at any period worse than the best. If any of you doubt the superi-
ority of this type over that of the seventeenth century, the study of a
specimen enlarged about five times will convince him, I should think. *Figure 3*
I must admit, however, that a commercial consideration comes in
here, to wit, that the Jenson letters take up more room than the imita-
tions of the seventeenth century; and that touches on another com-
mercial difficulty, to wit, that you cannot have a book either hand-
some or clear to read which is printed in small characters. For my part,
except where books smaller than an ordinary octavo are wanted, I
would fight against anything smaller than Pica; but at any rate Small
Pica seems to me the smallest type that should be used in the body of
any book.[5] I might suggest to printers that if they want to get more in
they can reduce the size of the leads, or leave them out altogether. Of
course this is more desirable in some types than others; Caslon's let-
ter, *e.g.*, which has long ascenders and descenders, never needs lead-
ing, except for special purposes.

69

I have hitherto had a fine and generous Roman type in my mind, but after all, a certain amount of variety is desirable, and when you have once got your Roman letter as good as the best that has been, I do not think you will find much scope for development of it; I would, therefore, put in a word for some form of Gothic letter for use in our improved printed book. This may startle some of you, but you must remember that except for a very remarkable type used very seldom by Berthelet,[6] English black-letter, since the days of Wynkyn de Worde, has been always the letter which was introduced from Holland about that time (I except again, of course, the modern imitations of Caxton). Now this, though a handsome and stately letter, is not very easy reading, it is too much compressed, too spiky, and, so to say, too pre-pensely Gothic. But there are many types which are of a transitional character and of all degrees of transition, from those which do little more than take in just a little of the crisp floweriness of the Gothic, like some of the Mentelin or quasi-Mentelin ones (which, indeed, are models of beautiful simplicity), or say like the letter of the Ulm Ptolemy, of which it is difficult to say whether it is Gothic or Roman, to the splendid Mainz type, of which, I suppose, the finest example is the Schoeffer Bible of 1462, and which is almost wholly Gothic. This gives us a wide field for variety, I think, so I make the suggestion to you, and leave this part of the subject with two remarks: first, that a good deal of the difficulty of reading Gothic books is caused by the numerous contractions in them, which were a survival of the practice of the scribes; and in a lesser degree by the over abundance of tied letters, both of which drawbacks I take it for granted would be absent in modern types founded on these semi-Gothic letters. And, secondly, that in my opinion the capitals are the strong side of Roman, and the lower-case of Gothic letter, which is but natural, since the Roman was originally an alphabet of capitals, and the lower-case a gradual deduction from them.

We now come to the position of the page of print on the paper, which is a most important point, and one that till quite lately has been wholly misunderstood by modern, and seldom done wrong by ancient printers, or indeed by producers of books of any kind. On this head I must begin by reminding you that we only occasionally see one page of a book at a time; the two pages making an opening are really the unit of the book, and this was thoroughly understood by the old book producers. I think you will very seldom find a book produced before the eighteenth century, and which has not been cut down by that en-

emy of books (and of the human race) the binder, in which this rule is not adhered to: that the hinder edge (that which is bound in) must be the smallest member of the margins, the head margin must be larger than this, the fore larger still, and the tail largest of all. I assert that, to the eye of any man who knows what proportion is, this looks satisfactory, and that no other does so look. But the modern printer, as a rule, dumps down his page in what he calls the middle of the paper, which is often not even really the middle, as he measures his page from the head line, if he has one, though it is not really part of the page, but a spray of type only faintly staining the head of the paper. Now I go so far as to say that any book in which the page is properly put on the paper is tolerable to look at, however poor the type may be (always so long as there is no "ornament" which may spoil the whole thing), whereas any book in which the page is wrongly set on the paper is *in-tolerable* to look at, however good the type and ornaments may be. I have got on my shelves now a Jenson's Latin Pliny, which, in spite of its beautiful type and handsome painted ornaments, I dare scarcely look at, because the binder (adjectives fail me here) has chopped off two-thirds of the tail margin: such stupidities are like a man with his coat buttoned up behind, or a lady with her bonnet put on hind-side foremost.

Before I finish this section, I should like to say a word concerning large paper copies. I am clean against them, though I have sinned a good deal in that way myself, but that was in the days of ignorance, and I petition for pardon on that ground only. If you want to publish a handsome edition of a book as well as a cheap one, do so; but let them be two books, and if you (or the public) cannot afford this, spend your ingenuity and your money in making the cheap book as sightly as you can. Your making a large paper copy out of the small one lands you in a dilemma even if you re-impose the pages for the larger paper, which is not often done I think. If the margins are right for the smaller book, they must be wrong for the larger, and you have to offer the public the worse book at the bigger price: if they are right for the large paper they are wrong for the small, and thus *spoil* it, as we have seen above that they must do; and that seems scarcely fair to the general public (from the point of view of artistic morality) who might have had a book that was sightly, though not high priced.

As to the paper of our ideal book we are at a great disadvantage compared with past times. Up to the end of the fifteenth or, indeed, the first quarter of the sixteenth centuries, no bad paper was made,

71

and the greater part was very good indeed. At present there is very little good paper made, and most of it is very bad. Our ideal book must, I think, be printed on hand-made paper as good as it can be made; penury here will make a poor book of it. Yet if machine-made paper must be used, it should not profess fineness or luxury, but should show itself for what it is: for my part I decidedly prefer the cheaper papers that are used for the journals, so far as appearance is concerned, to the thick, smooth, sham-fine papers on which respectable books are printed, and the worst of these are those which imitate the structure of hand-made papers.

But, granted your hand-made paper, there is something to be said about its substance. A small book should not be printed on thick paper, however good it may be. You want a book to turn over easily, and to lie quiet while you are reading it, which is impossible, unless you keep heavy paper for big books.

And, by the way, I wish to make a protest against the superstition that only small books are comfortable to read; some small books are tolerably comfortable, but the best of them are not so comfortable as a fairly big folio, the size, say, of an uncut *Polyphilus*, or somewhat bigger. The fact is, a small book seldom does lie quiet, and you have either to cramp your hand by holding it, or else to put it on the table with a paraphernalia of matters to keep it down, a table-spoon on one side, a knife on another, and so on, which things always tumble off at a critical moment, and fidget you out of the repose which is absolutely necessary to reading; whereas, a big folio lies quiet and majestic on the table, waiting kindly till you please to come to it, with its leaves flat and peaceful, giving you no trouble of body, so that your mind is free to enjoy the literature which its beauty enshrines.

So far then, I have been speaking of books whose only ornament is the necessary and essential beauty which arises out of the fitness of a piece of craftsmanship for the use which it is made for. But if we get as far as that, no doubt from such craftsmanship definite ornament will arise, and will be used, sometimes with wise forbearance, sometimes with prodigality equally wise. Meantime, if we really feel impelled to ornament our books, no doubt we ought to try what we can do; but in this attempt we must remember one thing, that if we think the ornament is ornamentally a part of the book merely because it is printed with it, and bound up with it, we shall be much mistaken. The ornament must form as much a part of the page as the type itself, or it will miss its mark, and in order to succeed, and to be ornament, it must

72

submit to certain limitations, and become *architectural*; a mere black and white picture, however interesting it may be as a picture, may be far from an ornament in a book; while on the other hand, a book ornamented with pictures that are suitable for that, and that only, may become a work of art second to none, save a fine building duly decorated, or a fine piece of literature.

These two latter things are, indeed, the one absolutely necessary gift that we should claim of art. The picture-book is not, perhaps, absolutely necessary to man's life, but it gives us such endless pleasure, and is so intimately connected with the other absolutely necessary art of imaginative literature that it must remain one of the very worthiest things towards the production of which reasonable men should strive.

25 One of three printer's marks designed by William Morris. This one appeared in the smaller volumes of the Kelmscott Press.

NOTE BY WILLIAM MORRIS ON HIS AIMS IN FOUNDING THE KELMSCOTT PRESS.

I BEGAN printing books with the hope of producing some which would have a definite claim to beauty, while at the same time they should be easy to read and should not dazzle the eye, or trouble the intellect of the reader by eccentricity of form in the letters. I have always been a great admirer of the calligraphy of the Middle Ages, & of the earlier printing which took its place. As to the fifteenth-century books, I had noticed that they were always beautiful by force of the mere typography, even without the added ornament, with which many of them are so lavishly supplied. And it was the essence of my undertaking to produce books which it would be a pleasure to look upon as pieces of printing and arrangement of type. Looking at my adventure from this point of view then, I found I had to consider chiefly the following things: the paper, the form of the type, the relative spacing of the letters, the words, and the

26 The opening page of Morris's *Note . . . on His Aims in Founding the Kelmscott Press . . .* (1898), the last publication of the Kelmscott Press.

A NOTE BY WILLIAM MORRIS ON HIS AIMS IN FOUNDING THE KELMSCOTT PRESS ✥ AN ESSAY PUBLISHED IN 1896

BEGAN printing books with the hope of producing some which would have a definite claim to beauty, while at the same time they should be easy to read and should not dazzle the eye, or trouble the intellect of the reader by eccentricity of form in the letters. I have always been a great admirer of the calligraphy of the Middle Ages, and of the earlier printing which took its place. As to the fifteenth-century books, I had noticed that they were always beautiful by force of the mere typography, even without the added ornament, with which many of them are so lavishly supplied. And it was the essence of my undertaking to produce books which it would be a pleasure to look upon as pieces of printing and arrangement of type. Looking at my adventure from this point of view then, I found I had to consider chiefly the following things: the paper, the form of the type, the relative spacing of the letters, the words, and the lines; and lastly the position of the printed matter on the page.

It was a matter of course that I should consider it necessary that the paper should be hand-made, both for the sake of durability and appearance. It would be a very false economy to stint in the quality of the paper as to price: so I had only to think about the kind of hand-made paper. On this head I came to two conclusions: first, that the paper must be wholly of linen (most hand-made papers are of cotton today), and must be quite "hard," *i.e.*, thoroughly well sized; and second, that, though it must be "laid" and not "wove" (*i.e.*, made on a mould made of obvious wires), the lines caused by the wires of the mould must not be too strong, so as to give a ribbed appearance. I found that on these points I was at one with the practice of the papermakers of the fifteenth century; so I took as my model a Bolognese paper of about 1473. My friend Mr. Batchelor, of Little Chart, Kent, carried out my views very satisfactorily, and produced from the first the excellent paper which I still use.

Next as to type. By instinct rather than by conscious thinking it over, I began by getting myself a fount of Roman type. And here what I wanted was letter pure in form; severe, without needless excrescences; solid, without the thickening and thinning of the line, which is

Figures 4, 5

the essential fault of the ordinary modern type, and which makes it difficult to read; and not compressed laterally, as all later type has grown to be owing to commercial exigencies. There was only one source from which to take examples of this perfected Roman type, to wit, the works of the great Venetian printers of the fifteenth century, of whom Nicholas Jenson produced the completest and most Roman characters from 1470 to 1476. This type I studied with much care, get-

Figure 3 ting it photographed to a big scale, and drawing it over many times before I began designing my own letter; so that though I think I mastered the essence of it, I did not copy it servilely; in fact, my Roman type, especially in the lower-case, tends rather more to the Gothic than does Jenson's.

After a while I felt that I must have a Gothic as well as a Roman fount; and herein the task I set myself was to redeem the Gothic character from the charge of unreadableness which is commonly brought against it. And I felt that this charge could not be reasonably brought against the types of the first two decades of printing: that Schoeffer at Mainz, Mentelin at Strassburg, and Günther Zainer at Augsburg, avoided the spiky ends and undue compression which lay some of the later type open to the above charge. Only the earlier printers (naturally following therein the practice of their predecessors the scribes) were very liberal of contractions, and used an excess of "tied" letters, which, by the way, are very useful to the compositor. So I entirely eschewed contractions, except for the "&," and had very few tied letters, in fact none but the absolutely necessary ones. Keeping my end

Figure 5 steadily in view, I designed a black-letter type which I think I may claim to be as readable as a Roman one, and to say the truth I prefer it to the Roman. This type is of the size called Great Primer (the Roman type is of "English" size); but later on I was driven by the necessities of the Chaucer (a double-columned book) to get a smaller Gothic type of Pica size.

The punches for all these types, I may mention, were cut for me with great intelligence and skill by Mr. E. P. Prince, and render my designs most satisfactorily.

Now as to the spacing: First, the "face" of the letter should be as nearly conterminous with the "body" as possible, so as to avoid undue whites between the letters. Next, the lateral spaces between the words should be (*a*) no more than is necessary to distinguish clearly the division into words, and (*b*) should be as nearly equal as possible. Modern printers, even the best, pay very little heed to these two essentials of

76

THE Kelmscott Press began work at Hammersmith in February 1891. The designer of the type W. Morris, took as his model Nicholas Jenson's Roman letter used in Venice in the 15th Century, and which unites in the fullest degree the necessary qualities of purity of line and legibility. Jenson gives us the high-water mark of the Roman character: from his death onwards typography declined till it reached its lowest depth in the ugliness of Bodoni. Since then the English typographers following more or less in the footsteps of Caslon, have recovered much of the lost ground; but as their work is almost always adapted for machine printing it has a tendency to exaggeration of lightness and thinness, which may well be corrected, in work printed by the hand-press.

207

27 Theodore Low De Vinne, *The Practice of Typography . . . Plain Printing Types* (New York, 1899), p. 207. Cockerell offers this explanation (British Library, shelfmark C.102.h.18, fol. [8]): "Short account of the Press written by W.M. for one of De Vinne's books on Printing. An electro was sent to Mr De Vinne. . . ."

seemly composition, and the inferior ones run riot in licentious spacing, thereby producing, *inter alia*, those ugly rivers of lines running about the page which are such a blemish to decent printing. Third, the whites between the lines should not be excessive; the modern practice of "leading" should be used as little as possible, and never without some definite reason, such as marking some special piece of printing. The only leading I have allowed myself is in some cases a "thin" lead between the lines of my Gothic Pica type: in the Chaucer and the double-columned books I have used a "hair" lead, and not even this in the 16mo books. Lastly, but by no means least, comes the position of the printed matter on the page. This should always leave the inner margin the narrowest, the top somewhat wider, the outside (fore-edge) wider still, and the bottom widest of all. This rule is never departed from in mediæval books, written or printed. Modern printers systematically transgress against it; thus apparently contradicting the fact that the unit of a book is not one page, but a pair of pages. A friend, the librarian of one of our most important private libraries, tells me that after careful testing he has come to the conclusion that the mediæval rule was to make a difference of twenty per cent from margin to margin. Now these matters of spacing and position are of the greatest importance in the production of beautiful books; if they are properly considered they will make a book printed in quite ordinary type at least decent and pleasant to the eye. The disregard of them will spoil the effect of the best designed type.

It was only natural that I, a decorator by profession, should attempt to ornament my books suitably: about this matter I will only say that I have always tried to keep in mind the necessity for making my decoration a part of the page of type. I may add that in designing the magnificent and inimitable woodcuts which have adorned several of my books, and will above all adorn the Chaucer which is now drawing near completion, my friend Sir Edward Burne-Jones has never lost sight of this important point, so that his work will not only give us a series of most beautiful and imaginative pictures, but form the most harmonious decoration possible to the printed book.

Kelmscott House, Upper Mall, Hammersmith.
November 11, 1895.

APPENDIX A 🍃 A SHORT HISTORY AND DESCRIPTION OF THE KELMS, COTT PRESS 🍃 BY SYDNEY C. COC, KERELL

HE foregoing article was written at the request of a London bookseller for an American client who was about to read a paper on the Kelmscott Press. As the Press is now closing, and its seven years' existence will soon be a matter of history, it seems fitting to set down some other facts concerning it while they can still be verified; the more so as statements founded on imperfect information have appeared from time to time in newspapers and reviews.

As early as 1866 an edition of *The Earthly Paradise* was projected, which was to have been a folio in double columns, profusely illustrated by Sir Edward Burne-Jones, and typographically superior to the books of that time. The designs for the stories of Cupid and Psyche, Pygmalion and the Image, The Ring given to Venus, and The Hill of Venus, were finished, and forty-four of those for Cupid and Psyche *Figure 29* were engraved on wood in line, somewhat in the manner of the early German masters. About thirty-five of the blocks were executed by William Morris himself, and the remainder by George Y. Wardle, G. F. Campfield, C. J. Faulkner, and Miss Elizabeth Burden. Specimen pages were set up in Caslon type, and in the Chiswick Press type afterwards used in *The House of the Wolfings*, but for various reasons the project went no further.[1] Four or five years later there was a plan for an illustrated edition of *Love Is Enough*, for which two initial *L*'s and seven side ornaments were drawn and engraved by William Morris. Another marginal ornament was engraved by him from a design by Sir E. Burne-Jones, who also drew a picture for the frontispiece, which has now been engraved by W. H. Hooper for the final page of the Kelmscott Press edition of the work. These side ornaments, three of *Figure 28* which appear on the opposite page, are more delicate than any that were designed for the Kelmscott Press, but they show that when the Press was started the idea of reviving some of the decorative features of the earliest printed books had been long in its founder's mind. At this same period, in the early seventies, he was much absorbed in the study of ancient manuscripts and in writing out and illuminating var-

ious books, including a *Horace* and an *Omar Khayyám*, which may have led his thoughts away from printing. In any case, the plan of an illustrated *Love Is Enough*, like that of the folio *Earthly Paradise*, was abandoned.

Although the books written by William Morris continued to be reasonably printed, it was not until about 1888 that he again paid much attention to typography. He was then, and for the rest of his life, when not away from Hammersmith, in daily communication with his friend
Figure 2
and neighbour Emery Walker, whose views on the subject coincided with his own, and who had besides a practical knowledge of the technique of printing. These views were first expressed in an article by Mr. Walker in the catalogue of the exhibition of the Arts and Crafts Exhibition Society, held at the New Gallery in the autumn of 1888.[2] As a result of many conversations, *The House of the Wolfings* was printed at the Chiswick Press at this time, with a special type modelled on an old Basel fount, unleaded, and with due regard to proportion in the margins. The title-page was also carefully arranged. In the following year *The Roots of the Mountains* was printed with the same type (except the lower-case *e*), but with a differently proportioned page, and with shoulder-notes instead of headlines. This book was published in November 1889, and its author declared it to be the best-looking book issued since the seventeenth century. Instead of large-paper copies, which had been found unsatisfactory in the case of *The House of the Wolfings*, two hundred and fifty copies were printed on Whatman paper of about the same size as the paper of the ordinary copies. A small stock of this paper remained over, and in order to dispose of it seventy-five copies of the translation of the Gunnlaug Saga, which first appeared in the *Fortnightly Review* of January 1869, and afterwards in *Three Northern Love Stories*, were printed at the Chiswick Press. The type used was a black-letter copied from one of Caxton's founts, and the initials were left blank to be rubricated by hand. Three copies were printed on vellum. This little book was not, however, finished until November 1890.

Meanwhile Morris had resolved to design a type of his own. Immediately after *The Roots of the Mountains* appeared, he set to work upon it, and in December 1889 he asked Mr. Walker to go into partnership with him as a printer. This offer was declined by Mr. Walker; but, though not concerned with the financial side of the enterprise, he was virtually a partner in the Kelmscott Press from its first beginnings to its end, and no important step was taken without his advice

Ornaments designed and engraved for Love is Enough.

28 *A Note by William Morris on His Aims in Founding the Kelmscott Press . . .*
(Kelmscott Press, 1898), p. 9.

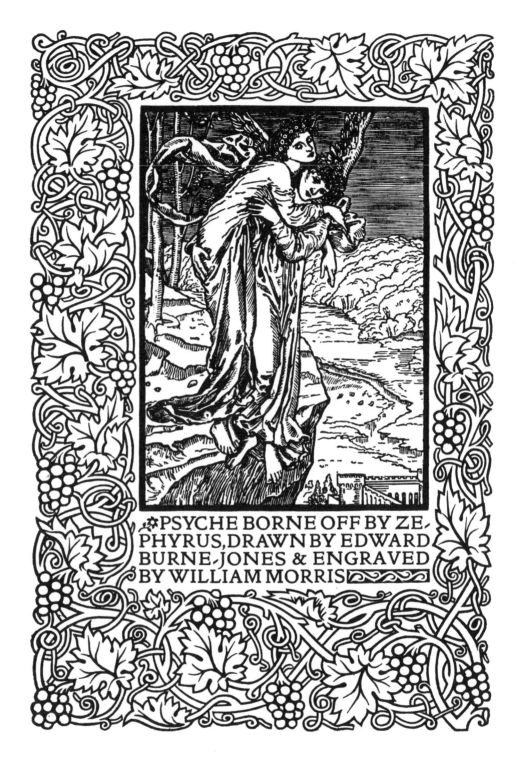

PSYCHE BORNE OFF BY ZE-
PHYRUS, DRAWN BY EDWARD
BURNE-JONES & ENGRAVED
BY WILLIAM MORRIS

29 *A Note by William Morris on His Aims in Founding the Kelmscott Press* . . .
(Kelmscott Press, 1898), frontispiece. (The wood-engraving was intended for
an edition of *The Earthly Paradise*.)

and approval. Indeed, the original intention was to have the books set up in Hammersmith and printed at his office in Clifford's Inn.

It was at this time that Morris began again to collect the mediæval books of which he formed so fine a library in the next six years. He had made a small collection of such books years before, but had parted with most of them, to his great regret. He now bought with the definite purpose of studying the type and methods of the early printers. Among the first books so acquired was a copy of Leonard of Arezzo's *History of Florence*, printed at Venice by Jacobus Rubeus in 1476, in a Roman type very similar to that of Nicholas Jenson. Parts of this book and of Jenson's *Pliny* of 1476 were enlarged by photography in order to bring out more clearly the characteristics of the various letters; and having mastered both their virtues and defects, William Morris proceeded to design the fount of type which, in the list of December 1892, he named the Golden type, from *The Golden Legend*, which was to have been the first book printed with it. This fount consists of eighty-one designs, including stops, figures, and tied letters. The lower-case alphabet was finished in a few months. The first letter having been cut in Great Primer size by Mr. Prince, was thought too large, and "English" was the size resolved upon. By the middle of August 1890, eleven punches had been cut. At the end of the year the fount was all but complete.

On January 12th, 1891, a cottage, No. 16, Upper Mall, was taken. Mr. William Bowden, a retired master-printer, had already been engaged to act as compositor and pressman. Enough type was then cast for a trial page, which was set up and printed on Saturday, January 31st, on a sample of the paper that was being made for the Press by J. Batchelor and Son. About a fortnight later ten reams of paper were delivered. On February 18th a good supply of type followed. Mr. W. H. Bowden, who subsequently became overseer, then joined his father as compositor, and the first chapters of *The Glittering Plain* were set up. The first sheet appears to have been printed on March 2nd, when the staff was increased to three by the addition of a pressman named Giles, who left as soon as the book was finished. A friend who saw William Morris on the day after the printing of the page above mentioned recalls his elation at the success of his new type. The first volume of the Saga Library, a creditable piece of printing, was brought out and put beside this trial page, which much more than held its own. The poet then declared his intention to set to work immediately on a black-letter fount; illness, however, intervened and it was not begun till

Figure 3

Figures 4, 5

Figure 30

June. The lower-case alphabet was finished by the beginning of August, with the exception of the tied letters, the designs for which, with those for the capitals, were sent to Mr. Prince on September 11th. Early in November enough type was cast for two trial pages, the one consisting of twenty-six lines of Chaucer's Franklin's Tale and the other of sixteen lines of *Sigurd the Volsung*. In each of these a capital *I* is used that was immediately discarded. On the last day of 1891 the full stock of Troy type was despatched from the foundry. Its first appearance was in a paragraph, announcing the book from which it took its name, in the list dated May 1892.

Figure 5 This Troy type, which its designer preferred to either of the others, shows the influence of the beautiful early types of Peter Schoeffer of Mainz, Günther Zainer of Augsburg, and Anthony Koberger of Nuremberg; but, even more than the Golden type, it has a strong character of its own, which differs largely from that of any mediæval fount. It has recently been pirated abroad, and is advertised by an enterprising German firm as "Die amerikanische Triumph-Gothisch." The Golden type has perhaps fared worse in being remodelled in the United States, whence, with much of its character lost, it has found its way back to England under the names "Venetian," "Italian," and "Jenson." It is strange that no one has yet had the good sense to have the actual type of Nicholas Jenson reproduced.[3]

Figure 5 The third type used at the Kelmscott Press, called the "Chaucer," differs from the Troy type only in size, being Pica instead of Great Primer. It was cut by Mr. Prince between February and May 1892, and was ready in June. Its first appearance is in the list of chapters and glossary of *The Recuyell of the Historyes of Troye*, which was issued on November 24th, 1892.

On June 2nd of that year, William Morris wrote to Mr. Prince: "I believe in about three months' time I shall be ready with a new set of sketches for a fount of type on English body." These sketches were not forthcoming; but on November 5th, 1892, he bought a copy of *Augustinus De civitate Dei*, printed at the Monastery of Subiaco near Rome by Sweynheym and Pannartz, with a rather compressed type, which appears in only three known books. He at once designed a lower-case alphabet on this model, but was not satisfied with it and did not have it cut. This was his last actual experiment in the designing of type, though he sometimes talked of designing a new fount, and of having the Golden type cut in a larger size.

Next in importance to the type are the initials, borders, and orna-

ments designed by William Morris. The first book contains a single recto border and twenty different initials. In the next book, *Poems by the Way*, the number of different initials is fifty-nine. These early initials, many of which were soon discarded, are for the most part suggestive, like the first border, of the ornament in Italian manuscripts of the fifteenth century. In Blunt's *Love Lyrics* there are seven letters of a new alphabet, with backgrounds of naturalesque grapes and vine leaves, the result of a visit to Beauvais, where the great porches are carved with vines, in August 1891. From that time onwards fresh designs were constantly added, the tendency being always towards larger foliage and lighter backgrounds, as the early initials were found to be sometimes too dark for the type. The total number of initials of various sizes designed for the Kelmscott Press, including a few that were engraved but never used, is three hundred and eighty-four. Of the letter *T* alone there are no less than thirty-four varieties.

The total number of different borders engraved for the Press, including one that was not used, but excluding the three borders designed for *The Earthly Paradise* by R. Catterson-Smith, is fifty-seven. The first book to contain a marginal ornament, other than these full borders, was *The Defence of Guenevere*, which has a half-border on p. 74. There are two others in the preface to *The Golden Legend*. *The Recuyell of the Historyes of Troye* is the first book in which there is a profusion of such ornament. One hundred and eight different designs were engraved.

Besides the above-named designs, there are seven frames for the pictures in *The Glittering Plain*, one frame for those in a projected edition of *The House of the Wolfings*, nineteen frames for the pictures in the *Chaucer* (one of which was not used in the book), twenty-eight title-pages and inscriptions, twenty-six large initial words for the *Chaucer*, seven initial words for *The Well at the World's End* and *The Water of the Wondrous Isles*, four line-endings, and three printer's marks, making a total of six hundred and forty-four designs by William Morris, drawn and engraved within seven years. All the initials and ornaments that recur were printed from electrotypes, while most of the title-pages and initial words were printed direct from the wood. The illustrations by Sir Edward Burne-Jones, Walter Crane, and C. M. Gere were also, with one or two exceptions, printed from the wood. The original designs by Sir E. Burne-Jones were nearly all in pencil and were redrawn in ink by R. Catterson-Smith, and in a few cases by C. Fairfax Murray; they were then revised by the artist and transferred to the

Figure 26

Figure 25

Figure 6

wood by means of photography. The twelve designs by A. J. Gaskin for Spenser's *Shepheardes Calender*, the map in *The Sundering Flood*, and the thirty-five reproductions in *Some German Woodcuts of the Fifteenth Century*, were printed from process blocks.

All the woodblocks for initials, ornaments, and illustrations were engraved by W. H. Hooper, C. E. Keates, and W. Spielmeyer, except the twenty-three blocks for *The Glittering Plain*, which were engraved by A. Leverett, and a few of the earliest initials, engraved by G. F. Campfield. The whole of these woodblocks have been sent to the British Museum, and have been accepted with a condition that they shall not be reproduced or printed from for the space of a hundred years. The electrotypes have been destroyed. In taking this course, which was sanctioned by William Morris when the matter was talked of shortly before his death, the aim of the trustees has been to keep the series of Kelmscott Press books as a thing apart, and to prevent the designs becoming stale by constant repetition. Many of them have been stolen and parodied in America, but in this country they are fortunately copyright. The type remains in the hands of the trustees, and will be used for the printing of its designer's works, should special editions be called for.[4] Other books of which he would have approved may also be printed with it; the absence of initials and ornament will always distinguish them sufficiently from the books printed at the Kelmscott Press.

The nature of the English hand-made paper used at the Press has been described by William Morris in the foregoing article. It was at first supplied in sheets of which the dimensions were sixteen inches by eleven. Each sheet had as a watermark a conventional primrose between the initials w.m. As stated above, *The Golden Legend* was to have been the first book put in hand, but as only two pages could have been printed at a time, and this would have made it very costly, paper of double the size was ordered for this work, and *The Story of the Glittering Plain* was begun instead. This book is a small quarto, as are its five immediate successors, each sheet being folded twice. The last ream of the smaller size of paper was used on *The Order of Chivalry*. All the other volumes of that series are printed in octavo, on paper of the double size. For the *Chaucer* a stouter and slightly larger paper was needed. This has for its watermark a Perch with a spray in its mouth. Many of the large quarto books were printed on this paper, of which the first two reams were delivered in February 1893. Only one other size of paper was used at the Kelmscott Press. The watermark of this is an Ap-

ple, with the initials w.m., as in the other two watermarks. The books printed on this paper are *The Earthly Paradise*, *The Floure and the Leafe*, *The Shepheardes Calender*, and *Sigurd the Volsung*. The last-named is a folio, and the open book shows the size of the sheet, which is about eighteen inches by thirteen. The first supply of this Apple paper was delivered on March 15, 1895.

Except in the case of Blunt's *Love Lyrics*, *The Nature of Gothic*, *Biblia Innocentium*, *The Golden Legend*, and *The Book of Wisdom and Lies*, a few copies of all the books were printed on vellum. The six copies of *The Glittering Plain* were printed on very fine vellum, obtained from Rome, of which it was impossible to get a second supply as it was all required by the Vatican. The vellum for the other books, except for two or three copies of *Poems by the Way*, which were on the Roman vellum, was supplied by H. Band of Brentford, and by W. J. Turney and Co. of Stourbridge. There are three complete vellum sets in existence, and the extreme difficulty of completing a set after the copies are scattered makes it unlikely that there will ever be a fourth.

The black ink which proved most satisfactory, after that of more than one English firm had been tried, was obtained from Hanover. William Morris often spoke of making his own ink, in order to be certain of the ingredients, but his intention was never carried out.

The binding of the books in vellum and in half-holland was from the first done by J. and J. Leighton. Most of the vellum used was white, or nearly so, but William Morris himself much preferred it dark, and the skins showing brown hair-marks were reserved for the binding of his own copies of the books. The silk ties of four colours, red, blue, yellow, and green, were specially woven and dyed.

In the following section fifty-two works, in sixty-six volumes, are described as having been printed at the Kelmscott Press, besides the two pages of Froissart's *Chronicles*. It is scarcely necessary to add that only hand-presses have been used, of the type known as "Albion." In *Figure 30* the early days there was only one press on which the books were printed, besides a small press for taking proofs. At the end of May 1891 larger premises were taken at 14, Upper Mall, next door to the cottage *Figure 31* already referred to, which was given up in June. In November 1891 a second press was bought, as *The Golden Legend* was not yet half finished, and it seemed as though the last of its 1,286 pages would never be reached. Three years later another small house was taken, No. 14 being still retained. This was No. 21, Upper Mall, overlooking the river, which acted as a reflector, so that there was an excellent light for

Appendix A printing. In January 1895 a third press, specially made for the work, was set up here in order that two presses might be employed on the *Chaucer*. This press has already passed into other hands, and the little house, with its many associations, and its pleasant outlook towards Chiswick and Mortlake, is now being transformed into a granary. The last sheet printed there was that on which are the frontispiece and title of this book.

14, Upper Mall, Hammersmith.
January 4, 1898.

APPENDIX B 🍂 FOUR INTERVIEWS WITH WILLIAM MORRIS THE POET AS PRINTER 🍂 PUBLISH͵ ED IN THE "PALL MALL GAZETTE" IN 1891

HE houses on the opposite bank are very ugly. They remind me of children crying over an arithmetic lesson. Otherwise the view is not bad from here, and if you turn to the right you look into the foliage of the big trees in Battersea Park," said Mr. William Morris as we stood in front of Kelmscott House, Hammersmith, and watched the grey light on the river. Everybody at Hammersmith knows Kelmscott House and Mr. Morris (writes a representative). A one-eyed grimy bargeman, whom I encountered in one of the labyrinthine passages of the neighbourhood, hailed with delight the opportunity of directing anybody to the centre of Socialism. "Mr. Morris's house? Why, bless you, of course I know it. Come down into the yard by the river, and I'll show you exactly where it is. You couldn't miss it."

There is nothing remarkable about the outside of Kelmscott House. It is square and high, like some of its neighbours, and over the front gate an old-world iron lantern-holder tells of the customs of the past. But as soon as you open the front door you are in another world. Rows of pictures meet the eye as you enter, and you have a vision of old oak, wrought iron, and shelves and shelves of bulky old volumes, arranged not as if they were part and parcel of a "show-library," but as if they were in daily, hourly use. Such is indeed the case, and it is they, or some of them, which formed the model for Mr. Morris's beautiful new volume of his *Poems by the Way*, of which a review appeared in our columns a few days ago: –

"I cannot see how we could do better than go back to the Roman type of the fourteenth century," said Mr. Morris, restlessly walking up and down in his workroom, where more old oak, more quaint china and pottery, more beautiful pictures, attract at every turn. The art treasures are arranged with a quasi-carelessness which is more effective than the most elaborate setting and gives a peculiar charm to the large, lofty room. "The typographic art is, of course, limited. You have the alphabet to work on. The chief object is to make the type as

89

legible as possible, and as beautiful. Now, it seems to me that the Venetians of the fifteenth century attained the highest perfection in typographic art, and after careful comparisons I selected the type of a Venetian volume of the fifteenth century as a model for my book. Let me show it to you."

And from his treasury in the hall Mr. Morris brought one old brown tome after the other, each beautifully preserved; each showing in progressive line a step from the old, uneven Gothic towards the clear Roman characters, and each in itself a treasure. The last in the line was the "Opus Nicolai Jansonis Gallici."

"This I consider the most perfect specimen of Roman typography," Mr. Morris went on. "I have taken it as a model for my book, although I have not followed it servilely. Where I thought I could improve, I have done so; but those old Venetians who perfected the Roman type knew very well what they were about, and there was no need for altering much. Look at the paper, too. It is beautiful. Of course, handmade. The paper, also, has been my model. Now just compare the two, and you will see." The dainty, light volume of *Poems by the Way* looked like a snowdrop by the side of a gigantic sunflower as it lay on the table next to old Jenson's massive book, but all the same the similarity between the two books was striking. The same clear, even type, the same mellow tone of the paper, the same deep black ink, and the same innumerable marks of watchful care over all the details by which a book is made beautiful. "England has always been the worst of all languages for typography. It was the Italians and the Germans who were most perfect in the art up to about the fifteenth century. Then they too began to go down, and in the seventeenth century only France and Holland had anything to boast of in the way of printing. Look at the books we turn out in this country nowadays. No book ought to be printed with smaller type than that which I am now using. Even the books of our best authors are spoiled by the type. Look at Mr. Ruskin's works. They are about the worst printed and ugliest-looking books in the language."

"But you are about to remedy that defect – at least, partly – are you not, Mr. Morris, by printing part of the *Stones of Venice*?"

"Yes, just one chapter of it. The one on 'The Nature of Gothic,' which is really the kernel of the whole work. In it Ruskin summarizes all he has to say on architecture. If larger and better type were generally adopted, there would be an initial expense for the type, and that would be comparatively large; but think of the benefit that would be

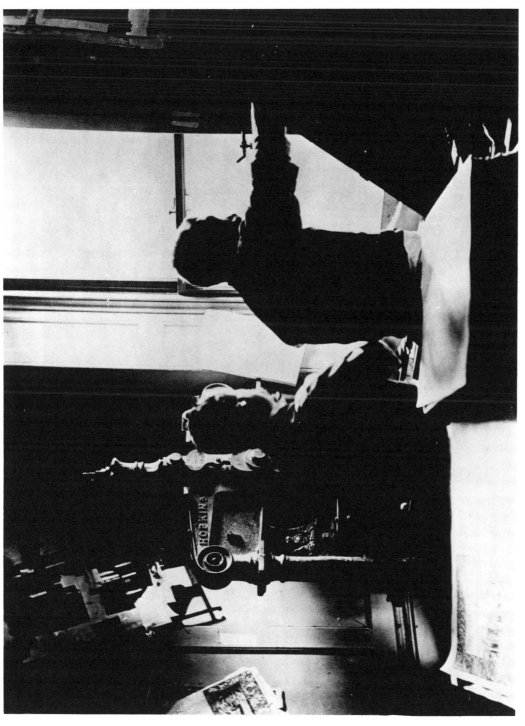

30 Two pressmen, W. Collins and W. H. Bowden, working on the Kelmscott *Chaucer*. Hanging on the wall at the left is the Burne-Jones illustration which appears on p. 355 of *The Life and Death of Jason*, and on the table in the left foreground are pp. 324–25 of the *Chaucer*. *Courtesy of the St. Bride Printing Library*.

conferred on the public! No more of the horrible type in cheap editions which the millions now have to read, and by which they spoil their eyesight."

"But, Mr. Morris, is it not better to give them books with small type, which they can buy cheap, than to prevent them from reading at all, which would be the case if there were no small type and consequent cheap editions?"

"Well, yes, that is where the difficulty lies. You see," Mr. Morris went on, with a sudden smile flitting over his face as he turned to the old, old story, "you see if we were all Socialists things would be different. We should have a public library at each street corner, where everybody might see and read all the best books, printed in the best and most beautiful type. I should not then have to buy all these old books, but they would be common property, and I could go and look at them whenever I wanted them, as would everybody else. Now I have to go to the British Museum, which is an excellent institution, but it is not enough. I want these books close at hand, and frequently, and therefore I must buy them. It is the same with everybody else, and if they have not money enough to buy them they must go without. Socialism would alter all that."[1]

"It would give us a hundred British Museums instead of the one, you mean, Mr. Morris?"

Figure 30 "Just so. But come and let me show you my printing press. It is close by, a small place, and I shall try to keep it as small as possible. A large business takes too much time." A small place, indeed, it is. There, near the window in the lower room, stands the hand press, an almost exact model of the olden days of Caxton, Gutenberg, Schoeffer, Coster, and Castaldi. A volume of Mr. Wilfrid Blunt's poems is in hand; sheet after sheet is "pulled" with square blank spaces for the red initials. Upstairs the compositors, a woman compositor among their number, are at work with *The Golden Legend*, pages of which, hanging like wet linen on clothes lines, fill another room. And all in the clear bold type of *Poems by the Way*.

"What about the purely ornamental part of your books, Mr. Morris? About the ornamental borders and initials; are the designs also rescued from the abyss of time, or are they your own designs?"

"All the designs are my own, but I have been guided in my designs by those in the old books. Yes, you can take one to reproduce in the *Pall Mall Budget*. Take this *T*, we can't spare an *S*; ever so many chapters in *The Golden Legend*, which I am printing for Mr. Quaritch, be-

31 The entrance at the left is to Sussex Cottage (14 Upper Mall, Hammer-
smith), the chief home of the Kelmscott Press from 1891 to 1898. The larger door
in the center belongs to Sussex House, then the photo-engraving works of Em-
ery Walker. *Courtesy of the British Library.*

gin with an *S*. It is all 'Saint' this and that and the other. The other let-
ter most frequently required is *A*, 'And it is to wyte:' 'And we ought to
note,' 'And the cause wherefore,' and so on, from first to last.''

"Then, in your opinion, the ornamental initials of the fifteenth
century are superior to those designed by the artists of the present
day?''

Mr. Morris shook his head, and smiled his quiet smile. "Every cock
crows on his own tub. I may think so, but it is not for me to pronounce
an opinion. The public must judge for themselves in this matter.''

"And now, Mr. Morris, tell me of your Chaucer. What is the edi-
tion you intend publishing to be like? Old English[2] or modern, bowd-
lerized or uncorrupted, including the things of which the authorship
is questionable, or strictly adhering to what is Chaucer's beyond a
doubt?''

"Old English, of course, and certainly not bowdlerized. I think I
shall include the 'Romaunt of the Rose,' and in fact everything that is
generally included in a good edition of Chaucer. It is very difficult to
get a thoroughly good edition, and to know exactly what to include.
Good work in clearing up the mystery has been done in our days.
Look at Dr. Furnivall and others. Still, it is not easy. I have a good
seventeenth-century edition; wait, and I'll show it you.''

It was a beauty, date 1602: a volume to covet. And from it we
dipped into other ancient tomes, many of them with the mark of the
chain by which they had been fastened in their youthful days still upon
them. But in their old age they live a life of perfect liberty, standing
carelessly in long rows, or lying about in a black oak press that dates
perchance from the same period as some of them.

"Here is a curious old German work,'' Mr. Morris went on, with
the evident delight of a true lover of old books, to whom his treasures
are a never-ceasing source of enjoyment. "Some old chap has made
marginal remarks in it which are sometimes very curious. Look here,
for instance; this passage refers to some German prince, and the old
fellow has written *falsum est* after it.''

Mr. Morris read the passage of Early German with as much ease
as he reads quaint mediæval Latin and Italian. "But I can't manage
modern German,'' he said, as we turned over the leaves and lingered
over the grotesque, suggestive old cuts. "It beats me altogether. In
Early German there is no syntax. I see no other reason for going to war
with Germany than their horrible syntax. It is true, they might retali-
ate and say that, where they sin in syntax, we do the same in our spell-

ing. You know the story of the Frenchman who had a lawsuit in Germany, don't you? The lawyer for the other side was pleading, and the Frenchman kept on asking his lawyer, 'What does he say? what does he say?' but the lawyer only answered, 'Hush, hush, I can't tell you just yet. I am waiting for the verb.' That is what it is. It is the scattered verbs that beat us."

"MASTER PRINTER MORRIS": A VISIT TO THE KELMSCOTT PRESS ☙ PUBLISHED IN THE "DAILY CHRONICLE" IN 1893

HEN I called upon Mr. William Morris yesterday I was told (says a *Chronicle* interviewer) that he was deep in the mysteries of lunch. So I sat in the square workroom, looking down on the Thames, which is comparatively clean at Hammersmith, and I let my eye wander over the shelf-full upon shelf-full of books. All sorts of books they seemed, most of them perhaps rare, some no doubt of the greatest value. I had to leave the bookshelves and explain myself when with a "Well, here we are," Mr. Morris briskly entered. What I wanted was an interview with "William Morris, master-printer" – a chat about the Kelmscott Press, and its mission.

"Ah, I see," quoth Mr. Morris, bending down to the fire for a light to his very plain pipe. He was, it is needless to say, in a navy-blue suit, and wore a shirt of brighter blue. "What do you think I can tell you about the Kelmscott Press?"

I told him much, and he bade me ask on.

"Well, to begin, what was your notion in starting the Kelmscott Press?"

"I wanted to print some nice books. Also I wanted to amuse myself. I think I may say I have done both. Of course, the serious point is the nice books. During the past twenty years printing has improved very considerably in this country. I should imagine that it has improved here more than anywhere else. Thought I to myself, any effort which can still help us in getting the very best printed books can only do good."

Appendix B "So for printing, you today put England well first?"

"There is no doubt about that. Even taking the worst view of English printing, we're far ahead of other countries. Here and there in France nice type may be in use, but not often, and now there are one or two good founts in Germany. Italy has the worst printing in Europe, and as for American printing, it is quite abominable."

"I suppose you desire to improve the general get-up of books as well as the printing pure and simple?"

"Certainly – the paper, the binding, the whole appearance of the book. Good paper and good binding naturally follow good printing. It would be absurd to waste beautiful type on bad paper bound with bad, or rather, I should say, not the best binding. What I say is, that it is just as cheap to print from a pretty stamp as from an ugly one, and fine paper is not so great a concern when you come to books costing more than 7s. 6d. or half a guinea. Today we cannot get the same quality in leather binding as our forefathers were able to get, and largely for that reason I bind most of the books I produce in vellum."

"Then your object in founding the Kelmscott Press was the missionary one of trying what could be accomplished in beautiful printing?"

"Precisely. In the course of my life I had obtained a good deal of knowledge of type. Particularly I was much among type when I was editor of the *Commonweal*.[1] The name 'Kelmscott' I got from a jolly old house I go to in the summer on the borders of Oxfordshire and Gloucestershire. It is two years ago last January – yes, that is accurate – since we started work. My prime idea was to go back to that period of printing when type was admittedly the best and at the same time the simplest. Take the Venetian printers of 1470, who in Roman type reached, I might almost say, the perfection of combining beauty and simplicity. One, Nicholas Jenson, comes down to us as a famous printer of the Venetian school. He was a Frenchman, by the by. Before his time there had been certain crudities in the Venetian printing. After him Venetian type began to suffer degradation, so much so that by 1490 Venetian printing had fallen off. But to the point. For printing my books I have three founts – one Roman, two Gothic or semi-Gothic. As I consulted the Venetian printers in designing my Roman type, so I consulted the early printers of Mainz and Augsburg in designing my Gothic founts."

"Now for the literary side of the Kelmscott undertaking. Being

96

able to produce beautiful books, what class of beautiful books did you wish to produce?"

"I thought I should like to see my own writings in the handsomest type, but apart from that I wished to print masterpieces in literature, and particularly to give a turn to early English classics like Caxton's. Take *Reynard the Foxe*, which I have brought out from the Kelmscott Press, and the *Golden Legend*, they are admirable from a literary point of view. Now the *Golden Legend* was last printed in 1527, and until my edition came out at ten guineas, you had, if you wanted a copy, to pay something like £200. And if you had gone to a bookseller and asked for a *Golden Legend* he would simply have looked at you as much as to say, 'My dear sir, you must wait until you get it.' Then *The Recuyell of the Historyes of Troye*, a mediæval view of the Greek and Roman mythology, is another very remarkable work."

"You have been pretty active during the two years the Kelmscott Press has been in existence."

"We have printed practically thirteen books, although they are not all issued yet. Of these, four are my own writings – *The Story of the Glittering Plain, John Ball, [The Defence of] Guenevere*, and *Poems by the Way. Godefrey of Boloyne*, a history of the first Crusade, is in the press; and so is a quite new work by myself, called *The Well at the World's End*. I don't know if it would interest you to be told that *The Well at the World's End* is a romance of the vague mediæval period, and that it will run to about 700 pages. By-and-by I am to print Chaucer, and Lady Wilde's translation of that wonderful story of the German witch-fever by Meinhold, *Sidonia the Sorceress*. Mr. F. S. Ellis is editing the text of Chaucer for us, and Mr. Burne-Jones is doing sixty illustrations."

"Are you satisfied with your career as a printer so far, and with the reception your books have obtained?"

"Very much so. I did not expect that I should be able to carry on except at a loss, but up to the present I have made both ends meet. I'm pretty well satisfied that there are a fair number of people in this country who really like beautiful books. I do believe that most of our books are bought, not so much by folks who desire to say they have them, as by those who really wish them for their own sake. I have a small public in America, but not in France as yet."

"Does the issue of the beautiful Kelmscott volumes have any direct influence on literature, do you think?"

"Primarily the object, I need hardly repeat, is the good printing of good books; but literature never suffers for being handsomely put

out. True, the prices are not the prices which Tom, Dick, and Harry can pay. I wish – I wish indeed that the cost of the books was less, only that is impossible if the printing and the decoration and the paper and the binding are to be what they should be."

"A last question, and then I shall cease from troubling you, only the question is rather a personal one. Don't you think there is a danger of our losing a poet in the Kelmscott printer – that is, if he becomes too much of a printer?"

"I see what you are driving at. But if a man writes poetry it is a great advantage that he should do other work. His poetry will be better, and he is not tied to making money out of his poetry. I do not believe in a man making money out of poetry – no, I don't believe in it for the sake of the poetry either. You have heard the story of the person who asked what sort of a branch literature was. 'Oh,' was the reply, 'a very good branch to hang yourself on.' If I want to write poetry I simply go and do it, and everything else can go to the devil. But it would be a jolly hard fate if one were to be condemned to do nothing else but write poetry."

Other things Mr. Morris told me, as, for example, that all the hand-made paper he uses in his books is manufactured in Kent. These things I might set down, but I do not know how to convey the freshness, the charm, and the magnetism which live in the personality and conversation of Master-Printer Morris.

MR. WILLIAM MORRIS AT THE KELMS-COTT PRESS ❧ PUBLISHED IN THE "ENGLISH ILLUSTRATED MAGAZINE" IN 1895

EVERYBODY knows, or ought to know, Kelmscott House, the great plain white house facing the river at Hammersmith, which is Mr. Morris's town abode. Even those who have never heard of the little grey-stone manor house on the far-away headwaters of the Thames, whence comes the name, now made familiar through his affection to so much of the world as is moved by beauty. Kelmscott House is associated with every one of the fields of Mr. Morris's superhuman activ-

ity, was the birthplace of the celebrated Hammersmith carpets, and for a long while the virtual centre of the English Socialist movement. In one or another way, there are but few among those who read or think or care for art to whom it is altogether unknown. But everybody does not know, even among those who cherish the productions of the Kelmscott Press among their most sacred treasures, that the Press also finds its home upon the Upper Mall, but a few doors east away from Kelmscott House. As will be seen from our Illustration, the Press is housed in what was once a family mansion, that has long since fallen upon unprosperous days, has lost its view of the river, been shouldered into the background by waterside cottages, and is now split unequally to serve productive purposes.

Figure 31

I found Mr. Morris in his study at Kelmscott House, surrounded by his books – literally so, for the walls are lined the whole way round with crowded shelves. Before him lay a pile of proof-sheets of most imposing appearance – great folio pages, many of them with woodcuts and marvellous borders, which proved to be part of the magnificent edition of Chaucer Mr. Morris is preparing. When these had been carefully read through and plentifully marked, the "master-printer" notified that he was about to take them into the Press and personally see that his directions were properly carried out. I gladly accepted his invitation to "go along too," coupling my acceptance with a promise not to bother him with questions until he gave me leave.

There is almost nothing to describe in the Press itself. Nothing whatever which allows of eloquent word-painting. No splendour of architecture or lavishness of ornament. No intricate machinery. No triumph of modern invention or engineering skill. The only motor is human muscle, and the appliances upon which it acts are of the very simplest description. In fact, the one thing which most forcibly strikes the visitor is the utter simplicity of the means employed to produce so much beauty. There is nothing whatever in the whole place that could puzzle Caxton himself were he to happen in. Indeed, after about twenty minutes spent in realising the advantages gained by the use of metal instead of wood – in the frames of the presses and elsewhere – any one of the old printers might fall into place and resume the practice of his craft, were he allowed to reincarnate himself and come here.

Figure 30

By the way, upon one detail of his craft he would have to spend more than twenty minutes – the handling of an ink-roller instead of his accustomed dabber. Simple as it looks when done by an expert, the

proper roll and swing is not acquired in twenty minutes: *experto crede*.[1]

As we went from room to room, inspected the press-work, questioned the compositors, and stood by the "stone" watching the wonderful "weepers" and "bloomers"[2] assume their proper positions on the page, I found that to keep my promise was altogether out of my power, and plied Mr. Morris with questions. I must do him the justice to say that I found him a perfect "subject," despite his preoccupation with the technical details of the work before him, and that his kindness and patience in explaining the recondite mysteries of artistic typography could not have been surpassed. I came away at last, feeling as though I could pass a pretty stiff examination in the art and mystery of printing. Though I don't feel so confident now.

I quickly found that the Kelmscott Press, like most important institutions – among which it may by this time claim to stand – has a history which dates from some time before it actually came into being. It was not until 1888 that Mr. Morris first turned his attention to the possibilities of modern printing. Until then, though he had always been a lover and a buyer of beautiful books, it does not seem to have occurred to him to spend time and trouble upon the printing of his own works; "but that was in the days of ignorance." Printing remained among the extremely small number of decorative arts which he had not mastered and practised. As may be seen from his *Odyssey* published in 1887, there is nothing distinctive or personal in the appearance of his books. Of course, their printing is good of its kind; type and paper relativity of type to page have been thought of, "though I sinned in the matter of large-paper copies." When all is said in their favour that can be, they remain respectable specimens of the "printing of the marketplace," and nothing more.

In 1888 came the first exhibition held by the Arts and Crafts Exhibition Society, in the preparation of which Mr. Morris took a leading part. In that Exhibition was included a selection of modern bookprinting and woodcuts. Prefacing the catalogue were a number of essays, each dealing with some art or craft from the point of view of a practical worker. That which treated of printing was written by Mr. *Figure 2* Emery Walker, who also delivered a technical lecture upon the same subject during the course of the Exhibition, illustrating his remarks by means of lantern-slides. Alike in the preparation of his essay and lecture, as in the selection of his slides, Mr. Walker had the advice and assistance of Mr. Morris, from books in whose possession, indeed, a large number of the photographs were taken. Many and long contin-

ued were the conferences *à deux* held for the purpose of "talking type," and, as they almost invariably took place in that book-lined workroom already alluded to, there was no lack of examples with which to enforce a point or uphold an arguement. From Sweynheym and Pannartz to Miller and Richard, from Gutenberg to the Chiswick Press, the discussions ranged over all that had been or could be done in designing, making, and setting type, in the proportion and presswork of the printed page. Needless to say that modern printing, apart from the work of the Chiswick Press and a very few others, came in for wholesale condemnation. One outcome of the discussions was a belief on the part of Mr. Morris that even modern printing under commercial conditions and the domination of the machine need not be so unutterably bad as it was. And he determined to show cause for his belief, and to demonstrate what might be brought about by a little thought and patience.

In the second Arts and Crafts Exhibition (1889) there was shown a copy of his then latest work, *The House of the Wolfings*, specially printed under his direction by the Chiswick Press. In this, as compared with any of its predecessors, the change is great and obvious. The type in which it is printed has since become familiar to the reading public from having been used in several of the best printed books of recent years, but was then a comparative novelty. It is founded upon a Basel type of the sixteenth century, and is the exclusive property of the Chiswick Press. The character of the type, the size, colour, and quality of the paper, the proportions of the page and the relativity of the two pages in an opening, were all carefully thought over and determined. As for the title-page, with its solid title and specially written piece of verse, device and motto in one, it offended in almost every detail against some accepted typographical superstition. In *The Roots of the Mountains* (1890), the change has gone further still. Type, paper, and page-proportion all show a further change, and the time-honoured headline has disappeared in favour of a shoulder-note, while the pages are numbered in the middle of the tail-margin instead of in the usual top corner. The page has gained immensely in solidity and a look of completeness. It is difficult to see what more could have been done with the means at disposal.

By this time the craft of printing had thoroughly taken hold of Mr. Morris and aroused him to the mastery of its technique. Having got as far as even the Chiswick Press would carry him, there was nothing for it but to set to work upon his own account. "I thought it would be nice

to have a book or two one cared for printed in the way one would like to see them."

The first essential was a fount of type which should combine the beauty of the types used by the old printers with a certain regard for readability by modern eyes. And this Mr. Morris set himself to design. In weaving or woodcutting, both of which crafts he mastered long ago, there still survived at the time of his pupilage a certain amount of old tradition. It was possible to find men still at work in those crafts whose methods and training were those of a period antedating the reign of steam. But in the designing of type there was nothing of the kind.

"It's curious enough when you come to think of it," said Mr. Morris, "what happened with printing. It was born full grown and perfect, but began to deteriorate almost at once. For one thing, of course, it was invented just at the end of the mediæval period, when everything was already pretty far gone. And its history, as a whole, has practically coincided with the growth of the commercial system, the requirements of which have been fatal, so far as beauty is concerned, to anything which has come within its scope."

In default of a living tradition, there was nothing to be done but to go back to the fountain-head, or as near to it as might be, and start thence afresh. As the type was to be aimed at modern eyes, it must be "Roman." As it was to be clear and easy to read, as well as beautiful, it must be properly placed upon its "body," so as to show a definite proportion of white between each pair of letters. It must not be laterally compressed, and its thicks and thins must not show the contrast which in its extreme form has so much to do with the "sweltering hideousness" of the Bodoni letter, "the most illegible type that was ever cut." Upon all these points there are elaborate rules which are accepted by the ordinary type-designer. "But," said Mr. Morris, "they are merely mechanical rules, not the living traditions of a craft; and, what's more, they're all exasperatingly wrong, and prescribe exactly the reverse of what they ought to. They seem to have been made by mathematicians or engineers, certainly not by artists." The various requirements of a really good type received the fullest existing fulfilment in the "generous and logical designs of the fifteenth-century Venetian printers, at the head of whom stands Nicholas Jenson. Jenson carried the development of Roman about as far as it can go. I must say that I consider his Roman type to be the best and clearest ever struck, and a fitting starting-point for a possible new departure."

Upon the type used by Jenson, then, Mr. Morris set to work, and patiently analysed it until he "got the bones of it in his head," or, in other words, had mastered the principles upon which the old designer had worked. Not that other designers of the "great period," more especially Rossi, were by any means neglected. When these principles had been discovered and abstracted, they had to be modified into accordance with the special aims which Mr. Morris had set before him, and necessarily underwent a further modification in the process through the influence of his individual taste and habits of work. As fast as the letters were designed they were handed over to the punchcutter. As fast as the punches could be cut and the matrices made the types were cast. The fount was rapidly completed, and towards the end of 1890 actual work was begun.

Figure 4

At this time the entire staff of the Kelmscott Press consisted of one man and a very small boy, and it was housed in a tiny cottage. In violent contrast with the size of the establishment was that of the first book it embarked upon. No less an undertaking than the printing of *The Golden Legend* of William Caxton, ultimately published in September 1892 in three large quarto volumes, containing altogether about thirteen hundred pages. This was edited and seen through the press by Mr. F. S. Ellis. From the fact of its having been first used upon *The Golden Legend*, the Roman type has always since been known as "the Golden." This, by the way, once led a country bookseller into advertising one of the Kelmscott Press books as "printed from golden type." On another occasion the editor of an American trade magazine remarked that "for all he could see" the books might just as well have been printed from ordinary type-metal! For similar reasons the two black-letter founts designed later on by Mr. Morris have received the names of the "Troy" and the "Chaucer."

Although Mr. Morris had started the Press purely for his own pleasure, in order to see what he could do as a printer and in order to have a few copies of his favourite books printed after his own fashion, and had no idea to begin with that any demand would exist for such things, he speedily found that it would be impossible to maintain the Press as a private toy even had he desired to do so. The growing dissatisfaction with machine work, and the desire for that in the doing of which the hand of the craftsman has had free play – a dissatisfaction and a desire with the creation of which Mr. Morris himself has had as much as any living man to do – had gone far enough, even among book-buyers, to create a demand for his books as soon as he was known to be at work

upon them. Man after man was added to the staff until the little cottage could hold no more, when the Press was compelled to migrate into its present home. And still it waxes larger, and has again outgrown its shell. The offices, readers' and store rooms, and one press, are housed elsewhere.

Having got his type, there was the paper and the ink, to say nothing of the binding, to be thought of. I pass over the troubles Mr. Morris met with, only noting that they were very great, before he found a paper-maker who could make for him the paper he wanted, or an ink-maker who could come up to his requirements. The type he had, and the ornaments he could design, and for them an engraver was at hand in his friend Mr. W. H. Hooper; but for the ink and paper he had to go to others and get them to carry out his wishes. When it came to printing some copies of *The Glittering Plain* upon vellum, there was even more difficulty than over the paper. However, even that was managed without having to go to the length of storming the Vatican and robbing the Pope, "who buys up the better part of the best vellum going."

The Glittering Plain, a romance by Mr. Morris himself, was the second book put in hand, but the first published, being finished, as the colophon declares, on April 4, 1891. Two hundred copies only were printed on paper, and six on vellum. It was followed in September by Mr. Morris's *Poems by the Way*, of which three hundred paper and thirteen vellum were printed. In this book the shoulder-notes, refrains, etc., are printed in red, *The Glittering Plain* having been wholly in black. These books, as most of their successors have been, were fully subscribed and at a premium long before they were ready for delivery. "I am afraid," said Mr. Morris, "that the 'forestallers and regraters'[3] got most of the benefit; but although I don't like that, I don't see what's to be done to alter it as things are."

In May 1892 the Kelmscott Press had risen to the height of a printed list of its productions, in which, under the heading of "Books Already Printed," appear Mr. Wilfrid Blunt's *Love-Lyrics and Songs of Proteus*, Mr. Ruskin's *Nature of Gothic*, and Mr. Morris's own *Defence of Guenevere* and *Dream of John Ball*. Copies of this list itself are now eagerly sought for by collectors, and are the more prized for the fact that they differ from all subsequent issues in being printed on the inside pages only of the half-sheet, without half-title or anything else upon the outside.

A glance at the latest list shows that the tale of completed work

done by the Kelmscott Press runs up to thirty separate works, ranging between the giant *Golden Legend* and the tiny *Gothic Architecture*. Of the latter, by the way, there were nearly sixteen hundred copies sold, and even then there was a cry for more. Of the books already printed the greater number are hopelessly out of print. A few copies each of about a dozen of them are, however, still within the reach of the happy mortal whose gold-lined pockets allow him to covet them.

"And which of them all were you most interested in, Mr. Morris?"

"Whichever I had in hand at any given moment. You see, each of them has its own individuality, and one was interested in all of them from one point of view or another. There are what I will call for the moment the archæological books, the Caxtons: *The Golden Legend, The Recuyell, Godefrey of Boloyne*, and *Reynard the Foxe*. They have a common interest as coming from Caxton and as belonging to that curious period in the history of the English language when the old had hopelessly gone to pieces and the new had not yet formulated itself. And then, besides all that, as history or as storybook, they have all of them a particular value. The little *Psalmi Penitentiales* has not only an archæological but a very high literary value. Quite different interests attach, of course, to the modern books, such as Ruskin's *Nature of Gothic*, Swinburne's *Atalanta*, Tennyson's *Maud*, and Rossetti's *Ballads and Narrative Poems* and *Sonnets and Lyrical Poems*. In all these cases one was glad to have the opportunity of putting good work into a shape that seemed worthy of it. Then there are the illustrated books. *The Story of the Glittering Plain*, with woodcuts by Mr. Walter Crane, has already been published. *The Well at the World's End*, with woodcuts by Mr. A. J. Gaskin, is nearly ready.[4] And the biggest undertaking on which the Press has yet embarked – the folio Chaucer, which will contain nearly eighty woodcuts, designed by Sir Edward Burne-Jones. Indeed, you may say that I am deeply interested in everything I do. And for the sufficiently good reason that I don't do anything that doesn't interest me in one way or another."

The Chaucer, which is the most important work immediately in hand, and to which I have before alluded, will be certainly the most magnificent book ever produced on an English press. But I hesitate to say much about it, lest I should arouse desires which it is impossible to gratify, inasmuch as every copy is sold, six months before its possible completion. It is being edited by Mr. F. S. Ellis. Next in order of the larger works that are in preparation come *The Tragedies, Histories, and Comedies of William Shakespeare*, edited by Dr. F. J. Furnivall, and *The*

Cronycles of Syr John Froissart, reprinted from Pynson's edition of Lord Berners's translation and edited by Mr. Halliday Sparling. The Shakespeare will be in several small quarto volumes, and the Froissart in two folio volumes with armorial borders, designed by Mr. Morris, and including the devices of the more important personages who figure in its pages.[5]

Among the other books in preparation are selections from the poems of Coleridge and Herrick, the poems of Mr. Theodore Watts, the romance of *Syr Perceval* from the Thornton Manuscript, and a new prose romance, *Child Christopher*, from the pen of Mr. Morris himself. Mr. Morris is also preparing for publication an annotated catalogue of his own wonderful collection of woodcut-books, early printed books, and manuscripts, which is to be illustrated with over fifty facsimiles.

The Tenth Commandment was nowhere as I bowed myself out, after that long *tête-à-tête* amid books and books and books, especially after it had been interrupted by Mrs. Sparling (Miss May Morris), who came to show her father a lovely piece of embroidery of her design, intended for the adornment of his bed-chamber at Kelmscott.

THE KELMSCOTT PRESS: AN ILLUSTRATED INTERVIEW WITH MR. WILLIAM MORRIS ✿ PUBLISHED IN "BOOKSELLING" IN 1895

O obtain the privilege of an interview with Mr. Morris is no easy matter. His time is so fully taken up with his business and his private work that he has hardly an hour to give to what, more often than not, is but the inquisitive prying of the curious into the home life of an earnest worker. Our purpose was in no way prompted by this feeling. We were anxious to present to our readers an account of a printing-house of the nineteenth century, where the purity of spirit for the love of the work itself, which characterised the master printers of the fifteenth century, was yet preserved and even glorified by the genius of a modern craftsman, who knew intimately what that spirit aimed at. So that when Mr.

Cockerell, the Secretary, who has charge of the business part of the Kelmscott Printing House, informed us that Mr. Morris would be pleased to give us a Saturday afternoon, we felt that we must make the most of our opportunity.

Mr. Morris received us in a very hearty fashion, making us at once at home in his workroom, the windows of which look out upon "the king of rivers," with the Hammersmith Bridge spanning it. We lit up pipes, cigars, and cigarettes, and enjoyed the comfort of an old and well-worn arm-chair. To come into Kelmscott House from the hard, prosaic, and matter-of-fact broadway of the "'Ammersmith 'Igh," is to be transplanted from the busy turmoil of a modern suburb to the quiet and cloistered peace of a mediæval country-place. Hardly a sign of luxurious furnishing, except a magnificent collection of rare *incunabula* and finely illuminated manuscripts. And even these cannot be considered "furniture." In reality they form Mr. Morris's tools – the helps by which he is enabled to work the designs and carry out the traditions of the artists who made them, and of whom he is himself the modern living descendant.

"And now, Mr. Morris, will you kindly tell us why you started the Kelmscott Press?"

"Oh! simply because I felt that for the books one loved and cared for there might be attempted a presentation, both as to print and paper, which should be worthy of one's feelings. That is all. The ideas we cherish are worth preserving, and I fail to see why a beautiful form should not be given to them, as well as an ugly one. It is just as easy to give the one as the other – only we have had the ugly and not the beautiful. My wish was to show that a book could be printed in beautiful type, on beautiful paper, and bound in beautiful binding, just as easily as we more frequently do the opposite to this."

"Then you think every book ought to be so produced?"

"Why not? Why should not every book be 'a thing of beauty'? It might as well be that as not – and it is just as simple."

"Would you print, say, *The Pickwick Papers* in your Golden type?"

"Certainly. As a matter of fact, I am particularly fond of Dickens, and especially *Pickwick*, and I have always felt that there has not yet been published an edition of Dickens's works in any way worthy of him. I should just be delighted to print him at my press."

"What, on hand-made paper?"

"Certainly. Why not on hand-made paper as well as on machine-made?"

"Well, for no particular reason, only it might look so incongruous."

"I fail to see the incongruity. That arises simply from preconceived notions of the right thing, established by a vicious custom. My purpose is, if possible, to change the viciousness of the custom, and make it the rule that it is better to have a pleasing handiwork rather than a displeasing one, or, at any rate, rather than an ugly one. In an age where ugliness is conventional, it is difficult, I know, to appreciate the opposite. The amount of trouble which modern workers take to make the outcome of their effort inartistic is something appalling. The same amount of energy, rightly directed, would long ago have brought about a more life-giving art and a truer spirit of craftsmanship."

"From what sources have you drawn for designing your various types?"

"From manuscripts and the early printers. Look at this volume," and Mr. Morris walked towards a book-case by the west wall of the room, and took down a fine old folio printed by Jenson. "If you will examine carefully the formation of the letters in this book and compare them with what I have called my 'Golden type,' you will see that it is on Jenson that I have drawn for inspiration. The early printers were wonderful fellows for seizing the main ideas, and they gradually worked out, taking the script letters for their basis, sets of types in Gothic and Roman forms, which we have hardly equalled today. Of course we have improved on the Roman letters, and the best work of the Caslons can hardly be excelled.[1] But what I want to point out is that the beauty of the form is with such printers as Jenson, Pannartz, Koberger, and others, almost perfectly realised. My own types hardly differ from theirs in essentials. They are not the same, of course; but they are not altogether original. It would be impossible to obtain absolute originality where the sphere of action, so to speak, of the designer is so very limited."

"Have you heard of the firm in America which calls itself The Jenson Press?"

"Oh, yes, and I have seen some of its work. As a matter of fact, it is not Jenson at all. The same type almost exactly was used by Caslon, and later by the Chiswick Press. On the paper on which the Americans usually print, with its highly glazed surface, the so-called Jenson type looks absurd."[2]

"What do you think of the Edinburgh Constables' departure lately?"

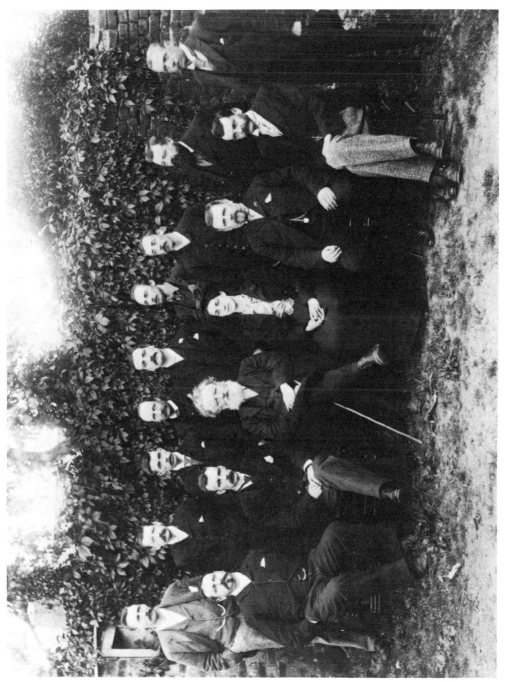

32 Morris, Walker, and the staff of the Kelmscott Press. Front row (*from left*): S. Mowlem, W. H. Bowden, William Morris, May Morris, W. Collins, L. Tasker. Back row (*from left*): H. Howes, Carpenter, F. Collins, Emery Walker, R. Eatley, H. H. Sparling, J. Tippet, T. Binning, G. Heath. According to Cockerell's diary, the photograph was taken at the annual printers' Wayzgoose at Taplow, Bucks, on September 13, 1895; Cockerell himself does not appear in the picture because he was busy elsewhere that day. *Courtesy of the British Library.*

"I don't think much of it. The Constables are good printers, but those square capitals with the thick faces, which they use in the headlines of their books, are simply hideous. I quite agree with you in calling the type which they frequently use now, a bastard Caslon.[3] In my opinion the best printers in Scotland are the Clarks. They have done some really beautiful work and have done it cheaply."

"What guides you in the ornamentation of your pages?"

"The subject, of course. In my *Froissart*, for instance, on which I am now very busy, I have made special designs, floriated ones, but having the coats of arms of all the nobles mentioned in the History. You will see from this specimen page what I mean."

"Speaking of ornamentation of the pages of books, what is your opinion of the young school of Birmingham artists?"

"Well, I think they have, in Gaskin and New, two very good men, who have ideas and originality. For the most part, however, they follow too slavishly the opposition to conventionality."

"We ask the question because it seemed to us that their ornamentation was used without the least attention to the contents of the book. Take, for instance, their book of *Nursery Rhymes* which Mr. Baring-Gould edited, and Messrs. Methuen published. Here you have the preface and some pages of notes, both of the most matter-of-fact substance, embellished with borders after a fifteenth-century style. It seems stupid."

"Well, there's certainly something to object to in that, but you must remember that the Birmingham people have not yet found their feet. They will do good work yet, I am sure. In my *Froissart*, and in my *Chaucer*, I have gone to great trouble to make the ornamental borders of the pages in perfect harmony with the subject, and you will find that the same designs, if repeated, are reintroduced because of their suitability."

"When did you start your press?"

Figure 2
"In April 1891, but I had made many experiments previous to that date. I was urged to the undertaking by my friend Mr. Emery Walker, to whose help and experience and knowledge I owe a great deal. I may tell you candidly, I was not much of a typographer before Mr. Walker took me in hand, but I have learned a little, and I hope to learn more. At any rate I have tried to put into my work the best craft I possess."

"May we see some of the advanced sheets of your Chaucer? The book has been so much talked of that we are curious for a sight of it."

"With pleasure. In this portfolio I have a set of all the sheets that, so

far, have been printed off, and I can tell you the work is a bigger one than I ever bargained it would be. The fifty or sixty illustrations which Burne-Jones drew originally have grown into eighty, and new borders and head- and tail-pieces have also had to be made. You have, no doubt, heard a great deal of the enormous profit I must be making on these books, because of the high prices I ask for them. I can assure you that, if the people who go about talking of my profits were to see my balance sheet, they would speak quite differently. In this *Chaucer*, in particular, the cost will hardly be covered by the subscriptions, although every copy has been sold. To give you an idea of how easy it is for me to make a loss, I may mention as a case in point my *Beowulf*. It was announced in the prospectus that it would be published at two guineas but in the printing of the book several sheets got spoiled and had to be reprinted. The mere cost of reprinting these sheets and the expense of the extra paper converted my profit into a loss – and the book is sold at less than what it cost me to produce it."

"We suppose you like the work?"

"Oh! it's jolly fun. I like it immensely. There is so much pleasure in seeing a beautiful form given to your favourite writers and knowing that you have worked of your own self to obtain that form."

"That must be the joy of the artist in seeing the objective realisation of his fantasies."

"If you like to put it that way – yes."

"Speaking of your *Froissart*, from what text are you printing, and in what form do you intend to issue it?"

"You cannot have a better text than old Berners's. It's fine old English and would take a lot of beating. The edition of the text I am using is the two volumes quarto published by Rivington and others in 1812. My reprint is a full folio and will take up two volumes. I also intend to publish it in four parts. Those who may like a strong binding will be able to get one from me for both the Chaucer as well as the *Froissart*. It will be in white pigskin – a beautiful material for wearing and showing designs – and the designs will be by Cobden-Sanderson."

"Who makes your paper?"

"Batchelor, from moulds which I provided. Both he and my binders have worked under my directions, and I have been able to obtain from them material and work which I do not think I can better elsewhere. The paper is really of beautiful quality, and the binding is strong."

"Now as to the future, Mr. Morris – what books would you like to

print, and what are you going to print? We want some information about these which has not gone the round of the papers."

Mr. Morris smiled broadly. He was sitting in his arm-chair smoking his pipe, his fine head lit up by the blaze from the fire. The night had come on while we had been chatting, and the room was filled with the twilight of the fine November evening. Mr. Morris tucked up his trousers, and laying the open palms of his hands upon his knees, began –

"The books that I would like to print are the books I love to read and keep. I should be delighted to do the old English ballads – and I will some day. But no book that I could do would give me half the pleasure I am getting from the *Froissart*. I am simply revelling in it. It's such a noble and glorious work, and every page as it leaves the press delights me more than I can say. I am taking great pains with it, and doing all I can to realise what I have long wished. I am printing it in my Chaucer type. The edition of *Chaucer* is also a pleasure to me, and Burne-Jones is as much interested in it as I am. Just now I am anxious to put in hand my *Earthly Paradise*. I think it will make a splendid set of volumes, don't you? I am rather exercised as to its *format*, but Cockerell is in favour of this new size – a sort of mild quarto, and yet looking like an octavo. What do you think of it?" We agreed with Mr. Cockerell, and thought the size perfectly unique, and one which would show off to excellent advantage the beautiful borders and ornaments on which Mr. Morris was already hard at work. "I will issue this in eight volumes, and as cheaply as I can. There will be only 350 copies printed on paper, and six on vellum. I do hope it will meet with the approval of those friends who have supported me hitherto. I can assure you that it requires no little manœuvring to make my ventures pay, and yet people think I make large profits, because the prices charged

Figures 10, 12

are comparatively high. Then, again, there is the Catalogue of my Collection of Woodcut-Books, Early Printed Books, and Manuscripts.[4] This will be largely illustrated with facsimiles of the plates and pages of the books themselves. Of course, this is just a little fancy for my own pleasure, and yet I have an idea that there ought to be many book-lovers and art-lovers who would find much in the volume to delight them. Here are some of the specimen-pages and blocks. You see that I am sparing no trouble to give the finest reproductions." We agreed with Mr. Morris that the book would be a valuable help to many a bibliophile and searcher for art treasures. Mr. Morris has, perhaps, one of the finest private collections of good specimens of typog-

raphy and early woodcuts that may be found in the British islands. And they are all preserved intact in the books themselves, which it has been his pride and pleasure to gather together during his lifetime.

"Now, a book which I am making ready for printing, and in which I shall put all I know, is my *Sigurd*. I don't want to say much about it now, but of all my books, I want to have this one more especially embodied in the most beautiful form I can give it. Burne-Jones will illustrate it, and it will be printed in the Troy type, on a folio sheet. I am even looking forward myself to seeing it finished."

"When do you expect to issue Mr. Theodore Watts's Poems?"[5]

"Well," with a smile, "as soon after I get the manuscript as possible. I shall be delighted to work on it."

"How have you found your smaller books go?"

"Excellently well. And I am not surprised. When you come to look at it, and see that you get a book like this" – and Mr. Morris caressed gently the pages of *Child Christopher* – "for seven and sixpence a volume, it would be impossible to refuse buying it. I love my books, and I love making them, and I think these little octavos quite the most charming things issued from my press."

"They are all out of print, are they not?"

"Oh! yes. Quite; but I have on the way a new one – a *Sire Degrevaunt*, one of the ancient English metrical romances. It will be uniform with the *Syr Perecyvelle*, and will be published at 15s. It will have a woodcut designed by Burne-Jones."

"What is that noble-looking volume?" we asked, pointing to a splendid quarto bound in the Kelmscott vellum.

"That is my edition of *Jason*. It is printed in the Troy type, and has two woodcuts by Burne-Jones. There have been only 200 copies printed, but the price must have been high (I published it at five guineas) because it is one of the very few of my books of which I have some copies left. Still, the price had to be high, on account of the small number printed."

Mr. Morris allowed us to examine the volume, the pages of which glistened again with the beautiful black type on the choice white paper. We have seen many of Mr. Morris's Kelmscott Press editions, but none to our mind that excelled this for nobility of appearance and beauty of effect. It was almost the first book Mr. Morris wrote, and he has given it now a presentation in book form which shows his own love for his early work.

Time went by without our noticing it. From typography, we wan-

dered on to books themselves – from books we went to illustrations, and from illustrations to art, and from art to our personal likings and dislikings. We chatted round the fire in clouds of smoke, before tea, and we resumed the smoke and the talk after tea. The house was ours for the time we spent in it, and we were made to feel that it was so. It was delightful to listen to the jolly gentleman as he sat discoursing of "all he felt and all he saw," and while we listened in delighted silence, except for a word now and then to show him that we were appreciating the favour he was extending to us, we could not help reflecting over the life and the history of this remarkable man – a man whose character is as manysided as his genius is pure, and yet charged with a simplicity as engaging as a child's, and as clear as a limpid brook in summer.

His capacities are so many and so different in themselves, and so important has been the outcome of each, that a just review and estimate of this product would be tantamount to an historical survey of the best artistic and literary influences of the latter half of the nineteenth century. In England and for Englishmen he is poet, designer, socialist, humanitarian, typographer, and artist all in one. The French tapestry weavers and the English lithographers know of Mr. Morris as a designer of the highest order. His tapestries and wallpapers are among the finest of industrial products. In Germany he is known as the "idle singer of an empty day," and for his eloquent words and ringing songs for the good time that is to come. In America he is also loved and honoured. Everywhere he is beginning to be appreciated, if not so much for what he has done, then, certainly for the purity of motive and earnestness of labour by which and with which they were accomplished.

He was born at Walthamstow, in Essex, in 1834. His early education was at Marlborough College; from Marlborough he went up to Oxford, and became a student at Exeter College. It was in 1857, when Morris had reached his twenty-third year, that his first great public work was entered on. It was nothing less than the execution of several mural paintings on the walls of the Oxford Union Debating Hall. In this undertaking he had for his associates Holman Hunt,[6] D. G. Rossetti, and Burne-Jones. The paintings were to be of heroic size, and to represent scenes from the Arthurian legends. Morris also came slightly under the influence of the Tractarian Movement, for what this movement was to the religious mind of that day, the Pre-Raphaelite Brotherhood was to the artistic feeling of the same time. Oxford it

was which gave birth and nurture to both movements, and when Morris left Oxford he became a pupil of Street, the famous architect. For ten years he studied and worked at his art labours, until in 1867 was established the mercantile house of Morris, Marshall, Faulkner and Co.[7] In the firm were also Madox-Brown and Rossetti, although their names did not appear. The business was founded for the purpose of introducing into domestic art and architecture something of beauty and simplicity. The ugly and, therefore, the malevolent were to be warred against, and although the Company of seven dissolved in 1874, the firm is still carried on, and the purpose of its original founders has been realised in far greater measure than even they in their wildest enthusiasm had hoped.

But it is not so much with Mr. Morris as a worker in the fine arts that we wish here especially to deal – our purpose is to place before our readers Mr. Morris the craftsman, worker in types and maker of books. In 1888 he already began to show a keen interest in this branch of human labour, for he identified himself eagerly with the first exhibition of the Arts and Crafts Society held in that year. At this exhibition much discussion as to the possibilities of typographical art took place, and Mr. Morris put his views into practical illustration by having printed at the Chiswick Press, and under his own supervision, his delightful romance *The House of the Wolfings*: this was followed in 1890 by *The Roots of the Mountains*. The type used in each case is altogether different to any type employed up to that date by any of either English or American printers. Since then, however, it has been slavishly imitated by other houses.

Mr. Morris now felt that he must go the whole hog or none. The resources of the Chiswick Press were evidently not sufficient to cope with his ideas. He determined, therefore, to raise a press of his own, fashion his own type, and show the world what a beautiful book ought to be like. And who shall say that he has failed? The success, so worthily achieved and so unselfishly kept in the background, has emboldened Mr. Morris to attempt the realisation of even finer work than he has already done, and so he is about to set himself the task of designing a new fount of long primer to harmonise with his "Golden type."[8] From the bibliography of the Kelmscott Press which we append to this present rambling account [*not reprinted here*], our readers may see for themselves that the four years of Mr. Morris's "press" work have not been spent in vain, and if to these we add those "in preparation," we cannot but wonder at the enthusiasm which could inspire so much in-

dustry, and the devotion of heart which supplied the impulse to carry it to so successful issues.

Among the many interesting and amusing facts which Mr. Morris interspersed in his conversation, there was one of peculiar interest. Mr. Morris had purchased a remarkably fine Book of Hours – a manuscript of the thirteenth century. It was shown to us in all the gorgeousness of its exquisite penmanship and painted initials shining with burnished gold. "My purchase," he remarked with a smile, "was not perfect – it wanted two leaves; but I was perfectly satisfied with it. Some time after I had acquired it, a friend who knew of my manuscript, and who also knew that it wanted two leaves, told me that he had seen framed and hung up in the Fitzwilliam Museum, at Cambridge, the very leaves that were originally in my book. I hastened down to Cambridge, and sure enough, my friend was right. I there and then offered to buy them, but the authorities had no power to sell. Instead of selling me their property, they offered to buy mine, and to this I consented, on condition that I was allowed to keep the perfect work so long as I lived. And it is now in my possession for me to use, but to be given up to the Fitzwilliam Museum at my death. Of course I am responsible for its loss, but it was a pleasure to me to be able to bring together the separated parts. The old boys who worked at these illuminated books must have been wonderful fellows. It seems now as if they could not do anything wrong. Every detail is so perfect, and in such absolute taste."

"Well, you see, Mr. Morris, they had plenty of time in those days."

"Yes, but that is not the whole secret. We have all the time there is, but we don't seem to be able to come in any way near them. No! it's not time that is the element here. That is a secret we have not yet discovered. When we shall have found that out, we shall understand our own lives better, I am sure."

"What are those red morocco books over the mantelshelf, Mr. Morris?"

"Ha! ha! those are my manuscripts.[9] I have taken Mr. Quaritch's advice and have kept them and had them bound. I used to give them away, but Q. said that I ought to keep them, and I suppose he knows."

"They must be worth something?"

"Oh! I don't know about that. Nobody but myself is interested in them; but now that I have them in that form, they seem to interest me more."

We asked and received permission to handle them. They consisted

116

of beautifully bound folio volumes (Mr. Morris always writes on a full folio sheet) of *The Story of the Glittering Plain*, *Love Is Enough*, *The Well at the World's End*, the translations of *Virgil* and the *Odyssey*, and the *Child Christopher*.

"Well," we remarked after we had placed them back on the shelf, "we should advise you to continue taking Mr. Quaritch's advice. Speaking for ourselves, we had rather have these six books than any six others in the room."

Mr. Morris smiled, "I think I'll do as you advise also."

The bell of the Hammersmith church clock tolled the quarter after seven, and we felt that we really must make preparations to go. We had arrived at three in the afternoon, and if we didn't move now, it would mean a lodging for the night. We thanked Mr. Morris for his hearty reception and genial hospitality, and we left with a kind invitation to come and see him again.

Out in the open lay the peacefully rolling river, with the reflected starlights on its waters. The quiet of the night had taken hold of everything, and as we walked along the Mall the sweetness and the strength of the man who had just bidden us "Good-night" seemed to gather power, and we felt that it had been indeed a privilege that we had enjoyed. The life of the struggling, toiling, grubbing, and rushing kind was not the life of this man. His was the calm and steady persistence of effort actuated by a pure impulse – an impulse which loves to labour for the labour's sake, and, on that account, knows how necessary it is that often the labourer must stay in his work, and wait – to reflect, to enjoy, to gather strength again, so that the work may receive the truest devotion of the artist's soul.

Mr. Morris is eminently a working man – and because he is that, he is also a thinking man. To the work that is rushed and tortured in haste into a so-called completion – to that work, thought is not wanted. It is reeled off as mechanically as one unwinds the cotton-thread from its bobbin. The work that is to be its creator's delight, must demand all the resources of one's being – hands, heart, and head. Only in such wise is labour worthy, and only after such fasion may the craftsman become an artist also. *Soll das Werk den Meister loben.* Surely the spirit which gives meaning to Schiller's words, must be the same spirit which Mr. Morris feels, and feeling it, reveals his worth and finds his joy in being ever faithful to its wisdom.

NOTES

The following abbreviations are used in the notes:

AWS — May Morris (editor), *William Morris: Artist, Writer, Socialist*, 2 volumes (Oxford, 1936).

Cockerell's diary — The diaries of Sir Sydney C. Cockerell, 1886–98 (British Library Add. MSS. 52623–35).

K.P. — Kelmscott Press.

Mackail — J. W. Mackail, *The Life of William Morris* (World's Classics, 1950).

Morgan *Catalogue* — *Catalogue of Manuscripts and Early Printed Books from the Libraries of William Morris . . . and other Sources, Now Forming a Portion of the Library of J. Pierpont Morgan*, 4 volumes (privately printed, 1906–07).

WMAB — Paul Needham, Joseph Dunlap, and John Dreyfus, *William Morris and the Art of the Book* (New York, 1976).

The place of publication for books cited in the notes is London unless otherwise indicated.

The library of the British Museum is, of course, now the British Library, but I have not seen fit to change Morris's references, and both names therefore appear in the notes.

Most of the persons mentioned in this volume are identified briefly in the index.

Introduction

1. Mackail, I, 124–25.

2. Cockerell's diary, November 7, 1892.

3. Nikolaus Pevsner, *Pioneers of Modern Design: From William Morris to Walter Gropius*, revised edition (Harmondsworth, Middlesex, 1974).

4. G[eorgiana] B[urne]-J[ones], *Memorials of Edward Burne-Jones* (New York, 1902), I, 161.

5. Letters, Morris to Gere, November 7 and 9, 1893 (Huntington Library).

6. Cockerell's Introduction to Mackail, I, vi.

7. *Printing Times and Lithographer*, NS 3 (September 15, 1877), 188.

8. Morison, *John Fell: The University Press and the 'Fell' Types* (Oxford, 1967), p. 203.

9. See Philip Unwin, *The Printing Unwins: A Short History* [of the] *Unwin Brothers, the Gresham Press, 1826–1976* (1976); "Our Portrait Gallery: Andrew White Tuer," *British Printer*, 6 (July–August 1893), 225–26; A. F. Johnson, "Old-Face Types in the Victorian Age," in his *Selected Essays on Books and Printing*, edited by Percy H. Muir (Amsterdam, 1970), pp. 423–35.

10. Vivian Ridler, "Artistic Printing: A Search for Principles," *Alphabet and Image*, No. 6 (January 1948), p. 9.

11. Ridler, p. 9.

12. WMAB, p. 139.

13. See Joseph R. Dunlap, *The Book That Never Was* (New York, 1971), and A. R. Dufty's Introduction to Morris's *The Story of Cupid and Psyche* (1974). The best general description of Morris's pre-Kelmscott attempts at bookmaking is Joseph R. Dunlap, "Morris and the Book Arts before the Kelmscott Press," *Victorian Poetry*, 13 (1975), 141–57.

14. On Walker's career, see the accounts by Sydney Cockerell in the *Dictionary of National Biography* and in *The Times*, July 24, 1933, p. 7; Colin Franklin, *Emery Walker: Some Light on His Theories of Printing, and on His Relations with William Morris and Cobden-Sanderson* (Cambridge, 1973); Bernard H. Newdigate, "Contemporary Printers, II. Emery Walker," *Fleuron*, No. 4 (1925), pp. 63–69; Noel Rooke, "Sir Emery Walker 1851–1933," *Penrose Annual*, 48 (1954), 40–43; John Dreyfus (editor), *Typographical Partnership: Ten Letters between Bruce Rogers and Emery Walker, 1907–31* (Cambridge, 1971).

15. [Wilde], "Printing and Printers. Lectures at the Arts and Crafts," *Pall Mall Gazette*, November 16, 1888, p. 5. For May Morris's recollections of the occasion, see her *Introductions to the Collected Works of William Morris* (New York, 1973), II, 415. Walker's notes for the lecture – part of a substantial collection of his papers – are at

Notes the Humanities Research Center, University of Texas.

16. Franklin, *Emery Walker*, p. 28.

17. Viola Meynell (editor), *Friends of a Lifetime: Letters to Sydney Carlyle Cockerell* (1940), p. 231.

18. The following are mainly reports of his lectures: "The Art of Printing. Illustrations in Relation to Types. A Lecture . . . at the City of London College," *British and Colonial Printer*, 25 (February 6, 1890), 102, 110; "Typography. A Lecture," *British and Colonial Printer*, 37 (January 2, 1896), 10–11; "Letterpress Printing as a Fine Art," *British and Colonial Printer*, 42 (March 31, 1898), 205–06; "Letterpress Printing as an Art," *British and Colonial Printer*, 74 (January 22, 1914), 6; "Report by Emery Walker, British Juror in Class 11: Typography; Various Printing Processes," in *Report of His Majesty's Commissioners for the Paris International Exhibition* (Paris, 1901), 11, 26–30; "Address by Emery Walker, Esq., F.S.A., on 'Printing,'" *London County Council Conference of Teachers: Report of Proceedings* (1907), pp. 43–44; "Printing Fine Editions: Some Governing Principles" and "Ornamentation of Books," in *Printing in the Twentieth Century: A Survey* (1930), pp. 67–73.

19. Cockerell's obituary of Walker in *The Times*, July 24, 1933, p. 7; Cockerell's diary, December 10, 1889; Colin Franklin, *Emery Walker*, p. 30.

20. "Fine Book-Work," *Printers' Register*, November 6, 1882, p. 82.

21. G.D., "Types and Characters. V. – Ornamentals," *Printers' Register*, April 6, 1885, p. 192.

22. Stevens, *Who Spoils Our New English Books?* (1884). See also Joseph R. Dunlap, "Two Victorian Voices Advocating Good Book Design. I. Henry Stevens and the Shoddimites," *Printing History*, I, No. I (1979), 18–25.

23. *Journal of the Society of Arts*, 38 (April 18, 1890), 527–38.

24. H. J. L. Massé, *The Art-Workers' Guild 1884–1934* (Oxford, 1935), p. 102.

25. Cockerell's diary, December 2, 1892.

26. *Stanley Morison and D. B. Updike: Selected Correspondence*, edited by David McKitterick (New York, 1979), p. 65.

27. Meynell's review of *An Essay on Typography* (1936) by Gill, in *Signature*, No. 5 (March 1937), p. 51.

28. Needham, "William Morris: Book Collector," in WMAB, pp. 21–22. Needham's essay (pp. 21–47) is the best analysis of Morris's library.

29. Mackail, 11, 239–40. See also John Dreyfus, "New Light on the Design of Types for the Kelmscott and Doves Presses," *Library*, 5th Series, 29 (March 1974), 36–41.

30. *Pi: A Hodge-Podge of the Letters and Addresses Written During the Last Sixty Years by Bruce Rogers* (Cleveland, 1953), p. 12.

31. Mackail, 11, 268.

32. Cockerell's diary, November 5, 1892.

33. The contract is preserved in the British Library (shelfmark C.102.h.18).

34. This statement is based on the testimony of George Wardle (British Library Add. MS. 45350, fol. 4).

35. Mackail, 11, 270.

36. Mackail, 11, 265; Sydney Ward, "William Morris and His Papermaker, Joseph Batchelor," *Philobiblon*, 7 (1934), 177–80.

37. *The Journals of Thomas James Cobden-Sanderson* (New York, 1926), I, 211–12, 311.

38. Both versions are reproduced in WMAB, Pl. LXXX.

39. Mackail, 11, 226.

40. For two twentieth-century essays on the subject of book margins which occasionally dissent from Morris's views, see Alfred W. Pollard, "Margins," *Dolphin*, No. I (1933), pp. 67–80; F. W. Ratcliffe, "Margins in the Manuscript and Printed Book," *Penrose Annual*, 59 (1966), 217–34.

41. H. Halliday Sparling, *The Kelmscott Press and William Morris, Master-Craftsman* (1924), p. 84.

42. H. Buxton Forman, *The Books of William Morris Described* (1897), p. 140.

43. Morison, *First Principles of Typography*, revised edition (Cambridge, 1967), p. 5.

44. Charles F. Richardson, "Kelmscott

Press Work and Other Recent Printing," *Bookman* (New York), 4 (November 1896), 217. For a detailed study of Morris's impact in America, see Susan O. Thompson, *American Book Design and William Morris* (New York, 1977).

45. Letters, F. S. Ellis to Cockerell, June 8 and 11, 1899 (British Library Add. MS. 52715, fols. 26–28).

46. Martin Harrison and Bill Waters, *Burne-Jones* (1973), p. 138.

47. Letter, Morris to Walker, [October 30, 1894], with an accompanying note by Walker (Humanities Research Center, University of Texas).

48. Morison, "The Art of Printing," in his *The Typographic Arts* (Cambridge, Mass., 1950), pp. 96–97.

Some Thoughts on the Ornamented Manuscripts of the Middle Ages

Undated and incomplete essay, probably written in 1892 or thereafter; transcribed from the manuscript in the Huntington Library. Privately printed in 1934 by the Press of the Woolly Whale, New York, with a brief introductory note by Melbert B. Cary, Jr.

1. The General Prologue to Chaucer's *Canterbury Tales*, l. 294.

2. Horace Walpole (1717–97), man of letters, was chiefly responsible for the eighteenth-century revival of interest in Gothic architecture.

3. This may have been the Bestiary owned by Morris (now in the Morgan Library) and described in the Morgan *Catalogue*, IV, 165–67.

4. Perhaps the French treatise owned by Morris (now in the Morgan Library) which is described in the Morgan *Catalogue*, IV, 167–69.

5. The Tenison Psalter is British Library Add. MS. 24686; Queen Mary's Psalter, also in the British Library, is Royal 2. B. vii.

Some Notes on the Illuminated Books of the Middle Ages

Published in the *Magazine of Art*, 17 (January 1894), 83–88.

1. "Example: 'The Book of Kells,' Trinity College, Dublin, etc." [Morris's note.]

2. "Examples: Durham Gospels, British Museum [Cotton MS. Nero D IV], Gospels at Boulogne, etc." [Morris's note.]

3. "Example: Charter of foundation of Newminster at Winchester, British Museum [Vespasian A. viii]." [Morris's note.]

4. The Arundel Psalter is British Library Arundel MS. 60.

5. "In France 'Bibles Historiaux,' *i.e.*, partial translations of the Bible, very copiously pictured, were one of the most noteworthy productions of the latter half of the century. The Bible taken in the tent of the French King at the battle of Poitiers, now in the British Museum, is a fine example." [Morris's note.]

6. "Though we have in the British Museum some magnificent examples of English illumination of the end of the fourteenth and beginning of the fifteenth centuries, *e.g.*, 'The Salisbury Book'; a huge Bible (Harl. i, e. ix.) ornamented in a style very peculiarly English. The Wyclifite translation of the Bible at the Museum [Egerton 617–18] is a good specimen of this style." [Morris's note.]

7. "'The Hours of the Duke of Berry' (Bibliothèque Nationale, Paris), and the 'Bedford Hours,' in the British Museum [Add. MS. 18850], both French, are exceedingly splendid examples of this period." [Morris's note.]

The Early Illustration of Printed Books

A lecture delivered on December 14, 1895, at the London County Council School of Arts and Crafts in Bolt Court, Fleet Street, London. (Other lectures in the series included Cobden-Sanderson on "Bookbinding" and Emery Walker on "Typography.") Summary published in the *British and Colonial Printer and Stationer*, 37 (January 9, 1896), 10–11. Cockerell, who was present,

recorded in his diary about the lecture: "Very successful & bright. Room packed. Slides went without a hitch."

The Woodcuts of Gothic Books

A paper delivered to the Society of Arts, January 26, 1892. Published in the *Journal of the Society of Arts*, 40 (February 12, 1892), 247–60; reprinted in AWS, I, 318–38, and elsewhere. On the evening of the lecture Cockerell noted in his diary that he had seen the lantern-slides already at the Art-Workers' Guild on November 28, 1890. On that earlier occasion Cockerell's diary records that Morris delivered an "exceedingly spirited lecture . . . on Gothic illustrations to printed books with 37 beautiful lantern slides" and that he was "full of brilliant aphorisms and sly sallies, and very enthusiastically received." Presumably the substance of the lecture was the same as that of 1892, since identical illustrations were used.

1. This woodcut is reproduced in *Fifteenth Century Woodcuts and Metalcuts from the National Gallery of Art* (Washington, D.C., [1965]), No. 124.

2. In Morris's copy (now in the Morgan Library) of *Fabulæ et vita Æsopi* (Antwerp: G. Leeu, 1486) is the following note in his hand: "The cuts in this Aesop are copied from the earlier woodcuts of the Ulm and Augsburg editions, but they are not literal reproductions of them. They cannot be said to be as well cut as their originals, or to have the same spirit and ease of drawing. At the same time they show a greater feeling for decorative effect than the German cuts. It may be noted, for instance, that in most cases the Flemish designer has substituted clean-drawn bunches of ornamental leafage for the mere fuzzy heads of trees in the earlier designs: he also shows his appreciation of the value of black as a colour by taking advantage of the shoes, belts, and other details of raiment, and the backgrounds of caverns and the like to introduce black points and masses. Altogether these cuts are a very successful and ornamental series; and in conjunction with Leeu's delicate and beautiful black-letter, and his telling and finely designed woodcut capitals (not to mention the neat and pretty painted letters of this copy) make a very beautiful book."

3. Fred Walker (1840–75) achieved sudden fame through his illustrations for Thackeray's *Philip* in the *Cornhill Magazine* (January 1861–August 1862). Some of his work was engraved by W. H. Hooper, later the chief wood-engraver for the Kelmscott Press.

4. Walter Crane (1845–1915), a friend of Morris, designed the woodcut illustrations for the Kelmscott Press edition of *The Story of the Glittering Plain* (1894). For Crane's comments on the ornaments of the Kelmscott books, see his "Note on the Work and Life of William Morris," *Magazine of Art*, 20 (December 1896), 91.

5. Burne-Jones expressed a similar view in a letter to his sister-in-law in 1862: "As to scribbly work, it enrages one beyond endurance. Nearly all book and periodical illustration is full of it – drawings, you know the kind, that have wild work in all the corners, stupid, senseless rot that takes an artist half a minute to sketch and an engraver half a week to engrave, for scribble is fearful labour to render. My dear, look at most things in *Once a Week* – the wasted time of poor engravers in rendering all that scrawl, if rightly used, might fill England with beautiful work." (G[eorgiana] B[urne]-J[ones], *Memorials of Edward Burne-Jones* [New York, 1902], I, 354–55.)

On the Artistic Qualities of the Woodcut Books of Ulm and Augsburg in the Fifteenth Century

Published in *Bibliographica*, I (1895), 437–55; partially reprinted in *Some German Woodcuts of the Fifteenth Century*, edited by Cockerell (K.P., 1897). The manuscript, in Morris's hand but with some revisions by Cockerell (especially of the spelling of printers' names), is now owned by the Huntington Library. Entries in Cockerell's diaries indicate that he and Morris visited the British Museum together to do research for the article on October 8, 1894, that the writing of it was then done between October 23 and

HF old man answer- ed not a word, and he seemed to be asleep, and Hallblithe deem- ed that his cheeks were ruddier and his skin less wasted and wrin- kled than aforetime. Then spake one of these women: Fear not, young man; he is well and will soon be better. Her voice was as sweet as a spring bird in the morning; she was white-skinned and dark-haired, and full sweetly fashioned; and she laughed on Hallblithe, but not mockingly; and her fellows also laughed as though it were strange for him to be there. Then they did on there shoon again, and with the carle laid their hands to the bed whereon the old man lay, and lifted him up, and bore him forth on to the grass, turning their faces towards the flowery wood aforesaid; and they went a little way and then laid him down again and rested; and so on little by little, till they had brought him to the edge of the wood, and still he seemed to be a- sleep.

HFT the damsel who had spo- ken before, she with the dark hair, said to Hallblithe: " Al- though we have gazed on thee as if in wonder, this it not be- cause we did not look to meet

Variant of first page printed at the Kelmscott Press see p. 12.

33 Cockerell's note reads: "Variant of first page printed at the Kelmscott Press." Both initials fail to align properly, and em quads are used after periods and colons. *Courtesy of the Pierpont Morgan Library.*

November 5, and that a draft of it was submitted on the latter date to A. W. Pollard (1859–1944), afterwards Keeper of the Printed Books in the British Museum.

1. Morris's copy of Günther Zainer's *Legenda aurea* (now in the Morgan Library) contains the following note in his hand: "The cuts in this book are done by an early artist of Zainer's, and have the look of being designed by an illuminator; they look like the work in Sorg's *Speculum*; many of them are very pretty, and they are decidedly ornamental in character, though lacking the freedom of the artist of the *Spiegel des menschlichen Lebens*. The type, though we have called it semi-Gothic, might rather be looked on as a slight alteration towards Gothic of Zainer's first Roman type."

2. Actually published by Johann Zainer in Ulm, *c.* 1476–77.

3. "By the by, in Gritsch's *Quadragesimale*, 1475, this zany is changed into an ordinary citizen by means of an ingenious piecing of the block." [Morris's note.]

4. "Another set of initials founded on twelfth-century work occurs in John Zainer's folio books, and has some likeness to those used by Hohenwang of Augsburg in the *Golden Bibel* and elsewhere, and perhaps was suggested by these, as they are not very early (*c.* 1475), but they differ from Hohenwang's in being generally more or less shaded, and also in not being enclosed in a square." [Morris's note.]

5. "The initials of Knoblochtzer of Strassburg and Bernard Richel of Basel may be mentioned." [Morris's note.]

6. In Morris's copy (now in the Morgan Library) of Sorg's *Æsopus Vita et Fabulæ* (Augsburg, *c.* 1484–85), which used the same woodcuts as Johann Zainer's edition, is the following note in his hand: "The woodcuts in this Aesop are from the same blocks as in the first edition, and are among the very best of the school of Ulm and Augsburg, itself the best school of German Gothic woodcuts. The designs are admirable for force of expression, both of feature and action; the accessories are most interesting and full of character, and in short the story is always told in the most direct and the clearest manner that the limited method (which is the best and most ornamental method for book decoration) will allow of. The cutting is worthy of the designs, the lines being always firm and rich, and never cut away; and everything necessary is done unfailingly. Some of these cuts seem by the same hand as those of J. Zainer's *Boccaccio De claris mulieribus*, who again may have designed at least some of those of the *Speculum humanæ vitæ* printed by Günther Zainer."

Printing

Published in *Arts and Crafts Essays* (1893), pp. 111–33, signed by both Morris and Emery Walker; a shorter version, signed by Walker only, had appeared earlier in the 1888 catalogue of the Arts and Crafts Exhibition. A set of proofs, dated January 30, 1893, with a few corrections and queries by a printer's reader, is in the British Library (shelf-mark Cup.502.f.11). Reprinted in AWS, I, 251–60.

1. T. C. Hansard, in his *Typographia* (1825), had offered a similar complaint against the recently-introduced "lining figures," which aligned with the capitals and had no descenders (pp. 429–30). Bradshaw published the standard railway schedule in England.

2. 10-point type.

The Ideal Book

A paper delivered to the Bibliographical Society on June 19, 1893. Published in the *Transactions of the Bibliographical Society*, I (1893), 179–86; reprinted in AWS, I, 310–18, and elsewhere.

1. "Not twice for the same purpose."

2. On January 31, 1893, after a day spent at Kelmscott House, Cockerell recorded in his diary: "The 1st no of the Westminster Gazette issued by old P.[all] M.[all] G.[azette] staff on beastly green paper."

3. Charles Ricketts observed in *A Defence of the Revival of Printing* (1899): ". . . the shaping of the top serifs to the 'u' causes some perplexity to each printer in turn. Let me add that among old printers this prob-

lem remains unsolved. In the Kelmscott Golden type the serifs to this letter are diagonal, thus avoiding the aspect of an 'n' upside down, and following the trend of the older scribes. To me this course reduces the apparent height of an important letter and produces a gap . . ." (p. 7).

4. Daniel Berkeley Updike, the noted American typographer, offered this comment in *Some Aspects of Printing Old and New* (New Haven, 1941): ". . . Morris said some very nasty and unjust things about Bodoni's types and books. Had Bodoni lived to see Morris's books he would probably have thought them unspeakably uncouth and barbaric! Both men were masters of typography, but they were trying to do the same things in ways diametrically opposite" (p. 28).

5. "Pica" was 12-point type; "small pica" was 11-point.

6. "I have only *seen* two books in this type, *Bartholomew, the Englishman*, and the *Gower* of 1532." [Morris's note.]

A Note by William Morris on His Aims in Founding the Kelmscott Press

Published in *Modern Art*, 4 (Winter, 1896), 36–39; reprinted in *A Note by William Morris on His Aims in Founding the Kelmscott Press . . .* (K.P., 1898), pp. 1–6, and elsewhere. A draft in Cockerell's hand, signed by Morris, is in the Carrie Estelle Doheny Collection, St. John's Seminary, Camarillo, Calif. Three sets of corrected proofs are owned by the Bodleian Library (shelfmarks Kelmscott Press b.4 and d.32) and the Clark Library, Los Angeles, Calif. The essay was originally written for Carl Edelheim of Philadelphia, who was responsible for publishing it in *Modern Art*.

APPENDIX A
A Short History and Description of the Kelmscott Press

Published in *A Note by William Morris on His Aims in Founding the Kelmscott Press . . .* (K.P., 1898), pp. 7–20; reprinted in H. Halliday Sparling, *The Kelmscott Press and William Morris, Master-Craftsman* (1924), pp. 139–47. In a set of corrected proofs (Bodleian Library, shelfmark Kelmscott Press d.32) Cockerell's original title is "Additional Notes Relating to the Kelmscott Press," revised to "A Short Description of the Press."

1. These specimen pages are reproduced in WMAB, Plates LVI and LVII.

2. This sentence does not appear in the first proofs of the essay.

3. This is what Emery Walker did a few years later when he designed the Doves Press type.

4. Longmans, Green, & Company, with the authorization of Morris's trustees, published an eight-volume limited edition of some of his later works in the Golden type during 1901–02. Since then the Golden, Troy, and Chaucer types have been used in a few other publications. The types, punches, and matrices are now in the possession of the Cambridge University Press.

APPENDIX B
The Poet as Printer

Published in the *Pall Mall Gazette*, November 12, 1891, pp. 1–2.

1. But in Morris's *News from Nowhere* (1891), a vision of a Socialist utopia in the twenty-first century, the British Museum has been largely abandoned, and very few Englishmen display an interest in books.

2. That is, Middle English. The text of the Kelmscott *Chaucer* was based on that of *The Complete Works of Geoffrey Chaucer*, edited by W. W. Skeat (Oxford, 1894).

APPENDIX B
"Master Printer Morris": A Visit to the Kelmscott Press

Published in the *Daily Chronicle* (London), February 22, 1893, p. 3; reprinted in the *British Printer*, 6 (March–April 1893), 97. For an unfavorable comment on Morris's views published shortly thereafter in the *Daily Chronicle*, see the *British Printer*, 6 (April–May 1893), 98–99.

1. Morris edited the *Commonweal*, the journal of the Socialist League (at first a

monthly, later a weekly), from 1885 to 1890; it was typographically undistinguished.

Published under the heading "Morning Calls" in the *English Illustrated Magazine*, 13 (April 1895), 47–55 (signed "A.B."). A reply, published in the *Realm*, was reprinted in the *Printers' Register – Supplement*, June 6, 1895, pp. iii–iv.

1. "Believe one who has tried."

2. "Weepers" and "bloomers" were borders and decorated initials, respectively.

3. Both of these medieval terms were defined by Morris in the first annual report of the Society for the Protection of Ancient Buildings, June 21, 1878: "A forestaller was a man who bought up produce to hold it for a rise, a regrater, a man who bought and sold in the same market or within five miles of it" (AWS, I, 133).

4. Gaskin's sketches proved to be unsatisfactory, so that *The Well at the World's End* was illustrated with four woodcuts designed by Burne-Jones.

5. Both the Shakespeare and the Froissart were never completed because of Morris's death in 1896. Two trial pages of the Shakespeare are known to exist, one in the British Library (shelfmark C.102.l.22) and the other in a private collection. Two trial pages of the Froissart were issued on vellum in an edition of 160 by the Kelmscott Press on October 7, 1897; in addition, thirty-two copies of sixteen pages of the Froissart were given to Morris's friends. The British Library shelfmark of the latter is C.43.h.21.

Published in *Bookselling*, Christmas, 1895, pp. 2–14 (signed "I.H.I.").

1. This statement is either a misunderstanding of what Morris said or a piece of sarcasm.

2. Morris's statement is slightly inaccurate: see Susan O. Thompson, *American Book Design and William Morris* (New York, 1977), pp. 205–06.

3. For an interview with Walter Blaikie, head of the firm of T. and A. Constable, see "How the Perfect Book Is Made: Printing as a Fine Art," *Printers' Register – Supplement*, February 6, 1894, pp. iii–iv. The "bastard Caslon" was probably the Dryden type, which Blaikie described as "midway between modern and old style."

4. Never published, though an abbreviated list of Morris's principal woodcut books, with thirty-five reproductions from them, appeared in *Some German Woodcuts of the Fifteenth Century* (K.P., 1898).

5. The edition of the poems of Walter Theodore Watts, afterwards Watts-Dunton (1832–1914), was never published.

6. William Holman Hunt (1827–1910), though a member of the Pre-Raphaelite Brotherhood, did not participate in the Oxford Union undertaking.

7. The firm of Morris, Marshall, Faulkner & Co. was founded in 1861, not 1867.

8. This was never done, though Morris often spoke of it. "Long primer" is presumably an error for Great Primer.

9. These manuscripts were acquired by the British Museum after May Morris's death: see R. Flower, "The Morris Manuscripts," *British Museum Quarterly*, 14 (1939–40), 8–12.

INDEX

This volume was designed by William S. Peterson. The text was set in Bembo on an Itek Quadritek 1200 by the Cottage Press, Greenbelt, Maryland, and the titles were set in William Morris's Golden type by the Cambridge University Press. It was printed by offset lithography at Malloy Lithographing, Inc., and bound at John H. Dekker and Sons.